MW00780019

CREATIVE REBELLION FOR THE
TWENTY-FIRST CENTURY

CREATIVE REBELLION FOR THE TWENTY-FIRST CENTURY

THE IMPORTANCE OF PUBLIC AND INTERACTIVE ART TO POLITICAL LIFE IN AMERICA

Diana Boros

CREATIVE REBELLION FOR THE TWENTY-FIRST CENTURY
Copyright © Diana Boros, 2012.

First published in 2012 by
PALGRAVE MACMILLAN®
in the United States—a division of St. Martin's Press LLC,
175 Fifth Avenue, New York, NY 10010.

Where this book is distributed in the UK, Europe and the rest of the world,
this is by Palgrave Macmillan, a division of Macmillan Publishers Limited,
registered in England, company number 785998, of Houndmills,
Basingstoke, Hampshire RG21 6XS.

Palgrave Macmillan is the global academic imprint of the above companies
and has companies and representatives throughout the world.

Palgrave® and Macmillan® are registered trademarks in the United States,
the United Kingdom, Europe and other countries.

ISBN: 978–0–230–33879–1

Library of Congress Cataloging-in-Publication Data

Boros, Diana, 1980–
 Creative rebellion for the twenty-first century : the importance of
public and interactive art to political life in America / Diana Boros.
 p. cm.
 ISBN 978–0–230–33879–1(hardback)
 1. Public art—Political aspects—United States. 2. Interactive
art—Political aspects—United States. 3. Political participation—
United States. I. Title.

N8835.B67 2012
701'.030973—dc23 2011036275

A catalogue record of the book is available from the British Library.

Design by Newgen Imaging Systems (P) Ltd., Chennai, India.

First edition: April 2012

10 9 8 7 6 5 4 3 2 1

Printed in the United States of America.

To all the artists out there who are working hard to bend the world into unimaginable shapes, and to make it sing with new possibilities

CONTENTS

IMAGES

PREFACE

What does it take to make people care?

This question has pervaded my mind for most of my adult life, particularly when thinking about voting, political activism, and revolutionary change—which for me, all go hand in hand. It is frustrating, and often truly sad, to see or hear a lack of care about our public spaces and public decisions. Although there are many examples of inspirational activism and community building—and these keep our neighborhoods, and our politics, as healthy as they are—there are also many examples among citizens of both passive, and very conscious, feelings of complacency, disregard, and disconnection with the public. In 2004, I first began to think seriously about the invigorating powers of a liberated imagination, and about Herbert Marcuse's ideas about the potential of revolution through art in the name of societal change. I considered his arguments about subversive cultural rearrangements and how his theories could be re-examined in light of the rapidly changing needs and values of twenty-first-century life.

By 2007, whether I was reading philosophy, or frustrating statistics on voting in the United States, I found myself asking this question again and again. Since then, I have kept an eye out for inspiring projects that seek genuine connection with individuals—both the interactive artworks evermore common in galleries and museums and the engaging public art projects that disrupt everyday life and involve and inspire passersby. I believe that there is a growing movement in art to create works that are both directly and indirectly increasingly "political" in both approach and content. Being in public outdoor spaces, creating interaction, and reminding participants to be more aware of and empowered over their lives in various ways, all create a desire to care—about yourself, and others, to participate—in public spaces and debates, and ultimately, to initiate change in individuals.

All the projects that this book discusses focus on some combination of public display, participation, and interaction. There are now increasing references made to "socially engaged art." Such socially engaged art can

vary from a project with a directly political purpose or message, to one that creates environments and mechanisms through which to communicate and interact. Often these projects— visual, musical, performative, conceptual—exist outside the bounds of any one artistic discipline. This book is about both public and socially interactive art. These two approaches to art are very often found within the same work. The very fact that an artwork would be created and or displayed in a very public open space is a main component of that artwork—in a way, its canvas is the street or building or park where it lives. In the United States, particularly since the liberating dialogues of the 1960s, and the work of graffiti artists in the 1970s, art of diverse forms has made its way onto our streets and our buildings, particularly in urban areas.

As this public art movement is growing, a move toward socially interactive, participatory, and performative artworks has been taking place within the walls of art institutions both in the United States and abroad. There is evidence that this is a considerable turn in the valuation and display of art, as major institutions have made notable advancements to purchase and offer art of this sort, and as a result, have brought more activity and engagement into the not-truly-public venue of the art museum.

All of this must logically have some sort of political significance. That art is in the public means it reaches more people more often, and it often reaches people who may not normally seek out art. Thus public art is a democratizing factor on experience with creativity and innovation. Likewise, inside the museums, that art is being increasingly appreciated, which is based on dialogue, participation, and physical and/or emotional immersion, is also simultaneously invigorating (disrupting, engaging) the already art-going public as well. So both in the inside spaces intended for art, and outside, in all the diverse spaces available for art, there is a buzz of activity. You can witness some laughing, surprise, sadness, sometimes even frustration; always a reawakening of sorts. This activity—more talking, touching, thinking, and connecting—is inherently of positive political value, for it means that the veins of communication are rippling with flowing blood, and positive democratic value, for it means that more people are becoming (more) engaged in life, and in public life.

This book is about art, and it is about political life and political change, and it is about how these two massive realms of activity interlink and inter-exchange, and at times, meld together into some hybrid that doesn't mix carefully into layers, but rather, melts together into a new form, a new force. The new horizon of art blossoms in the overlapping section of a Venn diagram,[1] with political life at one side, and artistic life at the other. In the twenty-first century, art is increasingly imbued with the

political vibrancy of public spaces as the art environment, and interactivity as the creative foundation.

This book is a place to immerse oneself in a political aesthetic theory that seeks to be ever reactive and accommodating to the changing conditions of everyday life. It desires to build a philosophical basis for the importance of the imaginative power of creative experience, and hopefully, through that, remind the reader to think and feel just a bit more with the liberation of a child, create within the reader a growing belief in the power and importance of creativity, and then finally, offer the reader a rich and diverse story of public and socially interactive art projects and exhibits, mostly located in New York City, over the last several years.

I began writing this project several years ago during an extended stay in Rome. I couldn't stop writing it actually. The ancient city had oozed with inspiration. I remember that I stood in front of Michelangelo's *Pieta*, at St. Peter's Basilica, and felt arrested. The image that it depicts is an iconic and common one—the holy mother grasping onto the limp body of her deceased child, Jesus—and I had seen beautiful versions of it earlier that day at the Vatican Museum. Still, this sculpture seemed alive with pain. The sadness and desperation in Mary's grip could be seen in the way her fingers pinched at his flesh, the way it looked like she could drop him if she was distracted from her focused distress for even a second. I remember thinking that Michelangelo had created interaction in a marble sculpture just by the way his still figures seemed mid-motion. I remember thinking that this was the experience of great art. The art you can't walk away from, that you discover has more layers to linger over than it had immediately suggested, that makes you well up with unexplained and tumultuous emotion on a perfectly relaxed ordinary day.

There are surely many unexplored links between religion and art. In the overlap between the two realms, there exists great potential for unifying and empowering experiences that can be accessed by all people. Listening to the words of great spiritual musical pieces like "Amazing Grace" or "My Souls' Been Anchored" brings to life images of the blind being given sight, of the lost finding their way home—some of the most powerful, moving, and truly universal human emotions. To see light, to really feel liberation, is (besides love) one of the most transformative feelings we could ever encounter. If you asked those who have experienced such a feeling, they would tell you that they felt it physically—their stomach's turned, perhaps their skin grew goose bumps, their eyes swelled with tears, their hands trembled, and their throat clenched. The strength of the particular transformative and liberating experiences can be at least partly attributed to the physical power of this combination of

emotions. Many have said that an experience akin to this changed their life, or encouraged them to try something new, different, or difficult. These invigorating and universal emotions are the same ones that are accessed through experiences with moving and visionary art, and thus the revitalization and empowerment that is borne of them becomes a political good when the art is experienced often and in our communal public spaces.

I read recently that the infamous Roman Emperor Nero, as a young man, loved to study philosophy, but was instructed to stop because he was told that it would interfere with his ability to rule effectively.[2] This made me laugh, and although I saw some truth in the warning to Nero, it also reminded me that to convince people that philosophical uncertainties and creative rearrangements are very much a part of political life is a tall order. The knowledge and self-confidence that experience with creativity can provide is vitally important to healthy, self-aware, interested, and participatory individuals. More importantly for the needs of political science, it is healthy participatory individuals that form the basis of both citizenship and society.

Transformation is the key to art. In transformation, there is change from one to another, and in that temporary disorder, there is liberation. In that liberation, the individual becomes more aware and knowledgeable about oneself and one's relation to the world, and in that gains interest in others. A feeling of connectivity is inherently participatory. This interest is the first part of participation. To encourage participation first in our own lives, and then in public life, the role of art, and particularly public or otherwise interactive art, should not be underestimated. Unfortunately, most of us today are, in general, lacking an abundance of public and socially interactive art projects in our daily interactions. I hope that this book can be one small step toward the building of a public and interactive art worldwide initiative that would work to change this by promoting a widespread resurgence of a belief in the value of creativity, and in the importance of interaction, inclusion, and empowerment in public life.

There are several very active organizations in New York City—where this project was focused—that support, fund, and publicize more and more public and socially interactive artists and their projects. These larger organizations, working in tandem with smaller groups that create and appreciate the hundreds of creative and challenging ephemeral interventions in everyday public life, are on the frontline of developments in art practice, and intimately witness to the fusion of art with political life.

Creative Time, one of the city's leading progressive public art organization since 1974, focuses on socially engaged projects, and works hard to "commission, produce, and present art that...breaks new ground,

challenges the status quo, and infiltrates the public realm while engaging millions of people in New York City and across the globe. We are guided by a passionate belief in the power of art to create inspiring personal experiences as well as foster social progress." The group endeavors to "promote the democratic use of public space as a place for free and creative expression while reaching people beyond the traditional limitations of class, age, race and education" (*Creative Time* website). Similarly, the *Public Art Fund*, the other pioneering public art association in New York City, in existence since 1977, seeks to make it "possible for artists to engage diverse audiences and, along the way, redefine what public art is in relation to the changing nature of contemporary art" (*Public Art Fund* website).

Founded just over ten years ago, the *Art Production Fund's* mission statement echoes these efforts in that they aim to "expand[ing] public participation and understanding of contemporary art." Further, the newer group similarly seeks to "reduce[ing] the physical as well as the psychic distance of cultural, class, linguistic, racial, and income barriers that may hinder participation in contemporary art" (*Art Production Fund* website). These motivating beliefs are the backbone of the ideas presented in this book.

I have included with the text in this book a selection of photographs of recent public and interactive art projects, so that the reader could connect with the situations and ideas described in an immediate and visual way. I have also included below a much abbreviated list of website links that will take you to articles as well as entire websites devoted to various public and socially interactive art projects. I recommend that you take a look at some of them and ride their inspirational value to a commitment (or recommitment) to experience art and creativity in your everyday life.

Notes

1. A Venn diagram consists of two interlocking circles, with each circle representing one realm or idea, and a section in the middle of the diagram where the two circles (and ideas/realms) overlap. This overlap expresses where the two realms or ideas mix and fuse.
2. Video exhibit in the Curia. Roman Forum. Rome, Italy, 2011.

Public Art Links

http://newyork.timeout.com/things-to-do/1673945/public-art-walk

http://blogs.villagevoice.com/runninscared/2010/05/the_street_pian .php

http://www.nytimes.com/2011/01/16/arts/design/16ryman.html?_r=1

http://www.artdaily.com/index.asp?int_new=38782&int_sec=2

http://www.marielorenz.com/tideandcurrenttaxi.php

http://newyork.timeout.com/arts-culture/art/1414653/your-guide-to-public-art

http://www.nyc.gov/html/thegates/home.html

http://www.nycwaterfalls.org/

http://www.woostercollective.com/

http://www.creativetime.org/

http://www.publicartfund.org/

http://www.artproductionfund.org/

ACKNOWLEDGMENTS

Deepest thanks to all those who have inspired, read, and commented on the manuscript. I am especially grateful to James Glass who has made countless valuable suggestions during the course of this project. I would also like to thank the capable editors at Palgrave Macmillan.

I am deeply appreciative of the support that my entire family has provided me during the writing of this work. Along with the artists, I dedicate this book to my maternal grandmother, who passed away in Hungary in 2010, but who is nonetheless always with me.

INTRODUCTION

Instinctual revolt turns into political rebellion.

Herbert Marcuse, *An Essay on Liberation*

Even the most realistic oeuvre [of art] constructs a reality of its own: its men and women, its objects, its landscape, its music reveals what remains unsaid, unseen, unheard in everyday life.

Herbert Marcuse, "Art as Form of Reality"

It is difficult to get the news from poems yet men die miserably everyday for lack of what is found there.

William Carlos Williams, "Asphodel,
That Greeny Flower"

We generally take for granted that the foundation on which American democracy rests is the interactive, and ever-evolving landscape of civil society—the social and civic associations of Alexis de Tocqueville's (1835/2002) famous observations. But whether or not we agree with Robert Putnam (1994, 2000) that American civic associations have for decades been on the decline and that more and more Americans are "bowling alone," we must confront the question of whether the public activity, debate, and inclusivity of our political and social organizations is enough to sustain the health of our system of democratic representative government, and the political culture it engenders. Do our associations harness a collective of truly independent and community-minded voices? Or is civil society's sincerity and effectiveness threatened by the excessively individualistic emphasis in popular culture, and as a result of this, the largely conformist tendencies that underlie American democratic culture? Do our civil organizations encourage sincere democratic life? And if these interactions do manage to keep democracy alive in our public spaces, and in our public interactions and debates, do they allow us only short sporadic breaths, heavy with dust?

Some in America—usually those sitting to the left of the aisle—contend that true democracy—of, by, and for the people—has gone the way of free love and Marxist revolution. What remains is the subject of debate. Some say that all of our political institutions are democratic façades for domination by the powerful few; others go only so far as to complain about the ineffectiveness of the Electoral College system, or of our voting booths. That the consistently challenging and interactive characteristic of democracy (beginning with our public spaces) is largely dormant in the United States, and that Americans themselves are generally, in this sense, dangerously publicly inactive, is a foundational assumption of this work. Regardless of the extent to which Americans feel alienated from the governing system, most would likely agree that a key issue with democracy in the United States is that it is not only far from working as a direct political mechanism (which is in part the intention of a representative democratic republic), but that it often lacks a sincere connection with the average citizen. It is not a logical stretch to conclude that a person who does not feel involved or needed by their government, or community, or larger society, will likely not wish to participate.

It is also an easy conclusion that in America one can be quite comfortable—politically, emotionally, and materially—and "free" without exerting much individual political will. The definition of citizenship in America today has devolved to mean little more than someone with the ability to vote for the offices of government. Citizens in the United States could, barring the occasional call to jury duty, theoretically never even leave their homes (in this sense, take no part in society) and all are still afforded the full protections of the U.S. Constitution. This "free rider" problem (Putnam, 1995, 2001), at work in many ways in American political culture beyond that of decreasing the apparent need or drive to vote, enables the "timid herd" mentality that is an inherent possibility in American life. Over time, this crisis of the "free rider" has become an abstract general truth in American public life. It is in this sense that we could argue that Ben Franklin was wrong when upon being asked, following the Constitutional Convention of 1787, whether Americans now had a monarchy or a republic, he famously replied, "[A] republic if you can keep it." The implication of his words being that a republic is a system of governance that relies on civic engagement and participation on behalf of its citizens—on *working* to keep it—or else it will falter. Americans today have shown that the United States can remain a mostly free, cohesive, and politically safe country, regardless of political effort exerted by each individual citizen. This is clear just from observing a voter turnout, that on a good day (for presidential elections) hovers at around 50 percent.

It is best to redefine the problem at hand. We must seek new solutions not to this lack of public participation, but to the lack of *interest* in public participation by the average American. We must seek ways, and provide the tools, to draw citizens from their individualistic tendencies into a more interested and dynamic public life.[1] What we can call the sincerity of citizenship—or genuine belief in and involvement in—in any system, particularly a political system, which is by nature social and interactive, should not be undervalued or avoided because of the difficulty involved in attempting to define and evaluate elusive levels of "sincerity." A society, seen as a machine with moving parts, is only a stale collection of those parts if the machine's movements fail to convey genuine meaning to the user. Still, we must be wary even when "meaning" is conveyed, because meaning in a post-Foucauldian (1991) and post-Baudrillardian (Baudrillard & Glaser, 1994) world—where even desires can be reproduced by the mechanisms of popular culture in a way that they become "hyperreal" simulations of their essence, or what we can call sincere or genuine meaning—can take on new forms. In the late twentieth century, Baudrillard wrote that in the world of simulation, reality disappears, and from its ashes rises the hyperreal. This conception of information [in the late twentieth and early twenty-first century] introduced the possibility that when concepts, meanings, and creative forms are co-opted by the ruling majority opinion, not only are they simplified and sterilized of both their natural emotional force and their uniqueness, but they may also actually cease to exist. It is this sort of invisible process that has enveloped public life, associations, and general notions of both local and universal community today.

Even when the movements of a machine convey "meaning," it is difficult to say whether these meanings penetrate beyond diffusing concepts that are so much a part of American cultural identity that they are mindlessly inhaled rather than adequately digested. Today's democracy in America is by all accounts more shallow and tepid than it could be. Despite the exceptions, democratic life in the United States today overwhelmingly yields to the power of popular opinion, rather than being inspired by a true collective of individual passions in deliberation. This popular opinion—whether one believes it is the product of manipulation by the forces of government, media, and big business, or simply the organic result of too many alienated citizens on autopilot—is a driver of American democracy and must not be ignored. Studies that have called attention to consistently poor voter turnout (as compared with much of the world), and to the free-rider problem, have failed to change the difficult situation. Americans, though self-conscious to take note of the lack of citizen involvement in political life (and its accompanying institutions), focus primarily on the inaction—the effect—rather than the cause of the

widespread dispassion. A redefinition of the problem would be valuable both to the discipline and to all those people who are cited as "at fault" in this.

The moderate and unquestioning tendencies of popular opinion have co-opted many facets of American public life, as can be seen in the dominance and ubiquity of "plastic"[2] (comfortable, redundant) art in public life. During co-optation, alternatives, for example, creative approaches to status quo ideas and beliefs, are invisibly gobbled up by popular culture and spit out as commodities. The result is that these newly minted commodities that masquerade as genuine artistic expression *appear* as they once existed—as fresh ideas—but their sources of genuinely free thought have been sterilized. Thus, the meanings they disseminate become like laminated playing cards—forever in play, but unchanging in character or appearance—and, despite the many possible combinations of meaning that can be played, there are clear limits well within the bounds of infinity.[3] This ability of people to live without having to create or even find meaning on their own, has the effect of alienating individuals from their own emotions and, ultimately, from aspects of public life and from the greater human community.[4]

Although it is the catalyst for this study, the most important issue is not that American democracy and public life have suffered in expressions of enthusiasm, mutual trust, and inclusivity, owing ultimately to the lack of enthusiastic and consistent participation in the public sphere itself. Rather, the greater concern is that the very nature of American democracy breeds the dangers of a conformist and complacent possessive individualism, and so a solution should look to the future of democracy, as well as to its past. Although there is an important Puritan and civic republican tradition in American political thought, it is the legacies of the Lockean (1689/1988) liberal individualism on which our democracy at least partially rests, that overwhelms our popular and political culture today. And it is this tendency that must be balanced with a force that enables us to access both our true individual beliefs, as well as the vital sense of universal unity that ultimately comes of such individual contemplation through the language and imagery of artistic experience.

The fields of public art, and socially interactive art, have become more prominent than ever in the last five years or so, as the production of public artworks, both large-scale and well-funded endeavors, as well as grassroots projects that often focus on performance and interactivity, has increased and gained more attention from the media and the art world. This is a fascinating field of study for at least two main reasons. One, because it liberates art out of a closed and regulated space, into the freedom of the outdoors, and two, because its placement makes art available to all members

of the public who happen to cross its path—in this way, it is inherently democratic. This work argues that there is an urgent need for greater support of public and social art projects and better access to these sources of funding.[5] More art, and more interactive art, in public spaces would first individually, and ultimately collectively, revive and animate communal environments; create new relationships between individuals and the public; strengthen feelings of community; and foster the desire to participate in public life on the basis of new relationships both to the self and to the public. Individual experience with creativity and the arts has been shown to lead to higher rates of civic engagement, and to an increased interest in public life as well as an empowerment in one's own personal life. Artistic experience, especially powerful and frequent experience, enables access to an inherent but latent spirit of community that exists within all individuals. This understanding of ourselves in others can then inspire a desire to participate in the public realm. This link demonstrates the utility of employing art as a tool to encourage political participation. According to the National Endowment for the Arts (NEA) (2007), "By every measure, literary readers lead more robust lifestyles than nonreaders. These findings contradict commonly held assumptions that readers and arts participants are passive, isolated, or self absorbed." The researchers concluded that "Americans who experience art or read literature are demonstrably more active in their communities than nonreaders and non participants. [. . .] Thus, literary reading and arts participation rates can be regarded as sound indicators of civic and community health" (NEA, 2007, p. 6).

Using the study's findings, NEA chairman Dana Gioia looks to the psychological processes that take place within individuals who experience art that inspires them to community life and public action: "Something happens when an individual actively engages in the arts—be it reading a novel at home, attending a concert at a local church, or seeing a dance company perform at a college campus[6]—that awakens both a heightened sense of identity and civic awareness. We must banish the stereotype that reading books or listening to music is passive behavior. Art is not escapism but an invitation to activism." In December 2009, the NEA released its 2008 survey of Public Participation in the Arts and reported that even the "most educated" (arts activity and education are correlated) adults had been participating less since 2002, and that there are "persistent patterns of decline in participation for most art forms." In this more recent study, Sunil Iyengar, director of Research and Analysis for the NEA, calls arts participation a "vital form of personal and social engagement" (NEA, 2009, p. 1).

Public art in the most formal sense is art that is commissioned and owned by the state, but when we speak of contemporary public art, we generally mean any form of artistic work—be it painting, music, or interactive

performance—that is intended for the public and social spaces in our lives. This presence of art in daily experience can help to reconceptualize the processes and meanings within a public space and can alert citizens to public concerns, as well as to shared individual fears and desires, through our creative instincts: "The public artist today engages issues of history, site, politics, class, and environment. These multiple visions may help to transform communities as they find common grounds" (Mitchell, 1992). Hannah Arendt used the idea of the "public realm" to mean a public where members meet to discuss common political desires and ambitions. The concept of "the public" employed here speaks to this understanding, as well as to a more abstract public life that is felt in the spirit of individuals, regardless of whether or not they are physically participating in the political scene. I argue that this reinvigoration of the depth and sincerity of our public lives must first occur so that these new individual relationships to the public can ultimately lead to a more inspired and active political body. In this sense, I also employ a particular definition of the "political" that asserts that politics is not just seen in our laws and policies and elections, and in the decisions made in Washington, but rather, 'political life' here is used primarily to indicate the myriad of interactions, unwritten rules, and communications, which take place in public life.

Friedrich Schiller (1794/2004) argued that it is the important role of the (visionary) artist in society to seek meaning in life beyond the paternalism of the watered-down symbols of popular will: "But how does the artist secure himself against the corruptions of his time, which everywhere encircle him? By disdaining its opinion. Let him look upwards to his own dignity and to law, not downwards to fortune and to everyday needs" (p. 52). It is of key importance that the artistic experience as a social good is a bi-level process; first, the individual experiences art and gains access to the liberation and connective feelings ("look upwards to his own dignity" (p. 52)) that artistic action and contemplation provide, and, second, the newly experienced independent reflection and awareness of the individual empowers the individual's relationship to his or her community, and to the greater society.

I will also endeavor to clarify a distinction between two approaches in art—what is referred to here as "plastic" or alternatively, conformist or mainstream art, and what I term "visionary" or transcendent (what I will later also call "rebellious," after Camus) art. I assert that although all art has positive societal value, "visionary" art encourages important political possibilities by reawakening (through rearrangement) and engaging (through the critical thought that the rearrangement invites) a participant. This aims to be neither a simplistic nor elitist argument; rather, it is imperative to draw out this distinction in order to determine the extent

to which the motivations and goals, as well as the effects, of an artwork can inspire imagination, change, and action, within the individual, and ultimately, in society. The notion of "plastic" or conformist art encompasses two primary ideas. The first is that art becomes redundant, however alternative or avant-garde it may have once been, once it is unveiled into the public realm and has reached the desires of a critical mass. This desire in our supply-and-demand-run popular culture forces a repetition of the art that yields it diluted and drained of its original effect. Once it is repeated many times among individuals in society, it loses its ability to create a fresh arrangement of our environments and our beliefs and thus cannot be truly transformative. The second is that much of "plastic" art is created, from the start, with profit, not creative and political transformation, in mind. Other works of "mainstream" art, as mentioned, began as transformative works, ideas, and movements; but after passing through the filtering process of dissemination into popular consciousness, and because of overproduction, oversaturation, and overanalysis, they have lost or diminished their original power.

It is not that "mainstream" creativity is entirely undesirable, or that it cannot sometimes serve a positive purpose; such stark distinctions between that which is conformist or reduntant, and that which seeks beyond, are difficult, and perhaps unnecessary, to make. Still, innovative, hardworking, forward-seeking, engaging, and interactive art must be celebrated and encouraged, as truly inspirational creativity is one of the main bloodlines of human development, of societal progress, and of healthy individuals.

I define visionary or transformative artistic creation, following Friedrich Nietzsche and Albert Camus, as art that seeks to disorder and rearrange previous conceptions, both of art and of life, through the dialectical union of emotion ("the irrational"), with reflection on those emotions (the "rational"). All art has the potential to create participatory empowered behavior, but visionary transformative art is the form of art where political progress can be best accessed and articulated. Camus (1951/1991) wrote that "rebellion is a preliminary to all civilizations" (p. 273). He defined rebellion first as an act of *creation* and concluded that "[w]ith rebellion, awareness is born" (p. 15). Much of "mainstream" art, despite its sometimes rehearsed rearrangements, fails to connect the viewers with questions that will engage them over time. Transformative art, especially public and social visionary art, is needed to seek out and materialize alternate possibilities for our individual lives, for our societies, and for the political systems by which they abide.

Public art can encourage participation in public life[7] and is a key factor in the development of a "civil religion." While that neither should be nor need be the ultimate goal in America, the American citizen is, in

general, lacking both a consistent need for, and access to, poetry, universal empathy, and true political desire, while hard work, pragmatism, and possessive individualism is encouraged at all levels of society. Despite the invigorating nature of our recent and historically significant presidential election in 2008 (an election is in itself an invigorating moment, yet one that occurs only every four years), we are still in a thinly veiled crisis and could use an injection of true civic interest in our society. Since the latter decades of the twentieth century, the status quo has advanced largely undisputed. Not since the upheavals of the 1960s have there been widespread efforts to create a truly new understanding of politics and a society with a new arrangement of values.

Personal artistic experience does not lead directly to institutional political participation. But it expands the limits of our conception of what is possible, both for ourselves and for our public lives and society. Artistic experience creates the desire for action through an expanded engagement with the world. Experiencing art draws people inward at first, to deeper reflection and self-knowledge, but then leads to greater participation in public life, which can ultimately lead to more democratic action (not necessarily in political institutions and processes, but in political change more widely understood). The approach in this work does not fault and discard the complacent "last men"; instead, it encourages everyone to expand their imaginative capabilities through art by promoting public and socially interactive art projects.

The Argument Further Explained

Psychologists have produced an abundance of studies on the mind processes that take place during artistic interaction to examine how it alters our psyches and why creativity makes us feel good.[8] The existence of the fields of art therapy, community art programs, and art in public education advocacy programs attests to the importance of these processes. For the many children and adults who use these types of art programs, they serve often as lifesavers, usually in several different ways. It is generally understood that a creative outlet is vital to a balanced life. How many times have we heard stories of a bored Wall Street financial analyst who comes alive after he (often by chance) discovers pottery, photography, or the art of cooking? This situation is most often described as the need for release in an everyday life that may otherwise be patterned and controlled. In another common example, we have heard countless times of the young child or teenager who is neglected at home, or lives in a neglected community, and is able to find a new world and a new family in art and creativity. Accessible community art exhibits and classes,

school art programs, and spontaneous outdoor art performances, as well as art festivals in our neighborhoods, are all vital resources for a healthy life. Not only does creativity provide balance in a world dominated by reason and practical concerns, it can also serve as a distraction and escape from the difficult realities of life. Some have said that the creative blanket can keep us warm, just as drugs are often able to do—we can lose our inhibitions and forget our troubles and responsibilities, at least for a short while. While this may be true, the psychological fulfillment that comes from artistic engagement has far more important ramifications for the individual, and for society, than the momentary joy of forget that intoxication can pour over us.

Forget takes us away from the world around us, whereas artistic engagement brings us closer to it by providing the opportunity to interact with the world on our own terms. When we create or encounter art, we may momentarily breathe free from the needs of our daily lives and from accepted reality, as we are able to reimagine the way that we perceive the world around us. This is what makes art inherently political. It affords us the ability to wield power over that which we otherwise have little or no control. In the realm of art, we can see the world as we would like it to be, and we can show others new possibilities through art. The individual gets full control in this sense, as art is the realm of imagination and fantasy. The capacity to imagine individual change must precede a change in daily public reality.

To identify the specific nature of the positive political power of artistic experience is not an easy task. The relationship between art and democracy, and more generally, between art and public life, is important, though it is not usually direct.[9] Like most relationships between experiences that are intrinsically subjective and ever changing, the correlation between experiencing art and experiencing increased public awareness and activity is difficult to simplify and cleanly categorize. Despite this relationship's resistance to easy understanding, its existence must be nurtured, not ignored. We need to encourage our children, our communities, and our governments to reengage with art as a political and social necessity.

Again, I do not argue that when one experiences art one is then, as a direct result, encouraged to participate in the political system. Unfortunately, there is no easy formula for determining a direct route from individual experience to an inclination or desire to take an active part in the political process or in political change. Many theorists of American politics have picked away at this puzzle. Most have concluded that people are guided primarily by self-interest, and that therefore—if you subscribe to this belief about human nature—game theory adequately determines

that they will most likely become a part of the free-rider problem unless there are clear incentives, or rewards, for participation. Before trying to identify why or why not a person votes, it is likely useful to try to understand why or why not that person cares enough about society, and about their fellow citizen, to vote.

The real question for American politics, and for the study of political behavior in general, is how does one become more inclined to participate in public life? Besides offering external, tangible rewards for participating in the political system, it is difficult to determine why any person desires (or decides) to participate in our political institutions and processes. Ultimately, natural diversity among people, even concerning civic virtue, is the determinant for participation. In other words, some are naturally more inclined to care and others not. It may be more fruitful to examine why an individual becomes more interested and active in public (as opposed to the more specific "political") life in general. Participating in public life is a necessary precursor to participation in the political system.

I argue that art, and public art, has a natural ability to motivate people in a variety of ways. In articulating our common emotions, as well as in rearranging our public spaces and public beliefs, art can consistently create something new. An experiment in art extracts moments and cross sections from the landscape of life around us. A work of art may emphasize or de-emphasize, or turn upside down, or show parts without their whole, or show the whole empty of some of its parts. This entirely new way of looking at ideas and feelings, which we already have some understanding of, can foster a reawakening of the everyday.[10] Making mention of a poem by Rilke on art, Hannah Arendt (1998) writes, "In the case of art works, reification is more than mere transformation; it is transfiguration, a veritable metamorphosis in which it is as though the course of nature which wills that all fire burn to ashes is reverted and even dust can burst into flames" (p. 168). If we agree with Baudrillard (1994) that life in many ways has become a mere "simulation" of life, then it follows naturally that art can stimulate the simulation and, in creating something new (a new perception of reality), can reattach sincere meaning to the daily transactions that have become predictable. When life is rearranged, it loses order, if only temporarily. It is in this destruction that possibilities are born.

In artistic experience, we can access a true independence and freedom, because of our ability within art to rearrange everyday reality as we please. We can experience known ideas and feelings in new ways, as well as gain an increased sense of empathy through universal insight into individual thoughts and emotions. Through art, it is emotional vision (the realm of poetry) that is able to take precedence over the societal or "rational"

vision, that is generally accepted as the "truth" of reality. Being able to stake a personal claim over our environments, and over our public lives, can be politically empowering. In all creation there is a vital component of ownership—it is an overcoming of the alienation Marx (1844/1978) described—but through the spirit, not through the mechanisms of the external economy. Hence the greater that sphere of the creation of ownership (the more often and varied it is), the more that individuals become spiritually tied to the world, and to the public life that they have now at least partially created. "By virtue of this transformation of the specific historical universe in the work of art—a transformation which arises in the presentation of the specific content itself—art opens the established reality to another dimension: that of possible liberation. To be sure, this is illusion, *Schein*, but an illusion in which another reality shows forth" (Marcuse, 1972, p. 87). Here, Herbert Marcuse reminds us that art is the realm of empowered illusion and fantasy; one can create infinite realities to experiment with and learn from, under its spell.

Through art, we can expand our imaginative capabilities, and thus envision life according to our own desires, beyond the confines of the status quo. Visionary art, linked with the progress of time (the material conditions), can create a stronger democracy (still not direct, but community driven) that can save us from the encroachment on our personal and creative lives of the manufactured nature of capitalist society. Capitalism is an economic system, but its philosophy inherently contains a need to encompass culture as well, and particularly, a need to inspire that society to embrace capitalism. Foucault (1991), writing about the complex problem of dispersed bureaucratic powers in the twentieth century, termed it "governmentality." He argued that capitalism had begun to be affirmed by those very individuals it works to exploit. The fundamental basis of all political and economic systems (and theories), even if they claim to be limited to their own stated spheres of distanced power, is the individual, and consequently, the forces of both politics and economics will transform individuals to conform to the needs of the system. Hence a culture is an accurate reflection of the political and economic systems it engages. In this sense, systems become like totalitarian leaders, with egos and cults of personality all their own, who bewitch their followers into obedience.

Accordingly, artistic production also does not escape the tentacles of capitalism. Artistic creation becomes part of a system simply because we live under a capitalism so omnipotent that nothing, not even our own bodies or ideas (our art), escape the value game completely. Now, in the twenty-first century, even the most alternative-seeking ideas and trends are usually quickly commodified, and thus stripped of their visionary potential.

My concern here is not with the proliferation and popularity of certain repetitive and regurgitated forms of "mainstream" art, or with the almost instantaneous commodification (transformation from visionary to mainstream) of any object or idea that is released into the public realm, although recognition of these issues lies behind all the ideas presented here.

Some advise that experimentation should not be confused with rebellion. In their end products, this may indeed be a valid distinction; still, it is the case that rebellion often begins with experimental thought and behavior. To attempt new possibilities—to be open to the new and to try feeling and expressing the new—is the foundation of true rebellion. Experiments transform an unexplained field by expanding its contours. Disordering or reordering, even if such rearrangement fails to achieve its purpose, whatever that may be, or is deemed a "failure" (by an audience or by the market), is much like a "failed" revolt that ultimately inspires successful political change: it has nonetheless expanded the imagination of the collective consciousness, which lays open the possibility for change. Sometimes, a stimulating, or strange, or interesting occurrence, does not immediately and noticeably change you, but there *is* rebellion in the sensory experience, even if the subject is not fully or immediately aware of the rebellion. Revolt can happen not only in the senses but also in our subconscious; this is not the traditional idea of revolt that takes place in our material or rational worlds. If we can experience our creative selves, it is not creating beauty but creating that is the prime concern. It is not conformist reiterations of previously explored artistic ideas, but rather, challenging visionary art that seeks the "new," which matters most for politics.

Even intellectual study of an artwork can do a great deal to expand the imagination, to tweak one's senses and perceptions. Arts education, in both schools and communities, is a given necessity, but visionary public art and interactive social art make the experience of art more confrontational and democratic—either by actively engaging the viewer, or by simply being in an outdoor public space, or both—in a way that attempts to alter one's everyday understanding of the outside world and the human community. Confrontation with artwork inevitably alters the individual by allowing one to feel that new and alternative ideas are conceivable.

The Social and Political Nature of Art

This issue of how to define art is a mildly distressing one, both philosophically and emotionally. All definitions seem to somehow fall short. Contemporary standard definitions usually describe art as an expression

of a combination of skill and creativity in order to create works that are beautiful or emotionally powerful. While this understanding does explain a good chunk of what art is, there are many interwoven layers to a complete definition of art, as well as some competing inner tensions. The primary inner tension reflects the distinction between visionary art and less innovative art. Still it would not be fair to say that creative works, which some argue fail to inspire, are not art. Still, art that actively seeks to change both the history of art and the development of society is a deeper process. Visionary art is a fantastical or poetic reorganization of the world around us. It is art that is pushing ideas forward, rather than sticking with known boundaries and proven to-be-successful formulas, and thus deserves its own definition. In this case, it may be useful to first add to this starter definition (of visionary art) the variable of novelty. Art should be a new creation in some way. It should offer a new idea, technique, approach, and/or philosophy. It is within this part of art's definition that we can locate conceptual projects that present an idea, or a service, or even an organization as art—in that it has been conceived in a new way.

The question of what makes an object, or an experience, a work of "art" reaches beyond the concern for identifying limits on the validity of an artwork; it seeks to understand what it is about art that permits it to appear in infinite forms and dimensions—in the people, objects, and ideas of everyday life. Over the course of history, art has shown itself in so many ways, that as a concept, it has become almost elusive—it is difficult to restrain it long enough to understand it—and yet has shown itself to be a condition of existence. Art has found its way into countless sociological and psychological studies, for the very reason that art is a way to understand how people view each other, themselves, and the world. It is necessary to constantly adjust for a fuller understanding of what art is endlessly becoming.

Perhaps Leo Tolstoy described it best over a hundred years ago in "What Is Art?" (Tolstoy, 1896), in which he answered this question by identifying what he believed to be the most important characteristics of artistic experience. In a lengthy list, his first three points stand out as not only the most important descriptors, but also as those that capture well the transformative capabilities of art. In the first point, he writes that one must first, "cease to consider it [art] as a means to pleasure and to consider it as one of the conditions of human life." In the second, he wrote that all artworks create a relationship between the "receiver" and "both with him who produced, or is producing, the art, and with all those who, simultaneously, previously, or subsequently, receive the same artistic impression." Finally in the third, he argued that art, like speech, not only allows us to share our experiences and ideas, but that it also creates unity

among those who have shared and communicated. Tolstoy concludes in this third point that "[w]hereas by words a man transmits his thoughts to another, by means of art he transmits his feelings." A century later, Herbert Marcuse echoed this description of art: "Aesthetic theory is confronted with the age-old question: what are the qualities which make the Greek tragedy, the medieval epic still true today—not only understandable but also enjoyable today" (Marcuse, 1972, p. 87). Marcuse is speaking here of the ability of art to transmit and highlight universal human emotions through time and place. The more that an artwork is able to express an important emotion in a universal manner, and through new and challenging approaches, the more visionary it becomes.

In one sense, a mother who spends an afternoon drawing with her toddler is making art just as the professional sculptor with the Master of Fine Arts degree, and the gallery representation, is. Despite there being a difference between the two situations—related both to the self-consciousness of the proclaimed artist and to the level to which the artist and the artwork posses the skill and creativity to rearrange our dependable perceptions—whether it is art or craft, the act of creation always holds the potential to be transformative. This general importance of all art should not be overlooked in our discussion of the political value of transformative visionary art.

Experience with art, particularly in creating it, is an unequivocal good, regardless of the ultimate value (as in transformative power) of the work. This is so because all creative action is a reconfiguration of its given reality—this is necessary to the ability to access a broader imaginative capability. All art is a productive experience that engages the creative spirit—at least for a moment. The problem is that much of redundant "plastic" art concludes the creative process with its seen-before end product, and the viewer is thus left uninspired.

The value of art in engendering more self-aware, empowered, and open minded individuals lies in part in its sincerity, its will, its intention. This focus on sincere or authentic creation, rather than solely on the material evaluation of the end product, means that all art created with sincerity, despite its sometimes vacuous visionary attributes, can change an individual's conceptualization of reality and of established perceptions, although far more slowly than truly transcendent artwork, and often to little political or communal benefit (sometimes even to negative effect in this sense, as "plastic" art affirms the status quo and reflects ruling ideals, rather than genuine rearrangements of our existing knowledge). Still, it is only human for us to be physically and emotionally affected by the striking materiality of artworks. Consider the average corporate-commissioned, space-dominating sculpture; even if it is uninspiring, in that you have seen works like it before, when standing next to it, you can still feel transported, affected at least by its sheer size.

It can still break the monotony, the known structure of daily life. This is the first-order communal benefit of public art—that any beautification or reconfiguration of public space endows that space with social value. In other words, any work of public art can create an emotional relationship between the individual viewer and the space in which it resides.[11] This is the power of art—even in its regurgitated, less challenging forms, it can inspire.

There are at least three main ways that public art can create, support, and enliven both communal spaces and feelings of community. The first is through the beautification and amplification of our public spaces in order to create pride and communal feelings of ownership. The second is through direct and overt political critique and protest, which is in itself a political action. This can be art that protests a societal issue such as domestic violence, or art that seeks to illustrate the shortcomings or corruptions of a political regime, or it could be art that is used by a political campaign or a civic group to create an organized movement or to incite participation in a specific event. This historically supported, and useful, concept of "political art" uses artistic experience, imagery, and language as a vehicle to voice a political idea or concern in a less formal manner than traditional political appeals and manifestos do. Its seeming disconnection from nonartistic realms of life enables it to communicate radical ideas in a nonthreatening way. The third way, and this is my primary focus in this book, is when art demonstrates imaginative new ways of seeing our world and our everyday lives simply through its restructuring of the everyday. This last way is what I call the "politically indirect" power of art, and of course of public art as well. This is the way in which visionary art can provoke connection to others, and to the public as well, through its inherent power to lift the human spirit out of the mundane, and into the sublime.

One individual, or one philosophical work, could never claim to determine the boundaries between expected experience and creative experience for all other individuals in their relationships with art and with various artworks. It is enough simply to establish that there is a way to experience art that is inspirational and self-empowering, and a way that is less so. Both are important to public and social life; all art in the public, even mass-produced or redundant art, creates a stronger sense of pride and interest in the public, which is vital to a sincere feeling of community,[12] but it is transcendent or visionary art that encourages within people the expansion of their imaginative capabilities, their true independence (knowledge of self), and likewise, their sense of empathy. Ultimately, the presence of challenging art on our streets brings creative and emotional knowledge into the public arena, and uses that knowledge as a tool to bring about a stronger natural desire for people to care about and participate in their communities, and in their political destinies.[13]

Indirectly political artistic experience does not require that the artistic experience invoke specific or tangible political concerns. Rather, it can create a "political turn" within individuals through transformations of space that enable the ability to envision rearrangements of the world, and through implicit suggestions of alternative approaches to how we view our personal and political lives. All art, whether "rebellious" or less so, is vital to a healthy imaginative life, and all public art is a benefit to our public culture. Still it is visionary or transformative art that throws a wider imaginative net. It can serve as a prime catalyst for the individual political rebellion that ultimately culminates in a more reflective and sincerely connected citizenry.

Some artworks and creative ideas rise above the rest in their rebellious and sometimes anarchic rearrangements. Visionary artists, those who forever altered the way we perceive ourselves, and our world, and continue to influence the way in which we understand even the most fundamental forms and concepts—from Da Vinci to Caravaggio, Van Gogh to Picasso, Duchamp to Dali, Merce Cunningham to John Cage—take great strides in educating the participants of their art by actively working to open minds to new possibilities.

Methodology

In this study of the political value of social and public art, I have consulted a wide variety of sources. Within a paradigm that links some of our most fundamental political questions with the world of art, my primary focus has been on works of Western political philosophy that not only provide the basis for many of the arguments of this work, but also supply the lens through which to evaluate the multitude of potential other sources. Drawing heavily on modern and postmodern thinkers, the ideas of Alexis de Tocqueville, Friedrich Nietzsche, Albert Camus, and Herbert Marcuse dominate. These thinkers are the foundational influences of this work for their shared belief in the power of spiritual or creative experience, and their adamant refusal to unquestioning accept everyday life as popular opinion (or Christian morality) presents it to us. Following the more directly political works, inquiries into the nature of art, and into the role of art in society, are important sources. Relevant discussions of art and the links between art-making (and experiencing) and feelings of both transformation and community-mindedness, by leading art critics, serve as an important point of view that both complements and contrasts with the political works.

To address the driving concerns of this work—how to reinvigorate Americans themselves, and American democratic culture, with new ideas and perspectives, as well as how to reignite the senses and the public

participatory desires of Americans—the arguments of a unique combination of theorists were called into examination. The query began with a fresh look at some of Tocqueville's most salient ideas as presented primarily in volume II of his *Democracy in America* (1835/2002). This was an important starting point as Tocqueville is well known for his aristocratic perspective on democratic life in America and for the potentially negative characteristics, especially of mediocrity and materialism, that he locates in a culture based on an equality of conditions. While his clear love for fading aristocratic values is evident throughout his works, the focus here is not on whether he ultimately sides with democracy or with aristocracy. Rather, I point here to the detailed and powerful warnings he provides on the dangers that democrats may fall prey to, if citizens living in democracies are not careful to uphold healthy connections to public and to spiritual life.

The use of the ideas that I argue are most valuable in Tocqueville's *Democracy in America*, was not only necessary in order to locate the arguments in this work within the unique characteristics of the American context, but also to establish a theoretical basis for the assertion that democratic conditions, while clearly a necessary basis for modern government, justice, and social life, also inherently breed a culture that can easily and often comfortably relax into conformity and complacency, while still reaping many of the benefits of democratic life. Beyond this, that one of Tocqueville's only solutions to safeguard democrats against these potential dangers is the involvement in associative and spiritual life, is another foundational key that supports the need for art, and its spiritual and associative benefits, in the public. Tocqueville speaks of the value of religion in democratic life, but it can be inferred from his words that it is not the religious rules themselves that combat the complacency of excessive individualism brought on primarily by a focus on commercial success (though the rules of religious life in America, he did argue, create needed structure and order, but this is another point altogether), but rather the attention and connection to otherworldly, nonmaterial feelings and values that religion incites. This valuable point created the launching pad for the argument made here that a spiritual component to everyday democratic life is needed to reawaken the spirit, and thus the self-awareness and self-exploration that is required in order to foster interest in the development of the world outside of oneself. In this work, the access door to a spiritual life is conceived as the encouragement of creativity through art. The argument follows that in order to expand the accessibility of art— sometimes considered to be an elitist or intimidating pastime or field of study—it must be available *in the public* to the most people possible.

Moving forward, in considering why art has the ability to produce deep feelings of self-awareness, innovation, and connectivity with others, the

ideas of both Nietzsche and Camus quickly leap to mind. Both of these thinkers understood the vast political power involved in the sense of discovery, revolution, and humanitarian justice that lives within art. Inspired by the true individual freedom that can be reached in denying, at least temporarily, the norms and morals of society, both Nietzsche and Camus, in varying contexts, advocated for increased self-awareness, and a more authentic and empathetic approach to questions of justice and morality. Beyond this, it was necessary to seek examples of philosophical artists who employed vivid techniques in their work that drew readers and viewers into an alternate otherworldly realm of encounter with the spiritual and the irrational. Among others, the Romantics, the Dadaists, and the Surrealists, each with their own mission in mind, exemplified the notion that valuable knowledge and insight into the human condition can be gained through creative and spiritual explorations of the irrational and the unconscious. Arthur Rimbaud's unrestrained style of poetry is an oft-noted inspiration for living by instinct, while the Marquis de Sade's subversive writings explored the animalistic predisposition of humanity, and likewise defended a morality that is individually defined, and accessed not through rationality, but rather through instinct, or nature. Both as an overarching foundation, and as the conclusive glue that highlights the revolutionary power of spirituality, instinct, and art, as seen within all the theorists' ideas that are explored in this work, Marcuse provides valuable insight on the many links between art and liberation of the mind through connection with the universal creative spirit.

In the course of this project, I examined many endeavors in public and socially interactive art through an analysis of relevant news sources, with a focus on New York City over the last several years. The majority of the articles cited here range in date from 2008, until midway through 2011. It was necessary to limit the bulk of the research to the culturally vibrant locale of New York City. It was clear from the beginning that this one urban community alone would tell a vivid and varied story of public and social art. Further, the comparison of the case of New York, with that of the public and social art that is being created in other cities, is material to be covered in another project. Although the focus of this research has been on New York City, I have included some notable examples from other parts of the country and from abroad, that provide a starter pool of evidence for the contention that this movement in art toward the public, the interactive, and the cross-disciplinary, can be seen in a diversity of environments.

The research collected together here examined the motivations and goals of many public and socially interactive creative projects, and the artists who created them. Most of these projects are detailed and reviewed

in several notable news and cultural sources. I have brought together an interesting array of articles and examined them thematically, sourced primarily from *The New York Times* and *New York Magazine*. Using these cultural journals in particular as guidance, this work also aims to serve as an overview of developments in the public art world, so that we may better understand through tangible examples, how the philosophical claims of this work are encountered in current creative projects.

This sampling of journalistic accounts bring to life both the art world and everyday life in New York City, and comes together to tell a still-developing story. The articles discussed here cover developments in the social and public art movement by examining how major cultural publications approach the topics of current exhibitions (both in major institutions and in fringe venues) in the city, public art (spontaneous projects as well as major works) on the streets, and changes in collective understandings of art. This is important because institutions are generally viewed as setting the standards for both definitions and exhibitions of art, and when studying public art, it is interesting to look at developments in nonpublic art alongside of it. The complete story of the current movement in art encompasses both the spaces inside the walls of museums and the vibrant public and interactive art happening outdoors in public spaces, like that of the streets of New York City. The articles collected here describe the art coming out of artist collectives, and small independent projects, as well as the contributions of highly funded ventures. I looked for creative approaches to public and interactive art, in mediums that ranged from the visual arts to the performative arts, and culled some of the most challenging and unique ideas to discuss here. It is certain that I have missed, and failed to include, some important developments, projects, or articles. It is an ongoing project to document these works and ideas, especially the most grassroots efforts. It is a testament to the vibrancy of the social and public art culture of New York City that there is such ample coverage of it in its cultural news sources.

Chapter Breakdown

Chapter 1 begins with a discussion of democracy in America today and draws heavily on Tocqueville's (1835/2002) observations on American life in the 1830s and 1840s. His ideas concerning the role of spirituality and civic associations in American public and private life are discussed to shed light on how to assess the state of democracy today. Tocqueville argues both that spirituality [borne of religion] and associations support each other in several ways (and that religion fosters association), and that religion provides a necessary balance through attention to the immaterial where a

focus on material pursuits tends to prevail. I then introduce the argument that art and artistic experience can replace the role of religion by providing an outlet from the "established reality" of everyday life (both public and private) and by enabling the self to connect with its immaterial needs and desires and thus access feelings of unity with nature and thus gain a stronger sense of community. To argue that with creative and spiritual knowledge one gains access to feelings of community, implies at least three interrelated ideas. First is the idea of community, that is the philosophical concept that encompasses anything outside of our own selves, or the counterpart to the notion of the individual. There is also the concept of community that is contained in our local cultures—the physical environment of sights, sounds, images, and voices that we encounter each day. Finally, there is the overarching concept of the universal human community, which we access through the feelings of empathy and connectivity that can be gained from our experiencing through art, what is felt universally in our everyday moments. The best artists and artworks capture these universal forms and ideas in ever-new ways.

Chapter 2 picks up the discussion of both the nature of art and the role of art in society. This chapter explores Nietzsche's (1872/1967) arguments on the characteristics of transcendent art. Nietzsche's belief in the necessity of the Dionysian, or the "irrational" realm of human experience, introduces the need for creativity in human life. He argues for the necessity of moments of freedom from, and reimagination of, the everyday (this is the emotional beginning of art). Art develops visionary attributes when the instinctual and emotional Dionysian moment is first processed, and then made lasting, by the reason of Apollonian reflection. Through the organization of the alternative reality that Dionysian experience enables within a person, an expansion of the imagination takes place. From this process can emerge political imagination, desire, and ultimately, praxis.

Nietzsche's conception of the union of Dionysus and Apollo as the overcoming of tragedy, or transcendent art, is traced from the early ideas expressed in *The Birth of Tragedy* (1872/1967), through the more nuanced discussions of *The Gay Science* (1882/1974). I agree with his later argument that the dialectic of these two opposing realms (of life) allows for visionary thought and action. The division between "mainstream" conformist art, that can be identified through its repetition of content and form, and courageous, novel expressions of the spiritual and the existential, is explored.

Chapter 3 discusses Camus's (1951/1991) understanding of art and its relationship to revolutionary ideas and to politics in general. He saw art as rebellion and, following Nietzsche's similar claims, as an eternal

fusion of two opposing realms—that of the rational and the irrational. Camus encouraged a new understanding of individualism that encompasses a unity of all selves. To support and highlight some of Camus's themes in a contemporary setting, this chapter explores how an experience with visionary artwork, whether outdoors or within the confines of a museum, creates valuable change within a person that is important to a fulfilled and active life. In the last two decades, two very different explorations of the power of art have been provided by Carol Duncan (1995) and Caroline Levine (2007). The ideas in their works, one rooted in art theory, the other in cultural history, serve as supportive arguments in making the case for the value and power of art. Duncan highlights the transformative potency of the rituals that are accessed when art is experienced in museums. Levine asserts that the presence of challenging avant-garde art within a democracy keeps the system committed to a freedom of ideas.

Chapter 4 examines the importance of dialectics, both to a healthy life and to visionary art. Drawing primarily on the ideas of Rimbaud and de Sade, I show that the eternal tension, between what is irrational, passionate, and natural and what is rational, ordered, and a product of reflection, is the most necessary component of visionary art. In the parallel relationship within art, there exist two interrelated aspects of art-making that demonstrate its inherently political nature. First, there is the initial connection to the instinctual or spiritual realm of existence (captured in the Dionysian moment), when the artist makes art out of found objects, empty space, everyday life. In these rearrangements borne of art-making, there is creation and destruction, elation as well as meditation. Then, whether consciously created or naturally apparent, there is art's modification of reality to illuminate the universal, the existential; life as poetry. This ability of art to provide an image or a sound for elements of the human condition which are difficult to see or describe, can be seen in works that either literally or abstractly evoke universal themes like love, death, pain, laughter, family, and work, and present them in provocative new ways.

Visionary, or "rebellious" art, following Camus, is fundamentally transgressive; it is a negation of the "established reality." In reorganizing and newly envisioning the world, art provides, for the creator and the viewer, contemplation of oneself, and of life. Within this reflection lies great potential for new viewpoints and behaviors to form within the self that challenge accepted ideas and create new possibilities. It is through experience with a "particular" visionary moment that one can access important universal emotions. Every experience with art is an expression of a particular moment, feeling, and place. Visionary art allows us to

momentarily transcend daily existence and *feel*, not think or organize or value or judge, but *feel* what it is to be human. We live within a narrow field of vision but can, through creativity and art, imagine the contours of the extended image. As we expand our picture of the world and of life, the picture not only becomes more whole, but also begins to take on an entirely new form. The new image reminds us both of our ultimate, and our mundane, connectedness to all others, to accompany our learned liberal conceptions of the importance of the individual.

We then come to chapter 5's discussion of the power that visionary artistic experiences in daily life can have on individuals. Marcuse's neo-Marxian work in the 1960s on revolution in everyday life through cultural rebellions, was in part instigated by his disillusionment with the widespread lack of human compassion that he saw in the violent and cowardly behavior that had bloodied most of the twentieth century. He believed that real societal change could result from the many subversive cultural developments he bore witness to during those exciting and divisive years of the countercultural boom—from conscious changes in vocabulary and diction, to new types of clothing, to new techniques like improvisation and action painting in visual art and music. Marcuse enthusiastically described a world where the ruling ideas of the Establishment could be subverted and inverted everyday through the transformative capabilities of art. His ideas exemplify a belief in both the healing and the political power of art.

Finally, chapter 6 provides evidence of the ever-increasing move to produce and exhibit public and socially interactive art. This final chapter catalogues a selection of interesting projects, created between 2008 and 2011 and enacted primarily in New York City, that have confronted the citizens of the city with imaginative inspiration. My goal is to demonstrate the various strains of the current public and socially interactive art movement and show how its many different projects all aim to contribute to individual awareness, liberation, empowerment, and community participation. Finally, I assert the need for increased both private and governmental funding, for not only arts awareness and the educational and cultural programs that support it, but also for accessible and open-to-the-public sources of funding for a variety of public and interactive art projects. Such projects would help both those artists who are not supported by either institutions or personal connections in the art world, and the many persons whom the art would reach on the streets, especially those who might not otherwise confront challenging art. These types of experiences build and support active self-awareness and a community-oriented, cosmopolitan mindset.

It is vital that the American government (and the American private sector as well) fund the arts, and especially public art projects, with greater attention, generosity, and consistency than is now forthcoming. Visionary art must now become social, and public, in the broadest sense. It must work to awaken a truly free individual instinct, unite communities, and challenge the liberal fallacy, and mainstream conception, of the importance of the lone individual. The twentieth century revolutionized the traditional boundaries of art. Performance and installation art, the "happenings" of the 1960s, and graffiti and outsider art became frontline discussions even in the mainstream art world. The defining movement in art for the twenty-first century has been to put it on the street. We must support and encourage this still-evolving trend, which is vital to the revitalization, and thus advancement, of our public lives, and ultimately, of our democracy.

Conclusions

The aim of this work is to make a contribution to two main areas of political philosophy, and political science in general, by looking at ideas of participation and community in a democracy, and by highlighting the need for revitalizing changes that seek true individual freedom and empowerment through art. In this way, the work seeks to be relevant to theorists in the fields of democratic participation, to practitioners of democracy in all its forms, to artists, and to those who fund and organize arts organizations. Further, it endeavors to add to ongoing discussions regarding the foundations of democracy and the problem of lack of citizen participation in public life, as well as to theories of the utility of nonviolent rebellion, and revolutions of the mind (or spirit), in the quest for a healthier American democracy in the twenty-first century. Beyond its relevance to civic engagement research, challenging and visionary art in the public sphere makes available the knowledge borne of creativity to all who cross its path, and thus promotes a theory of art for the individual, as a tool of liberation from the unquestioned knowledge of everyday reality, and as a way to access new or alternative possibilities. Creating and experiencing art is the only way to move *beyond* physical reality and the limitations of both history and daily life. This has always been art's power, even under circumstances where art was not intended for public consumption. Regardless of its use, art is fundamentally a recreation of life, a reorganization of the senses. Even before the presence of overtly impressionistic movements in art like cubism, surrealism, and expressionism, classical painters and sculptors created images that reinvented

and reinterpreted the divine, as well as the everyday, so as to provoke universal emotions and experiences.

Today in the United States, and around the world as well, outside the urban centers and pockets of communities that house concentrated art worlds, the social and interactive landscape of art remains largely hidden or nonexistent. Public and social art projects can provide access to one's truly free inner self, and to a connection with others. An increase in public art projects would not only create greater respect for and involvement in the community, but it would also have a transformative effect on the public as viewers. Especially those not often exposed to art would have new opportunities to experience the reorganization of reality that art provides. In this way, public art would reinvigorate the American individual.

Artists have historically needed sponsors—patrons willing to invest in their art—so artwork has always in a sense reflected those who supported its existence. If we want to support a free unbiased public art movement in this country, we must not only rely on the support of private organizations. It makes sense to invest tax dollars in public art so that our public arts could democratically reflect all of us—the public.

For genuine interest—in each other, and in public life—among most individuals to emerge, and the complementary increase in inclusion and participation to take root, democracy must ultimately rely on a true collective of individuals—each endowed with the truly independent reflection that yields both empowerment and connection to shared emotions—not merely on the dangerously conformist and complacent "popular opinion" of Tocqueville's (1835/2002) fears. Schiller (1794/2004) too had described the alienating feeling of excessive individualism (which, for Tocqueville, is a contributing cause of complacency in democratic conditions): "Eternally chained to only one single little fragment of the whole, Man himself grew to be only a fragment:...he never develops the harmony of being" (p. 40).

Experience with art enables the individual to reawaken, liberate, and empower oneself through access to universal emotions and reflections. Thus, as the individual becomes stronger, so does society, and the human community at large. This is akin to what Camus (1951/1991) meant when he argued that attention to the individual is not less important than attention to the whole, but that the idea of the individual must be reconceptualized to include a vital connectivity with, and reflection of, all others in the definition of one individual. This is relevant to humanity, but holds particular value to the discussion here as the political culture of the United States, with its vast borders encompassing

widely diverse peoples, would benefit deeply from a deeper recognition of shared fears, desires, and vulnerabilities. This type of connective glue would create more active communities, and the more inclusive and dynamic existence of an overarching American community.

Tocqueville (1835/2002) argued that democracy's conditions of equality inherently possess a potential for dangerous repression by the popular will—a new institution, a new form of tyranny, and a new paradigm for understanding the structure of society—that for him paralleled aristocracy's hierarchical system of power and wealth, as the creator of oppression in society. He argued that instead of formal and centralized de jure proscriptions for behavior in society, democratic conditions in America create and enforce rules through elements of dispersed de facto power.

Over a hundred years after Tocqueville published his warnings of the repressive capabilities of popular opinion in democratic culture, Marcuse (1970a) explored a parallel concern through a humanist Marxist lens and argued that the advanced capitalism of the twentieth [and twenty-first] century not only fails to respond to traditional Marxian class theory, but it actually succeeds in incorporating all classes of individuals into its grasp of conformity and sterility of shared desires. It is through this historical condition, these moments in the progression of capitalism as an economic system, that we must address democracy as a political system.

As Marcuse, Foucault, and others have described, capitalism has grown from a system of laissez-faire supply and demand with a focus on profit to one that has transferred the assembly-line perspective to the realm of the psychological. In a democracy, when individual needs—private needs— are consistently felt in tandem with the majority that has created them, liberation from the "established reality"[14] is imperative if both authentic individual freedom and the desire to participate in public life are to be accessed.

So, what can be said of today's democracy? What can be said for individual political involvement and empowerment when even the most private of emotions can be mediated and filtered through popular culture? How can participation and the desire for change be inspired within each individual? How does art expand the imagination and heighten a desire for both community and praxis? These are some of the driving questions underlying this work.

CHAPTER 1

EVERYDAY REBELLION: USING TOCQUEVILLE TO ARGUE THE NEED FOR A REVITALIZATION OF AMERICAN SOCIETY AND DEMOCRACY THROUGH ART

Each individual allows himself to be attached because he sees that it is not a man or a class but the people themselves that hold the end of the chain.... Choosing the representatives of this power from time to time...will not prevent them from losing little by little the faculty of thinking, feeling, and acting by themselves.

Alexis de Tocqueville, *Democracy in America*

Many thinkers in the Western tradition—Marx, Nietzsche, Freud, Camus, Marcuse, Gramsci, Beauvoir, among others—have critiqued our experience of everyday life and the role both society and the state play in that reality. In various ways, they have asserted the need for an awakening of true liberty within all individuals. As we seek answers to today's concerns with democratic life in the United States, it makes sense to consider the ideas of this critical tradition. An interesting addition to this tradition lies in the work of Alexis de Tocqueville, whose work provides not only sociologically comprehensive observations on American life, but also the elemental tools for better understanding American political culture. Tocqueville was a true political philosopher, the first to call attention to the potential dangers to individual freedom of thought that are inherent to American democracy, in his *Democracy in America* (1835/2002).[1] Writing around the same time that Marx (1844/1978) was finishing the early essays that became known as the *1844 Manuscripts*, Tocqueville, a Frenchman of aristocratic blood, traveled to the New World with the intention of studying America's justice system. He was a young lawyer in service to the French court after the revolution but

was so fascinated by America that he stayed far longer than intended to examine and experience the many different layers of American democratic life.[2] Some of the most salient and eloquent passages in *Democracy in America* concern the danger that true individual thought, cultural and civic activity, and a genuine sense of community will collapse into the rule of a complacent and conformist popular will.

There is a crisis in American democracy today, aspects of which are contemporary and others that are age old, that must be addressed. Further, it is not enough simply to cite the problems that repeat, such as low participation in the political process. Today's crisis of democracy is reflective of the passage of time; with age, our republic's power grows more and more dispersed, and becomes further internalized within individuals. This increasingly invisible, yet insidious power in society, results in growing feelings of a Marxian notion of alienation, or a division among people. This happens as popular opinion (the true power in American democracy) wheedles its way further into the very needs and desires of the people, while the complementary "myth of the individual"—a key part of alienation—is maintained in political culture. Popular opinion, in the United States and almost everywhere else in our globalized postmodern world, is heavily reliant on the capitalism and materialism that created the globalism to begin with, and both globalization and popular opinion benefit from organized alienation. Tocqueville's fears about Americans' acting as a "timid herd" from the force of equality joined with popular opinion in a democracy have been coupled with the current dominance in cultural life of a complex media structure, a focus on connectivity by way of the Internet, and a level of consumerism and globalization he could never have predicted, despite his prescience.

In considering this current lackluster state of citizen involvement in public affairs, and the unique political culture of the United States that accommodates this, Tocqueville serves as a guide to understanding why and how Americans have a tendency to focus more on work than on communal and spiritual affairs, and the implications that this characteristic has on public life, and on the individual psyche. Tocqueville observed that religious and spiritual life was necessary in the everyday life of the American, in order for democrats to avoid falling prey to the tyranny of popular opinion that is intrinsic to all democratic systems. The need both to acknowledge and develop our spiritual lives is critical to my primary argument—that public art can revitalize and expand individual imagination and motivation—for several reasons. First, since people are comprised equally of the inclination for reason, as much as of instinct and emotion, it is crucial to nurture both aspects of human nature. Second, with the influence of Locke's work on the development of the US Constitution, as

well as the enduring legacy of the Puritan work ethic, American political culture has focused heavily on commercial success, and the value of reason and science, while knowledge learned of creativity and spirituality seems to play second fiddle. Third, Tocqueville's work shows us that these tendencies within American democracy both have serious consequences on the safety of true liberty, as popular opinion dominates, and that they can be confronted and controlled through experience with the other worldliness and empathetic reminders of religion. And last, where Tocqueville employs religion in his theory, I insert creative experiences, and the role of public art in particular.

His theory of the role of religion in American public life, and consequently, in American democracy, creates an interesting point of departure for the theory presented here. In *Democracy in America*, the best elements of Tocqueville's political theory result from his ability to vividly describe almost every element of American life, both public and private, through the lens of an equality of conditions. It is his overlying belief that the fundamental experience of being regarded by society as an equal to your peers (at least far more equal than had been the case in feudal European society) creates a foundational political psychology that appears in every relationship, every communication, and in the values of popular opinion. This psychological condition is both revolutionary for Tocqueville, as well as a possible source of dangerous widespread complacency, in that it not only accepts certain inherent fluctuations in social and political life that allow for fresh input and fast turnover, but it also whitewashes over this potentially fresh independent thought, with the equally disseminated suffocating thickness of the ruling beliefs of society. It is easy for Americans to fall prey to, or give in to, the already-constructed ideas and values of the popular opinion in power, says Tocqueville, as they are generally more focused on individual economic success, and the private sphere of life, to think about advancing change in the public sphere.

Although there are many exceptions, this general lack of either empathy or independent will for and in the public is reflected in the ability of most Americans to simply "let things happen" that they largely feel they have little to no control over, rather than desire to be critical, and thus provide the fodder of true flux and change. Although the "free-rider problem" is not unique to America, as it demonstrates some basic human tendencies, Tocqueville's extended analysis of early American culture still elucidates how the many unique attributes of American society—its newness, its ingrained survival, and its commercial spirit—come together to create an ideal environment for an excessive focus on work and the pursuits of the individual. In attempting to understand why so many Americans fail to even vote, let alone be engaged, on their own accord, in

either governmental or civil society-based actions, without tangible and often immediate material rewards, it is valuable to turn to Tocqueville's observations to explain the qualities that are common to most who reside in America. Tocqueville himself implies his observations will stand the test of time, as they are the inevitable reflection, or by-product, of democratic governance.

In this chapter I employ several of Tocqueville's primary observations about democracy and American life to demonstrate that individual creative rebellion (for him, as exemplified through religious experience) in the pursuit of liberty plays a necessary role in American political life. Tocqueville argued that the Puritan drive for work, and the full embrace of a commercial mindset alongside the adoption of democratic goods, creates the potential for an apathetic and conformist American people, without much perceived need for community, or an understanding of the human condition; and that this weakness could be improved through religion.

Where he used religion as a balancing force against these drives, I argue that in our modern context we can transmute the role of religiosity into that of art. I aim to show that spirituality is a political concept and that art can fill this role. Artistic experience is a more democratically accessible avenue to counter our individualistic and capitalistic proclivities. To improve the levels of civic behavior and heighten genuine feelings of inclusiveness and community within and among individuals in society, Tocqueville's arguments about the importance of religion in democracy can be better understood in the language of art, and may be reformulated as the importance of art in a democracy. This replacement of the role of religion with art has important implications for individuals, for society, and for democracy.

There is a key distinction between religious practice and behavior, and religiosity, or what can be explained as the type or intensity of your belief, that is important to the ideas presented here. To abide by a religion's rules and doctrines is the condition of being religious, of following a religion in your everyday life. This is far different from what is understood as religiosity, or spirituality. The spiritual feelings and connections of the spirit that may, or should, arise when engaging in religious practice is what is important to the heart of this thesis. It is not about the religious behavior, but rather the emphasis here is on the depth of spiritual feeling as a result of reflection brought on or encouraged by religious knowledge or practice. This same reflection, connection to otherworldly values, and spiritual connectivity among creatures and people is encouraged by art and creativity. When Tocqueville discusses the role of religion in America, his point that its indirect relationship to political life actually

sustains its primary influence in that realm, and thus creates order in a society of equality of conditions, is important and holds a place in the history of American democracy, at the very least as seen through the eyes of a European. Still it is his other point about religion, the one that concerns not the rules of religion but the knowledge of the spirit, the belief in the values of the spirit, and the seeking of the spirit within and among us all, that is relevant to what I argue here.

Overview of Tocqueville's Primary Arguments in *Democracy in America*

In looking at American democracy, Tocqueville was interested in the perpetual tension between the establishment of equality among individuals in society and the encouragement of liberty that naturally perpetuates difference. Within this dichotomous relationship, he highlighted the important role of religion, and both the practical nature of Americans and their tendency for frequent change, what he called "restiveness." During the time of Tocqueville's visit, Americans lived as pioneers, pushing forward the boundaries of the rapidly expanding physical and philosophical frontier of their land; theirs was an enterprising mindset that sustained survival and growth. It is natural that both the pragmatism and the relative "mildness" ("middling" nature) of American political culture reflected the still-developing needs of a rapidly growing country. In all aspects of life, practical thinking and a focus on commerce, rather than on the emotions of poetry and art, helped to define Tocqueville's America.

Tocqueville's overarching arguments in *Democracy in America* rested on his belief that the chief defining characteristic of this new democracy was what he called an "equality of conditions." It was this leveling of "conditions"—the equal distribution[3] of political benefits among citizens, and mobility across social classes—that most reflected the vast changes that manifested in the transition from a hierarchical feudal society to a nonhierarchical democratic one. This equality of conditions trickled down to bring a new face to every aspect of social, political, and economic life in America.

Tocqueville had few complete solutions to the problems he feared in democracy, although he did suggest that American democracy needed a "new political science" that would attempt to identify, prevent, and correct the potential dangers inherent to democracy, and that democracy should hold moderation as its dearest virtue. This moderation in life would be achieved primarily through both the role of religion and the role of secondary voluntary social and civic associations (family and

friends being primary associations). It would also be achieved by encour-
aging what he called "self-interest properly understood," which can be
understood as a particular definition of self-love that asserts that loving
oneself naturally includes a love of all others and thus an attention to
the public good, in order to combat the dominance of material pur-
suits. Above all, Tocqueville believed it was necessary to love democracy
moderately. He saw public expression as necessary to liberal democracy
as protection against its internal contradictions. He concluded that the
new American democracy is a delicate balance of equality, liberty, and
religion. It is religion that both creates a permanent structure where
an equality of conditions had made the structure or order of society
fluid and regulates the mores of American life, and that could persuade
the American mind away from commerce and labor into the realm of
the immaterial. As a reminder of all that is important to human life
outside of physical and material needs, religion, by supporting a life
perspective that centers on the human spirit rather than on self-serving
pursuits, not only can push people out of the isolation that capitalism
naturally lends itself to but also can encourage a higher level of inde-
pendent thought. Once religion is able to discourage tendencies toward
isolation and materialism, then people who have unwillingly accepted
the rule of Tocqueville's tyranny of the majority while in isolation now
can see themselves as members of a true human community. As a result,
they will be exposed to a deeper understanding of true individuality
that embraces the desires of others and of the community. We must love
democracy, but in moderation, that is, rationally and pragmatically as
well, Tocqueville implied.

Morton Schoolman (2001) makes a relevant argument in defense of
American democracy. He believes that democracy makes individual inner
exploration and awareness, and the consequent understanding of the plight
of others, natural. This is indeed inherently possible, yielded by the equal-
ity of democracy, but it brings up a perpetually two-sided characteristic
of democratic culture. We must be aware in order to promote such con-
nectivity. Democracy also creates an environment that can make political
laziness, a free-rider mentality, and a driving desire for material gain, easy
tendencies to fall back on.

The Case of the Mediocre American

The first volume of *Democracy in America* is largely descriptive, depicting
Tocqueville's journey through America's towns and cities. Here he iden-
tifies the foundations of American democracy as equality and liberty, but

not until the second volume does he analyze the effects of equality on the conditions, sentiments, and relations of everyday life. In the pages of the second volume, Tocqueville describes the dangers to liberty that a focus on equality of conditions naturally brings, and tentatively discusses the need for rebellion from the potentially liberty-endangering tendencies of American democracy.

Perhaps most important is his contention that American democracy, and its accompanying tenet of equality, consistently, and in all realms of life, pushes the American toward the mean. Tocqueville views this development as natural to democracy and ultimately best for all, although perhaps still somewhat abrasive to his aristocratic sensibilities. This "middling effect" naturally has both positive and negative results, although for Tocqueville, the loss of certain extreme and imaginative ideas is acceptable when one considers the benefit that is a nation of mild and pragmatic, if sometimes conformist, democrats. This section of Tocqueville's work employs his arguments regarding the basis of American democracy and its accompanying mores to explain the unprecedented reinvention of social relationships based on equality. Unlike the fixed-class relationships essential to hierarchical rule, democracy encourages organic, fluid connections—such as the ones we encounter in a variety of social and civic meetings, charities, and associations—that bind people to one another in a more genuine partnership that can be revised and recreated at the will of the individuals (and not the social or political order) involved.

Tocqueville and How a Love of Commerce in Democracy Breeds Excessive Individualism

Tocqueville believed that a quest for, and the attainment of, property created an independence and drive that supported liberty, but that excessive self-interest and its consequence, greed, corrupted the benefits of a focus on commerce (Drolet, 2003). As we can learn from the Puritans, a hard-work ethic and a desire for material success yield a pragmatic and self-reliant worldview; but, without the benefits of a complementary religious life that asserts ultimate moderation and benevolence, as well as an active voluntary civic life, the excessive and diffused love of commerce will threaten to produce a society far less communally minded than that of our earliest European settlers, as individualistic citizens become increasingly alienated from their fellow citizens, from the potential complexities of public life, and thus become increasingly susceptible to the "soft despotism" Tocqueville feared.

For Tocqueville, the American obsession with commerce created a love of liberty that was essential for the democratic state, but with democracy's accompanying tenet of equality, the American people, encouraged to suc-ceed above all, were prone to placing political concerns behind his more important material ones (Drolet, 2003). Tocqueville argues, "Commerce is naturally the enemy of all violent passions. It likes even tempers, is pleased by compromise, very carefully flees anger....Commerce renders men independent of one another; it gives them a high idea of their individual worth;...it therefore disposes them to freedom but moves them away from revolutions" (p. 609). As a result, individuals in democracies are motivated by a greedy self-interest in material comforts that precludes a desire for polit-ical change or revolution and an inability to identify properly the needs of the public. This major weakness of the democratic system creates a need for a balancing force that can alleviate the pressure of material success, educate the people, and restrain greed and self-interest. Tocqueville observed that religion achieves this balance in material-and popular-dominated American life. Religion provides the necessary link to empathetic and community-minded emotions and perceptions that become clouded by the fog of the competitive mindset of daily commercial success.

Michael Drolet's work[4] likewise argues that Tocqueville, following Montesquieu, believed that "religion cultivated between individuals' sentiments of fellow feeling, sympathy, and benevolence. It also directed individuals' attention to spiritual concerns, obligations and consider-ations, and these took them beyond their daily and material preoccupa-tions" (p. 80). Invoking Tocqueville, Sheldon Wolin (2003) argues that like democratic man, "postdemocratic man wants to be led while feeling free" (p. 570). Wolin highlights what is perhaps the primary problem in American democracy: that citizens enjoy their equal access to liberty but lack a certain "spirit of liberty" that inspires them to take active part in sculpting and preserving that liberty.[5]

This spirit of liberty in American democracy is linked intimately to the spirit of community that is reawakened by religion, says Tocqueville, and as this work argues, also through artistic experience. Feelings of community are born of truly independent contemplation apart from the popular will. When a true spirit of liberty is accessed, the feeling of uni-versal empathy, or a spirit of community, is awakened inside the person. Religion is a portal to our immaterial world, and these intuitions work as a "check" on our pursuit of the material, both in their ability to create the feelings of intoxication and transcendence in which we find that we possess qualities that can't be quantified or commodified. In the absence of the divisive competition of ownership, unity as a real possibility is more readily perceptible. This was apparent in Tocqueville's time, in part

because of the way religion was woven into the everyday moments of life, even political life, thus illuminating earthly concerns. It was in his day, the key reminder of spiritual life in a commerce-based world; today it is artistic experience, and particularly public and social creative experience, that can invigorate, refresh, and connect together all members of society through its universally meaningful rearrangements of values and of life itself.

Tocqueville distinguishes between unrestrained self-interest and thoughtful self-interest that is guided by reason, what Drolet (2003) calls an "enlightened self-interest" (p. 182). It is clear that self-interest on its own will not naturally align with the interest of the public, but a reasoned self-interest demonstrates the importance of the public good. We must balance our taste for material success with this new conceptualization of self-interest—a self-interest that is restrained by a reasoned selflessness borne of a recognition of human connectivity—or true liberty will be at stake, argue both Tocqueville and, following him, Drolet.

Likewise, the other major threat to liberty, excessive individualism, is tempered both by religious life and by an active involvement in political and social associations.[6] In their examination of the social capital produced by civil society today, and the relationship of civil society to the mechanisms of the state, Edwards, Foley, and Diani (2001) suggest that civic organizations create empathy among individuals and employ the words of Putnam to illustrate their point: [Associations] "broaden the participants' sense of self, developing the 'I' into the 'We'" (p. 34). They thus foster what Tocqueville termed "self-interest properly understood," as well as a "wider sense of a community and social purpose" (p. 34). The spiritual aspect of both religious belief and associational life remind people of the value of that which is outside their everyday concerns and their material pursuits. Spirituality aids in the discovery of the universal, and the eternal. Similarly, when we associate with others, we are granted peeks into a greater sense of community as many small interactions and communications form a more interesting, and more interested, public realm.

Imagination and the "Spirit of Liberty"

Tocqueville's central quandary in *Democracy in America* is how a democracy, characterized primarily by equality, can be truly compatible with liberty. Tocqueville speaks often in that volume of the "spirit of liberty," of the good that liberty possesses in and of itself. Rather than being a means, a tool to achieve certain goods, liberty can be an end all its own,

a desire to create life actively, rather than to merely accept it: "[T]hey lack the taste itself for being free. Do not ask me to analyze this sublime taste, it is necessary to experience it." (Tocqueville, 1856/1955, p. 205). He argues that under democratic conditions men are apt to slowly give up their liberty to an administrative despotism, both to preserve their material comfort and to ease the insecurities of the constant flux and uncertainty of democratic life.

Allen (2005) looks specifically at the role of religion in American democracy and calls attention to the vital role of imagination in preserving liberty in a democracy. She echoes Tocqueville's call for a wider and more motivated imaginative capability among citizens so they may escape the tentacles of soft despotism. "Conformity originated in two ways—when 'innovators' silenced themselves and when the empire...(intellectual authority) was so vast that unorthodox ideas lay beyond the imagination. In politics self-censorship reaped any number of negative consequences, but in society the lack of imagination—the complete suppression of thought caused by 'an enormous pressure of the mind of all upon the individual intelligence'—seemed to Tocqueville far more dangerous" (p. 166). This relationship between feelings of insecurity and the desire to yield to a greater authority is a common theme in human history. Freud (1927/1961), too, pointed to how humans have historically readily accepted the "truths" of religion in order to fill the inevitable void created by our instinctual existential crisis. In agreement with Tocqueville, philosopher Hilde Hein (1976) has written: "In producing a work of art, one engages in deliberate choice, assuming responsibility for one's decisions and their outcome. By contrast, bureaucratic society diffuses authority to the point where autonomous action all but disappears, and paternalism buffers our conduct so that we become morally and intellectually atrophied" (p. 150).

It is when intermediate bodies of local governance are eliminated or undervalued that individual liberty begins to slip into the soft despotism of centralized governmental control.[7] In this historically new form of tyranny, the sovereign power of the state does not exert the traditional overt force of monarchs past. Rather it slowly and almost imperceptibly embraces the mind of the individual and quietly shapes it into conformity with the whole (Hein, 1976, p. 188). "Freedom alone is capable of lifting men's minds above...the petty personal worries...in...everyday life, and of making them aware at every moment that they belong each and all to a vaster entity...their native land. It alone replaces at certain critical moments their natural love of material welfare by a loftier, more virile ideal" (Stone & Mennell, 1980, p. 378).

Tocqueville and the Dual Role of Religion

Tocqueville may seem out of place among philosophers of rebellion and critique of everyday life, but his ideas about the dangers to liberty in a democracy, speak to a fundamental train of thought within this tradition. Although he did not directly argue in *Democracy in America* that Americans need, at times, to rebel, he implied as much. One of his few solutions to the dangers inherent in democracy lies in both the institutional and the spiritual nature of religion. Although it is the spirituality that religion provides for the Americans that is his most salient point for the purposes of the arguments advanced here, he begins by explaining how vastly different a role religion as an institution plays in a democracy than it does in European aristocracy. It is its uniquely indirect authority in America that creates needed structure in a democratic world of flux, by stressing proscribed moral behaviors and punishment for delinquencies, according to Tocqueville.[8]

Matthew Maguire's analysis of Tocqueville's contributions to political thought (2006) compares Rousseau and Tocqueville and focuses on the role of imagination in connecting everyday life to the infinite and the eternal. Maguire argues,

> Tocqueville develops a dualistic and quasi-Pascalian anthropology in which transcendence, including freedom, is explicably defined in opposition to the material cosmos and the desire for secure comfort and earthly well-being that shapes the modern opinion. Yet this dualism in Tocqueville persistently resolves itself in favor of those forces opposed to transcendence, against Tocqueville's stated intentions. (p. 13)

For Tocqueville, religion provided balance and served as the stabilizing force (married with popular opinion) that prevented the constant flux of democratic life to devolve into chaos. But the influence of the immaterial is particularly important when one considers how vital a desire for community interaction, an expanded world view, and ultimately association, can be for the progression of a vibrant and ever-changing American democracy.

Beginning in part two of volume I, Tocqueville describes how vastly different a role religion plays in social and political life under conditions of aristocratic hierarchy and under conditions of democratic equality. The primarily commercial nature of this new democracy fueled in the American people a pragmatism that craved the balancing force of spirituality. Americans had come to embrace religion with open arms, despite its many rules for the everyday. Tocqueville observed that religion in America plays a fundamentally *indirect* political role—ruling

by the superego (popular opinion as ego ideal) rather than by laws and bureaucracies. "Christianity therefore reigns without obstacles, on the admission of all; the result...is that everything is certain and fixed in the moral world....So the human spirit never perceives an unlimited field before itself; however bold it may be, from time to time it feels that it ought to halt before insurmountable barriers" (p. 279). He observes how, although state and church remain separated in American political life, religion exerts "its real power" (p. 283) by its very deliberate exclusion from political institutions. He described religion in democracy as being opposed to aristocracy and as garnering more devotion and being more powerful in the lives of people when it is unconstrained by institutions and official positions of authority.

Tocqueville observed how religion draws a tight circle around the boundaries of the American democrat's imagination. It is imagination that enables new ideas, participatory desires, and, ultimately, revolutionary action and change.

> The imagination of Americans in its greatest leaps has therefore only a circumspect and uncertain step....These habits of restraint are to be found in political society and singularly favor the tranquility of the people as well as the longevity of the institutions,...At the same time that the law permits the American people to do everything, religion prevents them from conceiving everything and forbids them to dare everything. (pp. 279–280)

Tocqueville's Ultimate Fear: The Squelching of Individual Liberty and the Advent of Soft, or Administrative, Despotism

Tocqueville wrote that "the same equality that facilitates despotism tempers it; we have seen how, as men are more alike and more equal, public mores become more humane and milder;...tyranny in a way lacks an occasion and a stage....passions are naturally contained, imagination bounded,[9] pleasures simple" (p. 662). Marini (1991) argues that "Tocqueville's analysis is, in the fundamental respect, primarily theoretical. It involves nothing less than the attempted reconciliation—on the level of political history—of the inherent tension which exists between the public and private; the general and particular. In the process he hoped to forestall the worst aspect of democratic life, the tendency to administrative despotism" (p. 270).

Tocqueville explains how the excessive possessive individualism that develops out of the equality of conditions (and the equal access to opportunity for wealth) of American liberal democracy slowly eats away at the natural human emotions of compassion. Without the ties of empathy, a

sole focus on material pursuits drives men apart: "Each of them, with-
drawn and apart, is like a stranger to the destiny of all others:...he is
beside them, but he does not see them; he touches them and does not feel
them; he exists only in himself and for himself alone" (p. 663). It is when
we focus on material gains that individualism is naturally logical, and it
is when excessive individualism sets in that a person becomes susceptible
to domination by the majority will.

When Tocqueville defines the political authority of the majority
will in American democracy, his description brings to mind Hobbes's
(1651/2009) also vividly visual explanation of the Leviathan as one man
consisting of many other men. This imagery captures Tocqueville's pri-
mary argument that in a democracy the most dangerous opportunity
for tyranny is within the people themselves who in the covenant of
democratic government and life seek a freedom that may ultimately
elude them:

> [T]he sovereign extends its arms over society as a whole; it covers its sur-
> face with a network of small, complicated, painstaking, uniform rules
> through which the most original minds and the most vigorous souls can-
> not clear a way to surpass the crowd; it does not break wills, but it softens
> them, bends them, and directs them; [...] reduces each nation to being
> nothing more than a herd of timid and industrious animals of which the
> government is the shepherd. (p. 663)

Tocqueville's language is noticeably strong in those passages, and strik-
ingly visual; the reader can almost taste his disgust with the creeping
American complacency that he has already argued is born of a compul-
sion with individualism. We can feel his fear, and his voice rising, as his
argument progresses.

> Our contemporaries are incessantly racked by two inimical passions: they
> feel the need to be led and the wish to remain free. Not being able to
> destroy either one of these contrary instincts, they strive to satisfy both at
> the same time. They imagine a unique power, tutelary, all powerful, but
> elected by citizens....They console themselves...by thinking that they
> themselves have chosen their schoolmasters. (p. 664)

Tocqueville was largely devoted to understanding the effects of equality
on the conditions, sentiments, and relations of everyday life. He employed
many of his fundamental arguments regarding the basis of American
democracy and its accompanying mores to explain the unprecedented
reinvention of social relationships in this new land based on equality. He
wrote that, unlike the fixed-class relationships essential to hierarchical

rule, democracy encourages organic, fluid connections that bind people to one another in genuine partnerships that are revised and recreated by the will of the people, not the social or political order. In this same vein, in an environment of equality, religion becomes linked to people's faith not by force and material promises but, rather, by individual acceptance of religious faith (and its mores) alongside the institutions of democracy.

Tocqueville observed that religion in America functions as the everyday constraint on boundless individual liberty (even in the realm of the imagination) through its complement, the power of mass opinion. It exists apart from institutions, is "an invariable disposition of the human heart" (p. 409), and is seen as a necessary part of democratic life, embraced with self-conscious determination. "I do not know if all Americans have faith in their religion...but I am sure that they believe it necessary to the maintenance of republican institutions. This opinion does not belong only to one class of citizens or to one party, but to the entire nation" (p. 280). Religion, by providing fixed answers, stabilized the newly free American society, but at the same time, by providing access to feelings of a universal whole, it also worked to protect against the excessive individualism that is a natural danger in democracy.

Following his initial assertion in volume I that in America religion rules de facto, or without the aid of laws and institutions, Tocqueville develops this argument in volume II to explain how religion captures the hearts and minds of Americans: "In America religion itself has so to speak set its own limits; the religious order there has remained entirely distinct from the political order, in such a way that ancient laws could easily be changed without shaking ancient beliefs" (p. 406). This quote demonstrates Tocqueville's belief that whereas the government could make laws, religion created and regulated morality and served as a check on politics, policies, and the law. In this way, religion banished the grave dangers of excessive liberty. In Tocqueville's eyes, an excess of freedom was breeding ground for perpetual change, revolution, and, ultimately, anarchy. Tocqueville had already seen that the prominent characteristic of American democratic life was the constant flux he observed in labor relations, family relations, and almost all aspects of life. If it is flux that defines relationships, and ultimately society, then this movement must be played out on a foundation of order. Without such a foundation, Tocqueville worried that this new, already-successful democracy would cease to function smoothly. While religion provided systemic order, it was its other powers—to provide access to immaterial questions and desires and to universal emotions—that would keep democracy fresh and independent thought truly free. Religion provided spirituality and compassion for others in daily life that sustained a necessary balance among

individuals in a nation built on the hard work of pragmatic, commerce-minded democrats.

Tocqueville offered insight into the nature of revolutionary behavior by observing that Americans, unlike the French, for example, never had a democratic revolution and thus never felt the paradigm shift (and sudden true freedom) of a crumbling belief structure: "There are no revolutions that do not disrupt ancient beliefs, weaken authority, and obscure common ideas. Therefore every revolution has the effect, more or less, of delivering men over to themselves and of *opening a wide and almost limitless space before the mind of each*" (p. 406, emphasis added). This, perhaps more than any other of Tocqueville's observations, holds the key to understanding American life. Tocqueville asserts that despite the freedom that equality yields, there is little true individual freedom of mind in America. Interestingly, he seems to despair of this lack of independent spirit almost as he points out the dangers of too much individual freedom: "Individual independence can be more or less great; it cannot be boundless. It is true that every man who receives an opinion on the word of another puts his mind in slavery; but it is a salutary servitude that permits him to make good use of his freedom" (p. 408). In similar fashion, he spoke of the role of mass opinion as both a liberty-suffocating force and as the vital glue that ensured the stability of the country.

Tocqueville argued, "The same equality that makes him independent of each of his fellow citizens in particular leaves him isolated and without defense against the action of the greatest number" (p. 409). This is one of Tocqueville's paramount fears. The public has a singular power among democratic peoples. This is what he wants to argue in *Democracy in America.*

> It does not persuade [one] of its beliefs, it imposes them and makes them penetrate souls by a sort of immense pressure of the minds of all on the intellect of each. In the United States, the majority takes charge of furnishing individuals with a host of ready-made opinions, and thus it relieves them of the obligation to form their own. American political laws are such that the majority reigns over society, which greatly increases the empire it naturally exercises over the intellect. For nothing is more familiar to man than to recognize wisdom in whoever oppresses him. (p. 409)

No individual or groups of individuals can, whether on the basis of class or wealth or even legitimate political power, ever claim to have any inherent authority over knowledge. Still, Tocqueville observes that under conditions of equality, the collective society, or popular opinion, does assert authority over societal knowledge and beliefs. His warning of what he termed a "tyranny of the majority"—that the power of

popular will does not need to use force to oblige belief but, rather, that it "penetrate[s] souls"—is strikingly anticipatory of C. Wright Mills's (1956) arguments that the power of authority in America is based not on force but on bureaucratic manipulation. In *Democracy in America,* Tocqueville wrote, "One can foresee that faith in common opinion will become a sort of religion whose prophet will be the majority" (p. 410). Equality births popular institutions based on the assumption of equal individuals and the complementary oppression of these individuals by the mass: "I see very clearly two tendencies in equality: one brings the mind of each man toward new thoughts, and the other would willingly induce it to *give up thinking*" (p. 410, emphasis added). This complacency extends into all aspects of life—the social, the intellectual, and the familial: "[In American democracy]...majority right had passed into 'the smallest habits of life'" (Drolet, 2003, p. 87).

Tocqueville asserts that "men cannot do without dogmatic beliefs" (p. 417). In other words, man cannot live well with too much freedom of any sort. For the sake of a stable democracy, observes Tocqueville, the masses must not be existentially curious. Rather, they can rely on the safety of the ready provision of knowledge. These are two interrelated points. Tocqueville does not trust the unstable nature of democracy without religion to rein it in and provide the necessary "master." That is, the master-slave relationship integral to aristocracy must reinvent itself in all political systems. The fixedness of religion is practical, useful, comforting; it saves people from existential crisis, from the void of true individuality. Religion serves as a moral check on desires for excess and greed—society's source for the superego. Democracy fundamentally allows for more freedom of choice, and, when in combination with the laissez-faire nature of capitalism, more individual material gain. In the New World, religion replaces class structure as a limit on human desire and greed. It supports the democratic and commercial interests, especially those of the majority (which are ultimately the interests both of government and of religion as well). The influence of religion, and its dissemination into the mass, works in tandem with majority opinion to prevent revolution.

Tocqueville revered the novel and indirect role of religion and religious mores in American democratic life. He observed that religion, despite its explicit separation from the state in American government, must nonetheless adopt a new role that engages popular opinion (and its supremacy in daily life) so as to create stability, both in government and in society, under the new conditions of equality. Tocqueville observed that, by the time of his visit, American religion had moved away from a focus on traditional theology (aristocracy and *the next life*) to an attention

to morality (dictated by religion) in this life. Accordingly, the representatives and leaders of religious institutions had also perfected their careful separation from institutional public life while maintaining less explicit but ultimately more influential power over the inherently interrelated but still distinct realms of society and mass opinion.

Tocqueville saw religion in America as a stabilizing and disciplining force. It is in this sense that is the first institution of American public life. It creates order and balance where there is great potential for excess. Democracy fundamentally allows for more liberty and thus more freedom of choice and seemingly boundless individual gain, so in the transition from hierarchy to equality, religion replaces class structure as the limit on human desire. The rules of religion, and the simplified "truths" of mass opinion, work together to prevent revolutionary desires from forming in the minds of citizens.

The problem of excessive individuality concerned Tocqueville greatly, and he rests the brunt of his solution on the power of religion. He made a strong case for spirituality as an elevation of consciousness. He greatly valued the ability of religion to elevate individual desires and curiosities beyond material concerns to the realm of the immaterial. In American democracy, religion as spirituality prevents an excess of individual sentiment, because the foundation of all religion is transcendent universality; religion as an indirect public institution provides society with a prescribed morality and a uniformity of behavior that favors order where democratic conditions fail to provide permanent structure. Both of these benefits create community where it threatens to dissolve. As the freedom to consume, acquire, and achieve, and, with it, material success, are highlighted under democratic conditions, religion, both as individual spiritual experience and as public institutional presence, creates a more active desire to pursue the development of the human spirit and the human community. It is this spiritual role of religion that provides the basis for the argument I make here. The knowledge born of spirituality must be reconceived not as the product of religious participation, but as the benefits of artistic encounters, and in particular public artistic experience, in American democracy today. In the creation of a public minded and participatory citizenry, this spiritual knowledge is as vital today, if not more so because of the high levels of consumerism, as it was in Tocqueville's America.

Art as Provider of Spiritual Balance in Today's Democracy

Following Tocqueville's assertion that a uniquely indirect role of religion was needed to create balance in a democratic society based on an

equality of conditions, I argue that art, particularly public and social art, is needed, perhaps more than ever, in America today. Artistic creation and reimagination highlights our most universal emotions and desires, and in its varied public forms is accessible to all, free of charge. Although spirituality, like creativity, is freely and individually accessible, a religious structure inherently excludes and limits; whereas an artistic structure, that is, art displayed in museums and galleries, though it can be exclusive (at least for its very physical enclosure of the art), is released from its bounds once placed in our streets, our parks, and our public buildings. With genuine spiritual inclusivity serving as our guide, creativity must be nurtured among Americans today and among all democrats. The spirituality of artistic experience, and the knowledge it produces, must be encouraged through the creation and support of public art projects. Increased occurrences of public art challenge the generally higher valuing of conformist aesthetics by the public, and more importantly, simply places thought-provoking and rebellious art in our everyday public lives. The knowledge gained through creative encounters is born within us, but the nature of this knowledge rests primarily on transcendent and universal ideas and emotions, which alert us to an expanded realm of possibility for everyday life and a greater empathy with others. Public art's occurring in the open and free spaces of our daily lives yields an easier and closer connection between how we perform our routine habits and how we express and understand our higher spiritual desires. Public art is located in public spaces rather than in such delegated spaces as museums, galleries, symphony halls, and libraries. It is often unregulated or less regulated than artworks housed in conventional spaces and is thus accessible to more people more frequently; and is experienced within the moments of their everyday concerns, rather than in those moments they have specially designated to "visit" art where it is likely they already have an expected experience in mind.

It is clear that by advocating mixing democracy with religion, Tocqueville did not mean the hierarchical religion of the ancien regime, but, rather, a new, distinctly American understanding of religion as exemplified in the Puritan belief that religious life is intertwined with political life. Tocqueville did not believe that a specific religion ought to be mandatory, like Rousseau's (1750/1993) civil religion, but rather that religious life should be fluid, without permanent structure, and chosen willingly, much like the nature of democracy itself and the political, economic, and social relationships it creates. This quality of the religion he admired in America is also present in artistic experience, which, spiritual as it may be, almost always appears to be more innocuous in society than the forces of religion or government, despite its possible active engagement in these other realms.

Tocqueville simultaneously revered and feared the forces of democracy. Like historian George Bancroft and other early American thinkers, Tocqueville, the French aristocrat, believed that in the course of history, democracy was both inevitable and natural. He greatly admired American democracy and the American people, but he also worried that this still-new system could be dangerously corrupted by its inherent weaknesses. As natural as was the development of American democracy itself, it was also natural to this particular political system that certain cultural traits develop within individuals and communities along with the democratic practices. An excessive love of material well-being, the excessive spiritual isolationism that Tocqueville called "individualism," and its complementary "general apathy," all ultimately contribute to a tyranny of the majority (tyranny of public opinion) and, beyond this, a situation of soft or mild (also called democratic or administrative) despotism. This was his greatest fear—a situation in which control is exerted not by overt force but through more insidious avenues to the mind. He warned that the strength of American public opinion could subtly, yet to devastating effect, subvert true independent thought among Americans themselves. As the editors write in their introduction to the 2002 translation of *Democracy in America*, one of, if not *the*, defining characteristic of Americans, according to Tocqueville, is that they "suffer from individualism." It is apparent throughout both volumes of the work that "individualism" is a complex phenomenon; it is at once natural, a privilege, a threat, and an oppressor. Americans' private isolationist tendencies become even more threatening when seen in conjunction with the flux that is also inherent to democratic society.

Many philosophers, particularly of the twentieth century (e.g., Baudrillard & Glaser, 1994; Hardt & Negri, 2000; Marcuse, 1969; see also Lefebvre & Moore, 1991), have lamented the difficulty of inspiring revolutionary ideas in people living in the comfort of advanced capitalist representative democracy. "But men who live in an ease equally distant from opulence and misery put an immense value on their goods....the number of these...small proprietors is constantly increased by equality of conditions. Thus in democratic societies the majority of citizens do not see clearly what they could gain by a revolution, and they feel at each instant and in a thousand ways what they could lose from one" (Tocqueville, 1835/2002, p. 608). This farsighted observation expresses this problem of complacency among citizens of a capitalist democracy.

Tocqueville argued that because Americans tended to focus on the pursuit of individual material gain, they were also prone to becoming complacent and conformist, traits he asserted were most prevalent in American democrats and most dangerous to the continued freedom of

American democracy. When we fall prey to the pursuit of excessive materialism, we are led naturally to excessive individualism, which then leads to apathy—we are comfortable enough staying home with our material possessions[10] to distract us from considering public involvement and new possibilities for our lives. If we believe that material accomplishment and wealth is the holy grail, then what incentive is there to seek community and political involvement (besides the possibility of exploitation in the name of self-interest)? While this mindset may have served frontier living, it also leaves us vulnerable to the invisible, yet encompassing, grip of soft despotism. Tocqueville affirmed the need to nurture the spiritual and emotional realm of life to balance the pursuit of material success. Likewise, I argue that spiritual experiences in the form of art, and especially public art, could awaken the senses of "middling" Americans that had been muted and relinquished to the sway of popular opinion by excessive attention to the quest for the material, the pragmatic, and the rational. Connection with the immaterial opens our minds to that which is universal and breaks down the boundaries between us as individuals. In this way, the immaterial can bring a revolution of the mind.

The ability to imagine revolutionary ideas is key to maintaining vitality and progress. Revolutionary ideas most often do not and need not lead to revolution, but they can help foster in people the desire to take on a more active role in affecting change in their communities. There is little reason for Americans, then and now, to pursue a truly community-minded everyday life. Nor is there always clear incentive to work through, alongside, or even without the institutions of the state to change their government or their conditions of life. To counter this complacency, Tocqueville's argument is revived here. We must add a daily recognition of the eternal, the universal, and the immaterial to our material desires. The need to confront the existential confusion that all humans share is as natural as the capitalist pursuit in conditions of liberty and political equality, but it is how one addresses and shapes this desire that can aid in affecting change in our public lives today. Religion, and spirituality in general, seizes on this natural human interest in otherworldly questions, on the instinctual curiosity we share for both the possibility of boundlessness in our actions, and oneness with others and the world itself. Experience with imaginative public art that challenges the status quo of majority thought through the exploration of new ideas and approaches could fulfill this vital balancing and revitalizing role in American life, in a more democratically accessible way. Tocqueville argued that religion plays a particularly helpful role in providing the focus on spiritual and

communal life that is required in order to balance the fundamental drive for success that underlies American democratic life. This work argues that art can similarly work to "tune" individuals in to their spiritual feelings and needs. Increased experience with visionary public and social artworks creates interaction with others (in the experience of the art), as well as self-engagement within individuals. It is the new engagement with our inner selves that frees the imagination to envision all sorts of potential change and to access the universal emotions that naturally foster empathy for each other.

Ultimately, an increased sense of connection to both oneself, and to others, creates a foundation for an increased involvement in communal life. Artistic encounters can alter, distort, and reenvision our everyday worlds. These reconfigurations of reality expand the boundaries of our imaginations and encourage desires alternative to what is present in the majority's will. These new desires, by their very existence, challenge the constructs and limits of everyday life. When these new desires are accessed through artistic experience, the consequent rebellion can reawaken political will within individuals.

Tocqueville keenly recognized man's natural existential yearnings. Despite these observations, as well as the many notes he made on the threat of "soft despotism" by the all-powerful body of mass opinion, he maintained his theory of balance and advocated the protection of the status quo upholding the stability of democratic conditions. In a powerful passage (pp. 662–665), Tocqueville described popular opinion in America as an organism that looms over the everyday in both public and private life. Popular will, though intimately linked with religion, greatly surpasses in influence both the Old World religious institutions and the rigid moral expectations of an aristocratic hierarchy. This influence permeates even the very desires and expectations of individuals. In other words, under the power of the popular will, individuals become replicas of each other, varying only in gradations. His words here are strong, wary, and almost revolutionary in spirit. One is moved by his warnings against this new monster of the collective. In the concluding section of his text, Tocqueville delves deeper into understanding the body of popular opinion that he sees permeating American life and harshly indicts the lack of independent thought in America: "Above these an immense tutelary power is elevated, which alone takes charge of assuring their enjoyments and watching over their fate ... [I]t renders the employment of free will less useful and more rare; it confines the action of the will in a smaller space. Can it not take away from them entirely the trouble of thinking and the pain of living?" (p. 663).

Conclusions

The desire for what is immaterial looms much larger than does religion—it is a defining cornerstone of human existence, and it is *because* of this primal longing that religion holds the primary role in society. In this same vein, before people create and join civil associations, they must encounter a different shade of the same feeling that propels them to come together. This feeling can be created, supported, and fulfilled by art. Art, then, fosters a desire for connection with the human community. This connection creates the motivation for action and change in daily life that supports this new understanding of unity.

I argue that the immaterial—whether it is religion or art—can foster a new understanding of self and humanity that enables the creation of a community-minded revolutionary consciousness. Tocqueville was no communitarian, but he valued recognition of the human community for its power to create balance in the everyday life of American democrats. Our experience with art creates new needs that propel us to desire, and be able to imagine, realities beyond the given conditions. Art, particularly public and social art, primarily because of its accessible nature, promotes a more imaginative, and in this sense revolutionary, consciousness that strengthens democratic life by empowering individuals with the desire to enact change.

Visionary art in the public arena encourages a spiritual jolt within passersby, which for a moment, often in the middle of a busy day, pushes away within individuals the daily concerns and yields them to the power of feeling the universal pains and joys that art so easily and naturally evokes. True liberation from the majority requires an expansion of the imagination beyond the system's prescribed limits, and visionary art brings out in people the desire for, and the ability to perceive of, new and expanded possibilities for everyday rebellion. Such deeper knowledge of ourselves, our imaginative capabilities, and the creative rebellion this supports could incite total social revolution, but, more importantly (and more commonly), it begins the project of awakening the individual consciousness to the liberation of independent thought and morality and to the crucial empathy for others that this independent thought naturally leads to. In the 1960s, Herbert Marcuse (1969/1970) introduced his theory of revolution through art and created a space for similar arguments. It is not a change in material conditions (Marx's [1844/1978] assertion that we need to replace capitalism with communism) that will bring recognition of the human community about, but, rather a fostering of the eternal dialectic of art and reason as exemplified through visionary art. The universal experiences of art can engage a rebellious (in the sense of being able

to imagine and desire alternatives beyond the status quo) consciousness within individuals, and finally, within society. Such a rebellious worldview can then incite participatory desires.

Art cultivates the spirit—one's inner life—and with this attention to the knowledge that is within, one finds the importance of connection to the world outside of them. This great benefit of creative life is the sense of community (empathy) and otherworldliness (that there are vital needs and desires beyond the everyday of practical concerns) that it can raise awareness to. Once the myth of the individual has been dispelled, people can, without having entirely to disavow material desires, be free to embrace their interrelatedness (without fear that they will fail in society) with each other and with nature. Individuals will be able to approach their relationship to society in a new way, with as much, if not more, of the participatory determination they use in their individual pursuits of material wealth. While we are in a societal state where we perceive ourselves to be apart from all others, our rational interests determine for us that we do not want things to change if they are good enough for our daily lives, but, once we come together, imagination will cast its net wider, as the entire landscape of human endeavor will have been broadened. This opening of the imagination allows for and encourages more active and consistent participation in public life by supporting change (and even major change) without fear of total disorder.

CHAPTER 2

THE COUPLING OF THE DIONYSIAN AND THE APOLLONIAN: NIETZSCHE AND TRANSCENDENT ART

An amoral artist-god who wants to experience, whether he is building or destroying, in the good and in the bad, his own joy and glory—one who, creating worlds, frees himself from the distress of fullness and overfullness and from the affliction of the contradictions compressed in his soul.

Friedrich Nietzsche, *The Birth of Tragedy*

The modern stage, at least in its predominant bourgeois realism, reflects the limited and barren spiritual landscape of modernity. The hopes for transcending this situation lie in a rebirth of tragedy through a reconnection with the spirit of music and with myth. For modernity, however, the gods have aesthetic principles, art having in a sense replaced religion.

M. A. F. Witt, *Nietzsche and the Rebirth of the Tragic*

As a young philologist in the late nineteenth century, Friedrich Nietzsche situated the ancient Greek god of sensuality, Dionysus, symbol of all that is instinctual and chaotic within the self, at the core of creative human experience and at the center of a critical and fulfilled life. Rather than deny its vital importance to an understanding of Greek tragedy and Greek culture in general, Nietzsche elevated the Dionysian (and its expression in tragedy and the Dionysian festivals of excess) to a realm of experience that existed on an even plane, as one half of a whole system, with that of Apollonian order and reason (and, in his time, with the grand narratives of the Enlightenment). The generally accepted nineteenth-century attitude and scholarship on ancient Greek culture (and likewise on modern life) had fundamentally misunderstood the ancients' legacy by sublimating, so to speak, evidence of raw passions in

Greek art into an appearance of pure Apollonian reason, harmony, vir-
tue, and order.[1] It is precisely in the unity of the two opposing drives that
Nietzsche discovered the foundations of what he deemed the highest art
form—tragedy, or true transcendent art. Nietzsche argued for a revival of,
and new appreciation for, the tragic in society to serve as the vehicle by
which to transcend everyday life and the falsely absolute values of Christian
morality through a positive and willful authentication of life. This dis-
covery of tragic knowledge would result in the rebirth of the individual
and the reawakening of culture. But, unlike Nietzsche's contemporary
Arthur Schopenhauer (1818/1969), who first acknowledged the impor-
tance of pain and pessimism to human existence, Nietzsche reformulated
tragedy (and the doctrine of eternal recurrence) to become a positive
and life affirming, rather than a nihilistic and debilitating, vision for the
future in a godless world.

This chapter examines the Dionysian drive that exists within all
humans, as well as its foil and complement, the likewise universal exis-
tence of an Apollonian consciousness, and their dialectical dance of
artistic creation. In dialectics, one sees life as a perpetual resolution of
contradictions, within concepts that are composed as dichotomous rela-
tionships that alternately come together and twist apart in an eternal
dance. This dialectic provides an understanding of existence that assists
in consciousness change. It is vital that encounters with Dionysian fears
and passions—these experiences may also be seen as akin to the notion of
the taboo, the "unclean," or the "abject" (Kristeva, 1984a)—be incorpo-
rated *into* the rhythms of everyday life, and that these work *in opposition
to* the routinized structure of contemporary image-mediated conscious-
ness, or the reiterations and simplifications of "plastic" art. Following
Nietzsche's (1872/1967) argument that the Greeks, who at one time had
exemplified true Dionysian tragedy, also witnessed its significant decline
in the development of their culture, I argue that contemporary twenty-
first-century life in America, with its myriad easy-to-access luxuries and
mass-negotiated experiences, has been, albeit on a very different scale,
in a decline of true Dionysian experience. As has been man's inclination
at least since the Enlightenment and the invention of capitalism, adher-
ence to reason and individualism has edged out the value of sensual and
spiritual knowledge in all areas of life. Today, individual experiences,
potentially possessed of true freedom, can become repressed by the invis-
ible yet powerful force of popular will and become part of the plague of
the conformity of mass experiences. The universal character of many
emotions and experiences has been exploited, as the middling quality of
popular opinion dulls the extremes of experience and forms a tepid and

simplified "social" concept of the experience that is then consumed by individuals in democratic society.

When we draw a connection between creativity and feelings of empowerment and empathy for others, the link takes several steps. When we tend to our spirit, we press pause on pragmatism and on everyday urgencies and allow ourselves to focus on the embrace of the melodic rhythms of poetry, of music, of dance. These feelings often bring deep calm, sometimes long stored-away sorrow. These emotions, enabled through the senses, access both joy and pain; creativity (like it is the intention of religion) enables the individual to feel not only for their particular situation, but also for the universal joys and pains of the human experience. The more frequently that we can access such emotions, the more we are exercising a healthy attention to our inner worlds, and to our truly free passions, which then illuminate knowledge that is gained from the spiritual experience of rebellious art. For Nietzsche, art could develop both the valuable knowledge of the senses and instincts, as well as the intertwined relationship of this knowledge to our rationality.

Both Nietzsche and Camus have a style of writing that feels melodic, or rhythmic, aiding you to feel the sensuousness of the unfiltered passions they want to revive in individuals, and in society. For Nietzsche, true art, and true philosophy, encourages the individual viewer to interpret it, and to consider its meaning, in their own personal way. In his own work, he presented his philosophy in spurts of thought, or aphorisms, not as a systematic and unified theory. A unified theory would falsely imply coherence in philosophy that could not be if it accurately reflected the complexities and divisions within life, and within the "self."

Nietzsche believed, in line with anti-Enlightenment writers like de Sade and Rimbaud, that a focus on the body, and on bodily sensuous experience, is a necessity of forward-thinking philosophy, and of a new understanding of morality that is borne of experience, not the church, or science for that matter. He did not intend to convey that the mind was not important to the "self," but that the mind could not create what it does without the experiences of the senses—that the mind is borne of, and intertwined, with the body. This is in contrast to viewing the body—and sensory experience—as a separate, and less important, entity from the mind, and from rational experience. Nietzsche's overarching point in his philosophy is that man must face his animal instincts, and in the face of a meaningless world forge his own moral path using art as his only guide. Nietzsche saw in art the same oppositional tension as he found in the "self." Artistic experience reflected the union of this unresolving tension and thus was the only source of authentic freedom and meaning for the

individual. Although he was clearly influenced by the Romantic tradition, he did not believe that art should function as escapism from life, but rather that one could live meaningfully through art, and actually recreate life from the creative perspective.

I propose the need for the encouragement and development of authentic Dionysian emotion—of the experience of true tragedy—within all individuals on a mass level. A truly independent development of will can be best achieved through the infinitely possible alternatives of creative interaction. To seek a healthy and balanced political culture, we are in need of the creation of visionary (tragic) art in defiance of a contemporary society that is evermore highly routinized and image-ized. Art, by definition, is an expression of an alternative reality. This is the vital distinction between art and aesthetics. I argue that "art" is Socratic by nature; it implies a constant questioning and resolution of contradiction. "Aesthetics," or what we can also call here redundant or mainstream art, provides entertainment through the repetition of an established idea of the "the beautiful"(see Cahn & Meskin, 2008; Cazeaux, 2006; Hofstadter & Kuhns, 1976). The increasingly urgent need to encourage imaginative artistic experience is in response to a society that thrives and expands largely on the promulgation of appearance-based experience that seeks to dilute lived reality. At least since the middle of the last century (Marcuse, 1969), in the mingling of an advanced and diffused capitalism and the force of powerful popular opinion, even seemingly visionary or taboo experiences are regularly and quietly [throughly the mechanisms of democracy and capitalism] stripped of their tragedy, their transgressive power, and thus also their authenticity—their natural connections to the truest moments of existence. In this way, important human emotions and experiences are reduced to a shallow and contrived universality.

Notwithstanding that consciousness change is necessary to revitalize and reawaken, first, individuals' true freedom of thought and, eventually, democracy, it can begin with small transformations—with the desire to truly confront life rather than take the easy road and accept mere images of life. Only after people reopen access to the knowledge of Dionysian sensuality can they become truly free in their own selves, and thus powerful against the disciplining tentacles of our image-ized culture. With the harnessing of the sensual and accordingly spiritual power of the experiences of suffering and of compassion, we can begin to see the truths of human connectivity through universal human experience. This knowledge could revitalize the latent community-minded American spirit and pave the way for a stronger, more tactile, and more participatory democracy.

With the passage of time, the Apollonian sublimation of Dionysian experiences has expanded and become perfected. By sublimation, following

Freud (1930/1961b), is meant the redirecting of potentially destructive raw passions. These chaotic instincts are transformed into more positive, constructive actions and also repressed into the recesses of the self. The primary form of societal sublimation today dilutes the reality that is necessarily Dionysian, especially its most taboo facets, and transforms true passions into simulated passions, and eventually into Apollonian images. These simulations serve the dual purpose of (1) strengthening the desire for constantly increasing choices and depths of experience in the consumerism of our capitalist society and (2) further alienating us from our personal Dionysian moments (unfiltered experiences with our selves) by creating the appearance of our having felt Dionysian transcendence, which, filtered through popular opinion and its reliance on both simplicity of ideas and purchased desire, provides only an image of an experience. The result is a sort of false consciousness.

We need to be aware of our increasing ability, made possible by the vast number of choices aimed at us, not to "face life (reality)" as individuals, as we must also be aware of the ramifications of possessing and using such ability (Barber, 2008). A new understanding of our shared experiences, such as of happiness and of individuality, must be created. This new understanding can create a life of happiness if we understand happiness to mean the comfort of stability (for Nietzsche [1872/1967], a lack of change meant a lack of life), but not if we understand happiness to mean thriving in the phenomenal experience of everyday life, complete with its discomforts, cruelties, and pain. Accordingly, we need to confront the issue of consciousness change in everyday life, particularly through the use of creative art works to create a life that is in harmony with both the Dionysian and Apollonian elements. Artistic creation, and likewise consciousness change, are self-overcoming. Julia Kristeva (1984a) explains that through creativity we can confront the valuable human experiences that may be taboo in collective life, or that may be filtered through popular opinion in a way that they lose their transformative potential: "[T]he artistic experience, which is rooted in the abject it utters and by the same token purifies" (p. 17). True confrontation with horror, or the abject, results in a purification of existence that replaces Platonic essentialist truths with a freedom to create the cadence of the everyday.

Nietzsche (1872/1967) believed that the true art of tragedy could serve as the tool by which to create meaning in life where the fallacy of universal values has been positively confronted. Martha Nussbaum (1991/2002) explains Nietzsche's underlying belief that we must face the meaninglessness of life with positive and willful determination, a determination to create. The other key part of this idea that the inevitable and inherent meaninglessness of the order of the universe engenders the need to pursue meaning elsewhere—meaning that is truly independently

created and experienced, not merely accepted as a hand-me-down truth. On this issue of meaning creation in a meaninglessness world, Julian Young (1992) elucidates Nietzsche's belief that the only true meaning that can be experienced in life is the connection with, and dependence on, all others in the face of a lack of universal, and God-given, ideals.

Matthew Rampley (2000) echoes the claim that Nietzsche's ideas about art are inseparable from his confrontation with the tragedy of nihilism: "[H]e accords to art the *potential* for functioning as the counter-movement to general nihilism" (p. 215), and "[Art], for Nietzsche, is constituted less by artworks and more by the state of artistic creativity" (p. 219). Rampley points to Nietzsche's belief that we must reform our aesthetic practices in our ever-evolving culture because we are constantly called on to overcome ourselves so that "aesthetic reform opens the way to cultural revolution" (p. 215). He further argues that Nietzsche, although greatly influenced by the Romantic tradition of thinkers like Schiller and Novalis, did not believe merely that aesthetic reform should take place because of the lack of transcendent values in popular cultural aesthetics, but with an existential bent, he believed that aesthetic renewal could serve as an antidote to a meaningless world.[2]

Nussbaum (1991/2002), in her explorations of Schopenhauer's influence on Nietzsche, argues that Nietzsche always denied "[that] we can [could] understand the role that works of art play in human lives, or even adequately explain our particular judgments of beauty and ugliness, without connecting these to human practical needs—and needs that are directed toward living and affirming life, rather than toward resignation and denial" (Nussbaum, 1991/2002, p. 55). Further, she argues that in art "we find life *justified*: that is, having abandoned all attempts to find extra—human justification for existence, we can find the only justification we ever shall find in our very own selves, and our own creative activity" (Nussbaum, 1991/2002, p. 59). She focuses on Nietzsche's argument that in the face of existential crisis and uncertainty, the empowerment of creation builds freedom and will.

Young's (1992) influential study on Nietzsche's philosophy of art[3] considers Nietzsche's beliefs about art as occurring in several stages but argues that the last parallels the first, thus creating a circle of thought. Young argues that art, for Nietzsche (and this is true for Camus's philosophy as well), saves us from our own existential anxieties. Young writes, "The psychological basis of altruism is sympathy—feeling the same kind of concern for the well-being of another that one normally has for one's own—and the basis of that is the altruist's...inarticulate, 'intuitive' realization that the *principium individuation is* an illusion" (p. 9). Further explaining this point, he echoes both Camus and Nietzsche: "[The]

realization that I am the only being that exists but that every other indi-
vidual is this 'I' too" (p. 9). Young (1992) is most interested in Nietzsche's
assertion of the myth of the individual, or the fallacy that our selves are
independently created and defined. Nietzsche, like Camus, believed that
true freedom and independence comes at least partly from the recogni-
tion of fundamental similarities and interdependencies.

The Birth of Tragedy

Through a genealogical exploration of the history of the Greek tragic
form, Nietzsche's first book, *The Birth of Tragedy* (1872/1967), critiqued
how repressed and misguided nineteenth-century German society had
become. In his early, dense prose style, he introduced life as formed by
a dialectic, with the comfort of reason, science, and culture (society)
on one side, represented by Apollo, the god of restraint and harmony,
and, on the other, nature, with its unrestrained passions and instincts,
represented by Dionysus. These two life forces complement yet actively
restrict each other.

Nietzsche believed that existence is not about eternal and universal
truths, but rather is the constant struggle of many competing "will[s]
to power" and a "continuously manifested representation of the primal
unity" (p. 45). Nietzsche proposed that the early tragic Greek chorus
functioned as the expression of that which is universal in the human
spirit through the body, and thus life-affirming Dionysian experiences.
Nietzsche argued that the Dionysian side of human life has been largely
denied and apprehended, whereas the already-filtered Apollonian
side of life is encouraged in society. Accordingly, the love of reason
and conscious knowledge—from Socrates and Plato to Descartes and
Kant—has dominated society and the cultural evolution of humankind.
Enlightenment's faith in reason as "truth and science" and scientific
progress as salvation has, like a veil, hid from our everyday view "excess
real[ing] itself as truth" (p. 46).

Thus Nietzsche presented Socrates as both the problem and the
answer. Socrates's influence destroyed the union of Dionysus and Apollo
in early Greek tragedy with his love of reason and the conscious mind.
Nietzsche asked, "Is the resolve to be so scientific . . . perhaps a kind of fear
of, an escape from, pessimism? A subtle last resort against truth?" (p. 18).
Despite Socrates's fear of pessimism and the unknown of art, Nietzsche
admired the strength and courage of Socrates (a man ahead of his time)
and was interested in the "artistic Socrates" as a model for life. This com-
bination of a rigorous, transcendent critique and free artistic passion is
what Nietzsche seems to have conceived of as the path for a true visionary,

for the philosopher of life, for the artist of progress. In his "Attempt at a Self-Criticism," which precedes the text of *The Birth of Tragedy*, Nietzsche mentions that his own artistic Socratic expression "had a knack for seeking out fellow-rhapsodizers and for luring them on to new secret paths and dancing places."

The Dionysian drive has many functions, according to Nietzsche. Perhaps most importantly, it allows for a healthy and vibrant social life by providing an outlet for repressed and restrained urges that, if held inside, could damage the health of the self or could ultimately dissolve the union of individuals that is culture (Apollonian). Dionysian urges are not simply unrestrained emotions and passions, they are desires for the abject, the "boundless and cruel longing to exceed all norms" (p. 10), the antirational yearning for spiritual life, for deep release, for dance, for song. On Dionysian occasions, we allow ourselves to disregard conventional boundaries and limits by experiencing natural animalistic urges for violence, pain, pleasure, and creation (and its counterpart destruction). In the process, Nietzsche argues, we experience transcendent feelings of freedom and mystical understandings of human unity and wholeness, and oneness with nature. In the 1998 film *Pleasantville*, the citizens of a fictional 1950s television suburban town live in a Puritanical, black-and-white world of reflected images, restraint, perpetual happiness defined by stability and relative to nothing else, and an almost complete lack of change—antilife living, for Nietzsche. It is only when knowledge of sensual pleasures begins to spread in the community that people are reborn in color, with all its accompanying ecstasy and pain.

Kristeva (1984a) defines the Dionysian, or a similar, concept as "abject"—not only what it feels like but also according to its transgressive role in consciousness: "It is thus not lack of cleanliness or health that causes abjection but what disturbs identity, system, order. What does not respect borders, positions, rules. The in-between, the ambiguous, the composite" (p. 4). Kristeva, inspired not only by Freud and Lacan but by Georges Bataille too, seeks to increase interest in, and understanding of, our universal and unifying connections with the abject, the bodily, the instinctual, what she terms the semiotic. She argues that the abject can be found in the universal human feeling of visually and sensually observing our own bodily mortality—an experience both exciting and revolting. In abjection, there is lapse in meaning, leaving only feeling. Kristeva associates the abject with the maternal; she says that when we part from our mother in birth, we experience the initial abjection of the maternal that creates our self-identity and brings us into the symbolic (not semiotic) realm of life. The semiotic and the symbolic are two poles of the dialectic of life, which Kristeva argues must balance each other.

I argue that these poles can be seen as parallel to the Dionysian and Apollonian relationship. The semiotic is prelingual, corporal, whereas the symbolic is referential, is of knowledge and reason (Kristeva, 1984a). Poetic language, which I would call visionary—the unification of the Dionysian and Apollonian—for Kristeva (1984b) mediates and confronts the universal contradictions in life. The best art, for Kristeva, explores that which is natural, taboo—the abject.[4]

The abject is experienced when we are confronted with the body in death, in birth, in illness and in decay, in excrement, in extreme pain, and in loss of control. The abject is regularly pushed from public sight and into private repression and concealment. We fear and quarantine our diseases and our garbage, our blood and our bodily waste. Yet the abject, Kristeva explains, provokes a semiotic response, a valuable addition to the symbolic—in our everyday lives.

The Union of Apollo and Dionysus

The Apollonian consciousness needs the Dionysian energy. "Apollo... shows us how necessary is the entire world of suffering, that by means of it the individual may be impelled to realize the redeeming vision" (1872/1967). The primal unity relies on the assistance of illusion; art seeks to understand and interpret. We need chaos to impel us to create, and out of pain comes the desire for beauty through the ordered nature of illusion. We are saved, as from the abject; it sculpts comprehension and veils us from a confusing and painful reality:

> Apollo, the god of all plastic energies...ruler over the beautiful illusion of the inner world of fantasy. The higher truth, the perfection of these states in contrast to the incompletely intelligible everyday world, this deep consciousness of nature, healing and helping....But we must also include in our image of Apollo that delicate *boundary*, which the dream must not overstep lest it have a pathological effect (in which case mere appearance would deceive us as if it were crude reality). We must keep in mind that measured restraint, that freedom from the wilder emotions. (Nietzsche, 1872/1967, p. 35, emphasis added)

The Apollonian consciousness, in seeking order and regulation through restraint, promotes an atomistic understanding of life through the "delimiting of the boundaries of the individual, measure" (p. 46), whereas the Dionysian drive, in revealing human desires and emotions, also reveals a mystical unity or oneness among humans and nature. This unified vision is very different from the artificial harmony of society; rather, it seeks a spiritual unity that is less about peace than it is about authentic living.

Throughout his life and his writings, Nietzsche argued that the reigning Christian system of morality had created and rationalized a false dichotomy between good and evil that simplified and thus misunderstood life. It was in *The Birth of Tragedy* that Nietzsche first called for life (and likewise art) that is "beyond good and evil." It is dangerous to follow the teachings of Socrates that if art is to be beautiful it must be of the consciousness (intelligible, "good"). Instead, we must not deny how instinct and the unconscious can (and should) fuel the creation of art (and the creation of life), wrote Nietzsche.

True art is an expression of our universal and instinctual responses, our inner worlds, of the unsafe, or of the taboo. It is for release, for catharsis, and, ultimately, for education, both for the artists and those viewing and experiencing the art. A true visionary artist expands the limits of our experiences, while simultaneously demonstrating our common bonds: "This Dionysian artist...exalts Life when he honours her with his love; and in exalting her, exalts humanity as well. For the mediocre, simply because they cannot transfigure life in that way, benefit extremely from looking on the world through the Dionysian artist's personality. It is his genius that, by putting ugly reality into an art-form, makes life desirable" (Ludovici, 1971, p. 51). This artist is a sage, a teacher, a healer: "[There] is a special kind of consciousness or perception which is uniquely aesthetic. Anything which is a genuine work of art must be created out of this state, created with the intention of prompting and aiding the recreation of a similar state in the mind of the spectator" (Young, 1992, p. 10).

Use of the symbolism of laughter, and its development as a concept, is abundant in the work of Nietzsche, and other thinkers such as Kristeva have followed course. Laughter, with its spontaneity and guttural powers, is the perfect representative of the Dionysian release—of the self, pouring out in unstoppable waves: "Céline—who speaks from within.... So his laughter bursts out...the gushing forth of the unconscious, the repressed, suppressed pleasure, be it sex or death" (Kristeva, 1984a, pp. 205–206). Nietzsche's main project was to elevate the importance of the unconscious: "You ought to learn the art of *this-worldly* comfort first; you ought to learn to laugh.... Laughter I have pronounced holy: you higher men, *learn*—to laugh!" (*Zarathustra*, "On the Higher Man," quoted in the second preface to *Birth of Tragedy*, pp. 26–27). But not all of what mass society terms or believes is "art" is either true Dionysian expression or true tragedy (visionary art). Nietzsche clarified this through his distinction between tragedy—true transcendent art—and the plastic arts. Art that is plastic (Apollonian) is concerned only with images and appearances (dreams, appearances of appearances) rather than with lived experience.

> The aesthetically sensitive man stands in the same relation to the reality of dreams as the philosopher does to the reality of existence…these images afford him an interpretation of life, and by reflecting on these processes he trains himself for life. It is not only the agreeable…images…the serious, the troubled, the sad…the whole divine comedy of life, including the inferno, also pass before him…he lives and suffers with these scenes—and yet not without that fleeting sensation of illusion. (p. 34)

Artistic creation (true tragedy) comes both from recognition of the importance of the Dionysian realm and from the healthy tension of the two life forces.

Nietzsche argued that intuition can access a deeper knowledge than philosophy can offer because instinct and passion operate beyond words and conceptual organizations and can articulate the universal core of human love and anguish. In later works, after *The Birth of Tragedy*, Nietzsche extended his argument against both the omniscience of rationality and a strict Christian morality. Nietzsche viewed traditional morality as hostile to life.[5] At times in his writing, he seems almost physically disgusted by Christian morality's function in society as a shield from the pain and suffering of everyday reality. He feared that a morality that relies on promises of a better, truer, other life is "the beginning of the end…because life *is* something essentially amora" (p. 23). First in *Beyond Good and Evil* (1886/1989) and then in *The Genealogy of Morals* (1897/2009), Nietzsche denied a system of absolute morality[6] and encouraged his readers to be self-reliant and live according to self-creation, without the constraints of the morality of the masses. Quoting from his *Thus Spake Zarathustra* (1891/1977), he wrote: "[A] philosophy that dares to move, to demote, morality into the realm of appearance…as delusion, error, interpretation, contrivance, art" (pp. 22–23). Similar to Camus's (1951/1991) notion of a "rebellion of moderation," which must be created in response to the nihilism bred by the absurdity of the human condition, a desire for *life* was Nietzsche's vision of a meaningful way to live in a meaningless world.

Before a man can create in true (the ultimate) freedom, "[h]e must first be an annihilator and break values (Nietzsche, 1891/1977, p. 228). Nietzsche's later writings were often focused on the artistic-creative overman versus the slave morality of the herd or the masses. This hierarchical conception's inherent elitism should not distract from Nietzsche's correct understanding either of the importance of the visionary (in and for society) or of the problem of consciousness change for the philosopher or artist (philosophical artist)—you can never reach everyone. Similar to Nietzsche's willful overman, Kristeva's (1984a) notion of the "deject"

never stops demarcating his universe whose fluid confines—for they are constituted of a non-object, the abject...impel him to start afresh. A tireless builder, the deject is in short a *stray*. He is on a journey...the end of which keeps receding....And the more he strays, the more he is saved. For it is out of such straying on excluded ground that he draws his *jouissance*. (p. 8)

Kristeva argues that the abject, not unlike the animal instinct of Nietzsche's Dionysian, cannot be understood rationally through the mind. Rather, it must be felt, experienced, smelled, touched: "It follows that *jouissance* alone cause the abject to exist as such. One does not know it [the abject], one does not desire it, one joys in it [*on en jouit*]. Violently and painfully. A passion" (p. 9).

Nietzsche's Evolving Definition of the Dionysian Realm of the Self

In a footnote to Nietzsche's (1882/1974) *Gay Science*, Walter Kaufmann warns readers that any reader of Nietzsche's work must be aware of his progression as a thinker, particularly concerning his understanding of the Dionysian realm. Kaufmann writes that Nietzsche's early works employed a very different understanding of Dionysus from those in his later works (after *Zarathustra*) (p. 331n). He argues that in his early writings, namely, *The Birth of Tragedy* (1872/1967), Nietzsche viewed the Dionysian as being in a dialectic with the Apollonian forces in society; later, he situated the Dionysian in opposition to both the Romantic, and the Christian approach to life. Kaufmann asserts that the Dionysian impulse of the later books was entirely unified with the Apollonian drive, while Nietzsche's initial ideas about the neglected Dionysian realm of the body and instinct, in *Birth of Tragedy*, asserted its relationship to, though also its distinction, from its opposing drive. In Nietzsche's later works, this view changed as he began to view and define true Dionysian expression and true artistic expression (the "artistic Socrates") as a convergence of the Dionysian and Apollonian realms whereby Dionysian urges are informed by thoughtful creativity. It is also clear from his writings that Nietzsche disliked both the energetic Romantic fondness for drink and reckless abandon, and the slave morals and ascetic nature of the Christians. To pit the exalted Dionysus against these two extremes tells us that the heart of Nietzsche's theory lay in the middle ground or cross-fertilization of the two. In this dialectical approach, Nietzsche seems to adopt an Aristotelian mean method where the message for morality, and for progress, is that we can locate a healthy balance in our lives between our two most dominant natural instincts—to understand and to feel with abandon—by tempering Dionysian disorder and rearrangements, with Apollonian order.

When you experience the Dionysian, you lose your subjectivity and gain a glimpse of universal oneness. The Apollonian realm, by its nature, encourages individual subjectivity; the subject-object relationship exists only in language, or in society (in the Apollonian sphere). In *The Birth of Tragedy* (1872/1967), where Nietzsche clearly contrasts Dionysus with Apollo, he does not especially admire the excesses of the Dionysian realm on its own, as alone guidance for life. Rather, he declares a union of the two parallel realms of life in his description of the "artistic Socrates" (p. 92). This artist-philosopher, rigorous yet emotional, was a true visionary, able to use Dionysian moments in a critical (through rationality) fashion in society, that is, for action. Nietzsche aimed to examine "*the problem of science itself...* presented in the context of *art*—for the problem of science cannot be recognized in the context of science—a book [*The Birth of Tragedy*] perhaps for artists who also have an analytic and retrospective penchant... *to look at science in the perspective of the artist, but at art in that [perspective] of life*" (p. 18). Kaufmann discusses the later characterization of Dionysus as "superabundant" (filled with life) as opposed to the guilt or "resentment" (antilife) of the Christian (p. 331n). The Dionysus of the later work seems to be a reflective version of Nietzsche's earlier idea of the God. The initial conception of Dionysus was simpler, characterized as the ruler over a realm of complete disorder and natural chaos, while his later images of the same God depicted the ruler over a liberating artistic drive that uses the transcendent qualities of "truly facing life" through creativity and lived experiences, to pursue critique and change within the individual, and also society. In this sense, Nietzsche's vision of a union of tragedy and the "artistic Socrates" carries through to his later ideas, where the notion of the Dionysian represents such a union.[7]

Nietzsche was disdainful of the Romantics in general and of the Romantic propensity to believe devoutly in the expression of wild and primal release, often in the easily accessible form of intoxication, as a road to truth. In *The Birth of Tragedy,* he called such Romantic art "a first-rate poison for the nerves, doubly dangerous among a people who love drink and who honor lack of clarity as a virtue, for it has the double quality of a narcotic that both intoxicates and spreads a *fog*" (p. 25). The visionary poet Arthur Rimbaud, despite his youthful wild behavior and seemingly "aimless" journeys, was ultimately aware subconsciously, and later seemingly consciously, of the need for the interjection of the reasoned Apollonian viewpoint into his exaltation of the instinctual. Dionysian feelings exist so that people can throw off the cloak of reason, at least for a moment, and feel the world without the filter of the many rules and symbols of society. Rimbaud lived a life of self-destructive excess.

But Rimbaud's notion of the visionary poet as a driving force of history was a concept that relied on the need to reflect on the chaotic and transcendent moments of Dionysian experience, in order to truly fulfill its claims, and Rimbaud, on several occasions, alluded (1869–1891/1975) to this dialectic—that reason must be overcome to experience the truly free and creative, but that reason can also create genuine knowledge from instinctual and artistic experiences.

Alongside his objections to life, and art, made of pure instinctual chaos, Nietzsche (1872/1967, 1882/1974, 1886/1989, 1897/2009) rightly observed that it is in the mixing of the Apollonian and Dionysian drives that we can locate political theory and a source for political action.[8] In other words, it is only when we dispense with the notion that antisocietal expressions alone can change or move society forward—a claim that was supported by nineteenth-century thinkers from Marquis de Sade (1795/1990) to Rimbaud (1869–1891/1975)—that we can begin to make real use of art as a force counter to politics and especially mainstream culture. It is noteworthy that Nietzsche, one of the men most associated with bacchanalian revelry, the idea of immorality, and a desire to live above or beyond the norm, was cautious in recommending that one live through true art. Although clearly that he was excited by his discovery of the importance of Dionysian experiences to political and social life, he also made clear that misuse of a discovery (or rediscovery) of a vibrant inner world could be fruitless as well as dangerous. Although Nietzsche (1882/1974) pointed out the destructive and painful struggle of human existence, he urged his readers to affirm life and face these aspects of life bravely, to fight nihilistic urges with an enthusiastic will to power.

It is important to remember that the Greek god Dionysus did not simply live with reckless abandon. She taught of truths that came from our passions, our bodies, from what is *individual* to each of us, but can be seen in only slightly varying ways within *all* of us. Henri Lefebvre (1991), the French humanist Marxist philosopher and sociologist, coined his version of this approach to life as the "art of living." Like Nietzsche's concepts of the overman and the eternal return, the art of living presupposes that a person sees his own life—the development and intensification of his life—not as a means to an end but as an end in itself. It suggests that everyday life become a work of art and "the joy that man gives to himself." Further, he alludes to the threat of Apollonian sublimation to the Dionysian project, as well as to the power of visionary art to enable unity among people and nature: "[T]his will not be reducible to a few cheap formulas... [they are] a shallow wisdom which will never bring satisfaction...the [true] art of living implies the end of alienation" (p. 199).

Lefebvre wrote of the importance of the Dionysian festival to healthy ancient rural peasant communities: "In celebrating, each member of the community went beyond himself, so to speak, and in one fell swoop drew all that was energetic, pleasurable, and possible from nature, food, social life, and his own body and mind. Festivals differed from everyday life only in the explosion of forces which had been slowly accumulated in and via everyday life" (p. 202). The rituals left men and women liberated—"[T]he festivities would end in scuffles and orgies" (p. 202)—and completely exhausted: "No aspect of himself [the peasant], of his energy, his instinct, was left unused" (p. 207). He argues, and his approach is part of the argument I am making in this chapter, that, with the development of industrialization and modernization in general, the true Dionysian nature of these festivals has faded leaving little more than superstitious repetitions of the traditional experiences, with people taking part in rituals only for the belief that it can aid the profits on their crops, Lefebvre argues, not for how it can provide needed true release and in this way, liberation.

In other words, Apollonian image and appearance have replaced the true connection with joy and suffering that historically maintained the health of the community. "Rituals and symbols...have tended to dispossess human actions of their living substance in favor of 'meanings'" (p. 209). It is indeed true that ultimately, all images, or reflections—described rather than felt—of intense human emotions and experiences pale in comparison with the indescribable pleasures and intensities of actual experiences. The ever-increasing mass manufacture of release leads to a sterilization and routinizing (in the Weberian sense) of potentially true Dionysian experience.[9] This dilution of experience, and of rebellion and nonconformity, is a common occurrence in a twenty-first-century world that thrives on transforming what is alternative and antisocietal into its opposite—an order-affirming (and ultimately capitalist) activity (Barber, 2008; Frank, 1998; Hinderliter, Kaizen, Maimon, Mansoor, & McCormick, 2009). Art is interested in progress and history. For it to function as a deciding force in society, rebellious creation must straddle intuition and reason by blending transcendence and critique.

The Apollonian realm demonstrates our propensity for reason, and in the reflection and order of reason, it also becomes the world of appearances. It is our natural desire to shape the chaos and sensuousness of Dionysian experiences into something palatable. Since the 1960s, the hippie culture has, for the large part, grown up and tuned back in to society. In the ensuing decades, though, with the smell of hippie culture still lingering, a new term developed for hippies who loved the intoxication and escapism of bohemian life, but not the true political

rebellion—who enjoyed the free love, but not the truly free mind. This new "hippie-lite" became synonymous with people who had the appearance of hippies but who had adopted the look mostly to enjoy the reckless abandon of drug experimentation without awareness of the political and social consciousness of the true revolutionary "hippie" (*VH1 Rock Docs,* 2006). This type of "watered-down" identity naturally sprouts where there is initially a strong lived experience. Powerful experiences are exciting and mysterious. No matter how one might describe, draw, or sing about such an experience, it can never be satisfyingly understood without your actually living in those moments. We can remember, and even try to describe, the sublime, but try as we may, one cannot adequately articulate Dionysian feelings through everyday symbols because doing so would be an attempt to relive Dionysian emotions *in terms* of Apollonian reason, which is not possible.

Marcuse (Kellner, 2007) argued that in the difference between true visionary or critical art and mainstream aesthetics that attempt to imitate true art, the key is the experience of a true Dionysian moment. Even those mainstream artworks that *appear* avant-garde fail to recapture the creative force of the original and are thus merely an empty vessel of what was once transformative art. "What originally started out as an authentic cry and song of the oppressed black community has since been transformed and commercialized into 'white' rock, which by means of contrived 'performances,' serves as a orgiastic group therapy which removes all the frustrations and inhibitions of the audiences, but only *temporarily* and without any socio-political foundation" (p. 229).

Similarly, *New York Times* art critic Ken Johnson (2010) argues that the institutional art world has become overwhelmed by what he calls "contemporary academicism." This genre of art making employs various elements of important and revolutionary ideas within the Western art canon. It moves them from their original contexts to new environments and creative confrontations. As Johnson points out, this appropriation of avant-garde artistic tropes may be seen as revolutionary in its own right, and in some ways it is. But, he argues, the "wild new beauty and freedom" that accompanies visionary creation is compromised by the routine enactment of its particular driving creative idea; eventually, I maintain, evermore quickly the visionary and transformative power of the original revolutionary work softens into mainstream assimilation.

It is because many of these Dionysian moments cannot be easily understood that there is both a natural human impulse to provide that experience in an accessible form and a complementary capitalist desire to market and package this same experience. What becomes threatened is our ability to live in the moment, to live to the fullest by feeling as much

as possible. "In the end, our only difference is our unwillingness to have a face-to-face confrontation with the abject. Who would want to be a prophet?...prefer to foresee or seduce; to plan ahead, promise a recovery, or esthetize; to provide social security or make art not too far removed from the level of the media" (Kristeva, 1984b, p. 209). When these two impulses meet, there is a successful market for whatever kind of alternative Dionysian experience one can imagine. But this marketed experience, lifestyle, or, more simply, party or artistic idea fails to replicate the experience accurately.

Kristeva explains the problem of recreating the passions of the abject: "Would he then be capable of X-raying horror without making capital out of his power? Of displaying the abject without confusing himself for it? Probably not" (pp. 209–210). The experience that marketed the appearance or reflection—or, as Kristeva would put it, the X-ray—of the true Dionysian experience. The result is a mere image, an end result obtained without the process of creation, without the Nietzschian primal unity. It is in this vein that Nietzsche (1872/1967) called Wagner a "Romantic." Nietzsche (1882/1974), like Rousseau (1750/1993), who argued against mainstream arts, derided Wagner and other artists who pandered to the "common man", for being overly theatrical, yet utterly status quo.

Open any newspaper in a major city in America and you will find a variety of avant-garde visual art exhibits, cutting-edge dance and music performances, ecstasy-fueled raves, and various urban festivals of debauchery. There is evidence of such Dionysian activities, existing both underground and in venues that are open to the general public, but this is primarily found in urban areas (especially in the bigger and more diverse cities) and on university campuses, which in many ways resemble the diversity and often complementary liberal nature of urban life. It is largely in these experimental communities and areas that unique and antiestablishment artistic experiences work to expand our imaginative and empathetic limits and encourage community consciousness, rather than support the individualism that is encouraged by the increasing routinization and image-ization of everyday life (Lash & Lury, 2007; Ritzer, 2007, 2010).

Nietzsche called on us to cast aside the temptation of mass society's postmodern nihilism in favor of a constantly self-reflecting individualized system of morality. This "will to power" in the face of existential crisis is a fundamental reinterpretation of the Enlightenment itself—to think for oneself and to act for oneself as much as is possible, true autonomy. Most systems of morality assume that there is an objective source of moral knowledge. These systems base on these gods their justifications for these rules and their ideas about how the rules ought to be obeyed.

Nietzsche (1882/1974), for whom independent individual morality was only possible after the "death of god," warned us not to engage in any totalizing discourse, to confront life passionately, and to follow our own paths by way of artistic creation. Creative expressions of public art in our everyday lives can democratically invite all those who cross the artwork's path to engage with the Dionysian realm, explore the union of creativity and rationality, and develop a more empowered self-awareness through this self-knowledge.

Conclusions

Nietzsche (1886/1989) suggested an alternative to a fixed or universal moral basis for practical life in the form of true moral individualism. In contemporary philosophy, Agnes Heller (1989, 1999) (among other post-modern thinkers) advocates an "ethics of personality" that her colleague Mihaly Vajda (1999) has summed up as a free ethics that contradicts the way that traditional moral philosophy tries to prescribe how people should behave: "Be yourself! Follow your own destiny!" Many thinkers talk about the end of "grand narrative(s)" and big "truth" sounding board(s) for moral life. Instead they admire Nietzsche's call for constant self-critique and creation. Instead of becoming an "-'ist" or trying to develop a new "ism," Nietzsche (1891/1977) asks us to think "personally," to find our own way: "One repays a teacher badly if one always remains a student. . . . Now I bid you lose me and find yourselves; and only when you have all denied me will I return to you" (p. 190). In response to Schopenhauer's philosophy, Nietzsche (1872/1967) wrote, "Is pessimism *necessarily* a sign of decline, decay, degeneration, weary and weak instincts? Is there a pessimism of *strength*? An intellectual predilection for the hard, gruesome, evil, problematic aspect of existence, prompted by well-being, by overflowing health, by the *fullness* of existence?" (p. 17). "How should we then . . . explain the origin of the . . . *craving for the ugly* . . . the origin of tragedy? Perhaps *joy*, strength, overflowing health, overgreat fullness?" (p. 21). Nietzsche (1882/1974) pointed out that the Greeks had grown more outwardly optimistic at the very point that their civilization began to dissolve:

> [A] society in which corruption spreads is accused of exhaustion . . . while the comforts of life are now desired just as ardently as warlike and athletic honors were formerly . . . the ancient national energy and national passion . . . have now been transmuted into countless private passions and have merely become less visible. . . . Thus it is precisely in times of "exhaustion" that tragedy runs through houses and streets, that great love and great hatred are born, and that the flame of knowledge flares up into the sky . . . for they carry the seeds of the future . . . corruption is merely a nasty word for the autumn of a people. (pp. 96–98)

We find ourselves in a relatively similar situation today. Our culture, in dialectic with the (mostly) free markets of capitalism, has reached a point where money can purchase almost anything. One can buy a service, an experience, or, even better, a taboo experience, with little restriction. Simultaneously, from Nancy Reagan's "Just Say No" antidrug campaign, to the antismoking crusades of Elizabeth Dole and others, the last 30 years have seen a "cleaning up" of society. In the twenty-first century in America, cigarette machines are virtually extinct, there are smoking bans everywhere—in airplanes, restaurants, even bars, and many schoolchildren can no longer snack on soda or other sugary foods in their cafeterias. Most would not disagree with these governmental and societal measures that provide safer and cleaner environments for us. Nonetheless, besides the obvious advances in health care, what might these sanctions say about our culture? Our fear of the "abject" and our societal impulse to order it and package it appealingly (make it image-ized) makes it more difficult for people to confront the true Dionysian realm. That we generally fear the abject, and the body in general, also makes it all the more important to confront those fears, and our own abjection.

Dionysian experience is vital to the visionary need and capability to see beyond and ahead. It is not possible to teach until you learn, and Dionysian experience engenders the ability for one to be a spiritual teacher, to facilitate progress outside of science. It is important to create, encourage, and experience art that is both intoxicating and thought provoking, and in this way empowers the individual the sensuous and rebellious Dionysian spirit and instinct. Creative art presents the particular experience of the artist fearlessly, knowing the particular is also the universal, so as to conjure a similar experience within all who then confront the art. The emotion that embraces every listener of transcendent music, or viewer of an evocative performance or of a painting that seems alive, or reader of vibrant and pungent poetry, guides them to that too often ignored or sublimated terrain of our inner worlds, the realm of the Dionysian. It is difficult to describe well in words how it can feel to be suddenly filled with joy through music, or reawakened by art, or simply calmed by a beautiful, transcendent image of nature. These are moments that can provide relief from everyday pressures, but more importantly, they are that which remind us—in our instinct, our gut—both that indescribable, nonrational feelings *can* change us, and that there is a "spirit of life"—a feeling of being bodily and sensuously alive—that all people feel at some point or other, and that connects us to each other. Nietzsche (1882/1974) heralded the dawn of postmodernity with his denial of essentialist reified truths. His recognition of the importance of Dionysian destruction and creation to a healthy, balanced life acknowledged both the importance of art in society, and the need for

a confrontation with our inner passions through visionary art. Visionary creation can empower us to live an authentically free life.

Art, for Nietzsche, is intrinsically related to morality and to political life. Art is born of transgression and taboo—the crossing or elimination of boundaries. Freedom and unity are revealed in the destruction of fences, in the forging of a personal moral path. This freedom is essentially the existentialist "opening up" that Nietzsche (1886/1989) addressed by espousing positive self-overcoming. He knew that the path of such courage in the face of the looming threat of nothingness is a struggle to follow. But if it is difficult, then the visionary artist needs to be brave; he or she can create life, and make history. Aesthetic rebellion through a unity of the Dionysian and Apollonian drives is for Nietzsche, the route through which to pursue political change and the encouragement of alternative views on universal ideas and situations.

CHAPTER 3

CAMUS AND THE TRANSFORMATIVE NATURE OF ART: THE INVIGORATING AND COMMUNITY-BUILDING EXPERIENCE OF PUBLIC ART

> *Art realizes... the reconciliation of the unique with the universal of which Hegel dreamed.*
>
> Albert Camus, *The Rebel*

> *The end, the aim, is to make thought—the power of man, the participation in and the consciousness of that power—intervene in life in its humblest detail... more remote than the means, the aim is to change life, lucidly to recreate everyday life.*
>
> Henri Lefebvre, *Critique of Everyday Life*

Art, it has been said, is a reflection of its time. The discipline of art history tells us that the study of art should include an examination of its historical environment. This assertion, coupled with the claim that public art museums and the rituals experienced within them provide rich fodder for understanding society and its many relations and interactions, shows us that art is, indeed, inseparable from the public sphere. If we turn this idea around, we can see not only that art is created in response to society, but also that society is shaped by the values and knowledge born of creative endeavors. Art revives us as individuals and invigorates the spirit through its ability to expand imaginative boundaries and reveal universal human ties. A healthy society—and democracy itself—ultimately relies on the participatory inspiration and consequent political will of individuals. This individual will, to be truly free from the dominating values of popular opinion, can be accessed and developed through rebellious and visionary artistic experience. Our postmodern

world is not only globalized, but technologically sophisticated as well. While this state makes communication, trade, and travel more efficient, it also burdens people with almost constant stimulation, the need to rush, and the encouragement to work harder. This is particularly the case in the United States, where democracy has, from its beginnings, been intimately tied to a spirited and pragmatic work ethic and a capitalist ethos, rather than to poetry and community life, despite the influence of the Puritans (Young, 1996).

Artistic experiences, particularly social and public visionary creative encounters, are vital sources of *life*, of quiet thoughtful moments, of chaotic rearrangements, of confrontations with taboos and fears, of affirmations of innate unity and interconnectivity among humans, and of nature. These opportunities to create our own "realities" in the creative realm, however temporarily, make possible true liberation. For Albert Camus (1951/1991) and his philosophy of creative rebellion, this need to rebel against popular opinion and society is highlighted by the multitude of status—quo injustices.

I submit that more frequent and in-depth experiences with art, first, enable a healthy liberation from alienation, isolation, and mainstream beliefs, and second, following Camus, they will reveal the basis of true justice—the chains of human unity. This chapter examines Camus's concept of creative rebellion. His argument, especially as seen alongside contemporary arguments regarding the transformative properties of art on individuals and on communities, makes clear that, although art cannot be the final answer to our political problems, it should be explored as a way to excite people and encourage them to be critical. From Camus's (1951/1991) argument about the possibility of rebellion through art, it logically follows that wider access to public art would increase access to art and could encourage such rebellion. We do not yet have evidence of the ultimate result for community cohesion and participation, of a considerable increase in public and socially interactive art projects, as this movement is currently in development. An excellent example though that demonstrates well the enormous influence of a community densely populated with public art is that of the story of ancient Rome and its varied and active use of art. The Ancient Romans exemplify a society (and a leadership) that paid close attention to public aesthetics and to public art as tool of communication (as well as propaganda), which resulted in a deeply felt public pride and obedience, that relied on genuine interest and inclusion on the part of the populace. Although the example of Ancient Rome does not capture the meat of the argument here—that experience with visionary art can empower the individual and motivate their desire to participate and create change in the public—it does

provide vital supportive evidence, as it shows the incredible influence that high numbers of public artworks can have on a community.

Before discussion of the Ancient Romans, it is necessary to explore Camus's philosophy, and particularly his concept of rebellion. Camus is perhaps best known for his literary explorations of the absurdity of the human condition in novels like *The Stranger* (1942/1988) and *The Plague* (1948/1975), and plays like *Caligula* (1944/1958). His more directly philosophical and political essays, beginning with a vivid description of absurdity in *The Myth of Sisyphus* (1942/1983), and a call to individual creative rebellion in *The Rebel* (1951/1991), explored this human desire to relentlessly seek meaning in our tangibly meaningless existence. For Camus, when we confront a world devoid of meaning, it is best to enjoy life subjectively— according to our own desires and structures of morality—rather than "objectively," according to the commandments of a false god. We must understand that life is meaningless and hence the quest to give it meaning is ultimately absurd. When people are no longer willing to accept the values of society, they are likely to rebel. Camus (1951/1991) described the yearning to rebel, its necessity, its rewards, its potentially dangerous consequences, and the truly individual nature of freedom, both in society and within the human condition.[1] Camus, writing at the midpoint of the last century amid copious horrors created by power-hungry tyrants and oppressive modern governments, seems to have been almost desperately searching for an answer, or better yet a solution, that would limit and prevent the forces of human destruction and (re)teach governments and individuals the benefits of moderation (and justice). Seeking to explain why rebellion is a natural human proclivity, Camus described the ever-present tension between reason and imagination and asserts that in the act of individual aesthetic rebellion, we can achieve a crucial moderation between the two realms. Instinctual Dionysian and rational Apollonian forces ultimately limit each other and work together to enable the rebellion of visionary creation.

I propose that in order to combat the lack of energy, the lack of feelings of full inclusion on the part of the citizenry and, ultimately, their lack of participation in today's democracy in the United States—and to enable more and more individuals to gain access to alternative conceptions of everyday reality through creative reconceptualization, and likewise, to become closer to a sense of universal unity and true community—we should explore the encouragement of more frequent, and broader-based, artistic experiences in our outdoor public spaces. If we consider Camus's (1951/1991) ideas about the power of rebellion through art alongside other arguments that contend that artistic experience can be a transformative ritual, and that there is a liberty-preserving role for art in democracy,

we can summarize these connections in the four parts I describe next. A desire to question our existence, and to access uninhibited passions, is natural to the human condition, but this drive is also naturally stifled by the dominance of reason, and the materialism and conformity of popular opinion, and thus needs to be especially encouraged. This rebellion is best accessed through artistic experience and best developed through the democratic approachability of public art. A visionary revolt is limited by its inherent moderation, and gives birth to a compassionate understanding of justice. This, as experienced by many individuals, can culminate in an overall (re)awakening of American democracy through the invigoration of public culture with heightened self-knowledge among individuals, and likewise, with feelings of empathy and community.

Combining Perspectives: Camus, Duncan, and Levine on the Power of Art

A revealing examination of the transformative as well as the empowering and emancipatory nature of artistic experience requires creative interdisciplinary analysis. Carol Duncan and Caroline Levine each provide a foundational support for a key part of the process described above. Levine shows us, in the American context, how much art can challenge and question a democracy and its culture, and argues that the liberty that Tocqueville worried was at stake in democratic life could be preserved through the existence of provocative artworks. Working on a different angle of this question of the power of art, Duncan looks at how we feel in the presence of art, and the myriad rituals that play out within us, and between the art and its other viewers. Her works show that museums are a place of spiritual experience, not simply education or entertainment. With this assertion that experiencing art is otherworldly, the main argument in this work—that public art is the prime vehicle for democratically encouraging inner reflection within individuals—gains traction, as public art encourages ritualistic experiences not just in a museum, but on the way to work, or to school, as well.

If we look at Camus's assertion that there is freedom and empathetic justice contained within rebellious artistic experience, alongside these contemporary ideas presented by Duncan and Levine, we can see both how Duncan implicitly employs Camus's ideas when arguing that art is ritual and how Levine similarly does so in her belief that the existence of what Camus would call rebellious art, maintains freedom and independent thought in American society. From Camus's belief that the individual could experience true freedom in the form of universal empathy (justice), it follows that the key to the rebellion that yields such liberation is truly

independent thought, and likewise, the necessary "authentic" experience with the self. Camus saw true freedom as liberation from both the unjust realities of life and the suffocating embrace of a popular opinion that too often permitted tyranny.

Art alters and reinterprets time, place, the body, and emotions. All art, indeed *life*, itself ultimately comes down to choice and interpretation. To create something new from the material of the everyday is both to acknowledge the characteristics that define our social lives and to attempt to change them, at least temporarily. Camus (1951/1991) described this relationship between art and everyday life:

> To create beauty, he [the rebel] must simultaneously *reject* reality and *exalt* certain (of its aspects.) Art disputes reality, but does not hide from it (p. 258).... It [art] is born of a mutilation, and of a voluntary mutilation, performed on reality (p. 265).... Through style, the creative effort reconstructs the world, and always with the same slight distortion that is the mark of both art and protest. (p. 271)

The framing that creation relies on does not allow you to deny reality completely, nor can you ever claim a truly objective understanding of it. Camus believed that formalism (abstraction) is an attempt at rejecting reality entirely, but that it can never succeed in this goal because, as long as you are capturing real life, there is always a boundary to which you can abstract it. Realism can attempt to affirm only reality. "Realism cannot dispense with a minimum of interpretation and arbitrariness. Even the very best photographs do not represent reality; they result from an act of selection and impose a *limit* on something that has none" (p. 269). Neither the purely irrational nor the purely rational exists; although these extremes can be momentarily accessed, they always meet between these extremes within a dialectical relationship.

It is also necessary to reconcile the inherent individualism of artistic creation, the inevitably unpublic aspect of creativity, with its role as mediator between the particular and the universal and between the self and the community. Artistic endeavors begin within the individual mind and spirit, in that even the most publicly created works have their roots in the ideas of individuals. Visionary art evokes an ability to comprehend the self to be like *all* others, to perceive the self as universally constructed, but creation is ultimately a solitary affair. In other words, it is important to examine how an individual artistic experience translates into a more active participation in life, and thus in society. Making and experiencing art can draw you further inside yourself, and it should begin this way. Experience with art should create reflection *first* and, with the new

possibilities that the knowledge of art yields, enable you to explore needs beyond the material and the individual and, ultimately, lead to a desire to connect with the collectivity of selves within each of us.

Further, I am not implying that experience with art will necessarily make you a "better" or more generous or more tolerant person. Because all art is transformative, in that it transforms an object, or an emotion, or a space, it expands the imaginative capability and is thus valuable in the development of a more interested and active citizenry. In destroying the expected to make way for new approaches, artistic experience opens doors both within and outside the self. This is increased with visionary rebellious creation.

By nature of its symbiotic relationship to the public sphere, and its reliance on human interaction, public and social art is in a constant dialogue with society beyond that which is possible either for art that is housed in museums or for solely object-based art. Camus (1951/1991) argued that visionary or rebellious artworks inspire a transformative experience for both creator and viewer that enable access to true liberation and justice. To place his ideas in a contemporary American setting, and to explore the effects of transformative art that is created and displayed in the public arena, we briefly turn to the work of Levine and Duncan before returning to Camus's ideas.

Several researchers have produced studies indicating a link between public art and ideas of community. They have recognized that art is a transformative force, in both the literature of political science and art history, not only in the field of philosophy, and have shown that examining the relationship between art and politics is an interdisciplinary effort (Corbit & Nix-Early, 2003; Edelman, 1996). These studies demonstrate the contemporary appreciation of the ability of art, and particularly public art, to serve an important political role. Some have looked at the spiritual results of interaction with art and others, examining art's vital relationship to democratic conditions, have advocated provocative and challenging art as well as the avant-garde. Duncan (1995) tells us that museums create a stage for important spiritual rituals between artworks and their visitors, and among the visitors themselves as they experience the artworks. Levine (2007) defends the role of the avant-garde, or the visionary, as a check on democracy's pledge to freedom. These two very different approaches to the study of the relationship between art and political life blend well to help illustrate in the contemporary context that art is vital to democratic life and that experience with art can be transformative. These arguments, taken together, form the foundations of the point I am making here. Duncan illustrates why and how looking at art in museums, and artistic experience in general, can be transformative and

spiritually invigorating, and how artistic ritual affects our relationships and interactions with those around us. Levine also speaks of the power of art, but she aims to show how it can support the needs of freedom in a democracy. In a discussion of the dynamic role of art in our social and political lives, and by demonstrating the need to view our political problems through an interdisciplinary lens, it is my hope to bring art out of a restricted aesthetic space.

In this work, I suggest that the role of visionary art (and art in general), especially when placed or created in the public sphere, counters Tocqueville's (1835/2002) claim that religion in a democracy provides an easily accessible path to expand the self awareness of individuals by working as a balancing force against the individualistic capitalistic tendencies of American culture. My argument is an inverse of sorts of Levine's (2007). Rather than viewing the existence of avant-garde art as a check on cultural freedom, and proof that a democracy is as free as it claims to be, I see interaction with art, especially visionary art, following Camus, as inspiring a rebellion within individuals that creates a more active and interested citizenry by creating moments that value the immaterial and the universal, as opposed to the material and individual needs of everyday democratic life.[2] Exposure to public art creates in people an expansion of the imagination, particularly in the capacity to conceive of new and revolutionary possibilities in general, and in achieving a closer connection to truths accessed through intuition not intellect, especially the recognition of the unity of all selves, and ourselves in others, as an alternative to the reigning liberal materialism in America.

How Art Can Nurture Individual Transformation and Challenges to Society

In her study on the history of avant-garde art in the United States, Levine (2007) aims to explore the cross-influences of aesthetic and political life. She explains her motivation: "*[D]emocracies require art*—challenging art—to ensure that they are acting as free societies. Democratic citizens have gotten into the habit of believing that theirs are the freest societies in the world. But political theorists since Alexis de Tocqueville have warned that democratic governments can actually work *against* freedom. Intent on imposing the will of the majority, democracies are inclined to repress and silence nonconformist voices. And since majorities can—and do—decide to squelch unpopular expression, democratic societies always run the risk of becoming distinctly unfree societies."

Levine believes that we need to challenge mainstream norms in the tradition of the artistic avant-garde. They have always worked to stir

up unconventional norms through shock value, pushing the majority to become aware that their will is not absolute. Although the avant-garde period is supposedly over, Levine argues, its philosophical challenge to mass culture and beliefs will never die: "[T]he idea that art represents a struggle for freedom...remain[s] surprisingly robust and influential. In fact, whenever art works are contested in the public sphere, artists and arts advocates leap to invoke the revolutionary, heroic, marginalized figure of the avant-garde artist and set that oppositional figure against the idea of the 'people'" (p. x). For hundreds of years, arts controversies have rested on the struggle between democratic majorities and deliberately provoked outsiders. Levine terms this the "logic of the avant-garde" (p. 3).

Over the centuries,[3] it has become accepted knowledge that artists serve an important role in observing, questioning, and critiquing society. "The critical autonomy and rebellion associated with the avant-garde have come to serve as a kind of default definition of the social role of art....Art that intentionally shocks and unsettles majority preferences seems to set itself...against the will of the people" (p. 11). In contrast to the philosophical point of view, Levine's social historical work demonstrates how important a function art can serve in society, and specifically, in American democracy. She shows how, throughout the last century in particular, the creation of visionary and controversial art not only forced political and social change (particularly with regard to censorship laws in America) but also challenged the limits of prescribed democratic individual freedoms. The ability of rebellious art to question and to create constantly shifting alternatives for human political life becomes even more useful when joined with the idea that individual artistic experience is transformative for both creator and viewer. Together these two ideas mean that art can first question society, and then invite viewers into a sensory or spiritual moment that is vital to developing more publicly participatory and community-minded citizens.

Duncan (1995) believes that the experiences of art can be both transcendent and transformative for the spectators. She places her argument in the context of the museum, although her underlying assumptions about the "ritual" power of art are valuable in many other contexts. Her high regard for the ability of art to affect and change people echoes the ideas of both Camus and Nietzsche. Duncan contends that museums are not merely well-designed structures in which to store art[4]; rather, they are places for "ritual"—or some form of transformative or spiritual activity—and thus not unlike the experience of traditional places of worship. The key to, or heart of, her argument is that viewing and interacting with art (and the architecture that it is housed in) is a

transformative individual experience. Instead of viewing a museum as many different objects brought together to be looked at separately, she sees the "totality of the museum as a stage setting" where all the visitors (and it is to be presumed, the art they are viewing) participate in one ritualistic "performance" (pp. 1–2).

Duncan references the sociological studies by Pierre Bourdieu in the 1960s where he, in collaboration with Alain Darbel, interviewed hundreds of people and, using that data, concluded that "art museums give some a feeling of ownership and belonging while they make others feel inferior and excluded" (p. 4). She uses their study as support for her premise that art museums function as a places for ritual.[5] She argues that if this was not true, then visitors would not, as they do so often after spending time in an arts institution, feel emotions related both to their esteem and worth, as well as feel changed after interaction with others (those participating in the ritual with them). If the experience of experiencing art in a museum was simply about observing and learning—using reason—then people would only gain access to information about the aesthetic and educational appeal of the objects of art on view; they would not leave so often feeling noticeably happier, or sadder, or simply more in touch with themselves and others.

I agree wholeheartedly with Bourdieu and Darbel's thesis. In fact, my fundamental arguments in this study could not stand on solid foundation were it not for the problems of exclusion inextricable from all institutions, including those of art. Despite this belief, as with Duncan's self-conscious aim, I do not focus explicitly on the valid concerns with institutionally presented and maintained artwork, or with institutions (as a sociological or political category) in general, though I begin with an understanding that institutions by nature of having to make the choice to enter them, exclude people, while public outdoor spaces are more inclusionary.

Of course, art museums are public places open to all, but this is only a reality to a point. If we begin with Duncan's main thesis—that art museums are places of ritual and participation, not simply of observation—then a natural next step is to claim a fundamental place for public and social art (i.e., art taken out of the institutional context) in the building of community feeling, a desire to participate in social and public (and therefore political) life and in democracy. "Its [Duncan's book's] larger argument is not simply that art museums are ritual structures, but rather that, *as ritual structures*, museums are rich and interesting objects of social and political history" (p. 6). Our culture identifies religious buildings, such as churches, temples, and mosques, as different from secular buildings like museums and courthouses. This "religious-secular dichotomy," Duncan says, structures "much of the [our] modern

public world" (p. 6), but it should not be seen as natural or intuitive. Rather, she explains, this dichotomy itself has historical and man-made roots in Western life. The classification began with the Enlightenment movement's attempt to use the new discoveries of science to weaken the power of the church over society and public thought. By the late eighteenth century, this goal had become a reality and since then it is secular-rational, verifiable truth that reigns as "objective" truth in our culture; religious truths are only for those who choose to take them on.

Art museums, Duncan continues, are "secular," both because they are organized by "scientific and humanistic disciplines" and because they are said to be caretakers of our cultural memory. She, however, claims that ritual, despite its usual association with religion, is actually at the heart of the art museum experience (p. 8).

Liminality, a term associated with ritual, can also be applied to art museums. It was used in the anthropological writings of Victor Turner to indicate a mode of consciousness outside of or "betwixt and between" the normal, day-to-day cultural and social states and processes of getting and spending. His category of liminal experience had strong affinities to modern Western notions of the aesthetic experience—that mode of receptivity thought to be most appropriate before works of art. Turner recognized aspects of liminality in such modern activities as attending the theatre, seeing a film, or visiting an art exhibition. Like folk rituals that temporarily suspend the constraining rules of normal social behavior (in that sense, they "turn the world upside down"), so these cultural situations, Turner argued, could open a space in which individuals can step back from the practical concerns in social relations of everyday life and look at themselves and their world—or at least some aspect of it—with different thoughts and feelings (p. 11).

Duncan cites Swedish writer Goran Schildt who has noted that museums are settings in which we seek a state of "detached, time-less and exalted" contemplation that "grants us a kind of release from life's struggle...and captivity in our own ego" (p. 14). Referring to nineteenth-century attitudes to art, Schildt, notes Duncan, observes "a religious element, a substitute for religion" (p. 14). He succinctly identifies and describes the birth of the study of aesthetics and explains its natural relation to religion.

> The eighteenth century's designation of art and aesthetic experience as major topics for critical and philosophical inquiry is itself part of a broad and general tendency to furnish the secular with new value. In this sense, the invention of aesthetics can be understood as a transference of spiritual values from the sacred realm into secular time and space. Put in other

terms, aestheticians gave philosophical formulations to the condition of liminality, recognizing it as a state of withdrawal from the day-to-day world, a passage into a time or space in which the normal business of life is suspended. In philosophy, liminality became specified as the aesthetic experience, a moment of moral and rational disengagement that leads to or produces some kind of revelation or transformation. (p. 14)

Duncan asserts that art museums are sites of transformative ritual that enable people to achieve liminal experience—"to move beyond the psychic constraints of mundane existence, step out of time, and attain new, larger perspectives" (pp. 11–12). If we transfer the context of this argument about the transformative power of art from the museum or gallery to the truly public realm of our outdoor spaces, it can be argued that art that creates social interaction and appears on our streets is transformative. Therefore, when it appears in our everyday lives and in our everyday places, often with the element of surprise, it encourages new ways of feeling and thinking about that with which we are already familiar. More than art viewed inside museums, public art is a faster, more democratic, and more physically encompassing way to access and harness the unifying and liberating power of artistic experience.

For Camus (1951/1991), the ultimate meaninglessness of existence, coupled with the horrors of human injustice, meant that people needed to experience creative individual rebellion truly free from all societal constraints, not the traditional, institutionalized revolution he saw in his lifetime. He argued that genuine change, and true freedom, must be felt within each person if it is to create new needs that reflect universal unity and community. He knew that artistic and creative experience held a unique ability to reinvent the world according to individual desire and opinion, and that this rebellious reinvention could expand imagination, which was vital to an active political life. Art created or displayed in public as well as creativity conceived and experienced socially seem a natural extension of Camus's beliefs regarding the function of art in society.

Camus and the Desire for Order

Camus's theories, following both Kierkegaard and Nietzsche, all began with the tenet that *the* fundamental human desire is to understand and order one's own existence and place in the universe. He believed that our inability to comprehend our own existence and purpose produces in us and in society a deeply rooted frustration that leads to a variety of paternalistic style myths, beliefs, and organizations. These ideas act as both a protective shield from the lack of absolute meaning in this world

and as a source of clear and fixed answers to the mysteries of existence and to the goals and decisions of our everyday lives. Camus (1951/1991) wrote, "Man…tries in vain to find the *form* that will impose certain limits between which he can be king. Religion or crime, every human endeavor in fact, finally obeys this unreasonable desire and claims to give life a *form* it does not have" (p. 262).

In the quest for meaning, it is inevitable that people looked, first, to religion and, later, to science as providers of "objective" knowledge and truth. It was evident to Camus that neither the oppressive rules of religion nor the misleading reliance on rationality that science espouses can bring us to the most important "truth"—accessed through intuition—that, because we are defined in relation to one another, each of us contains all others within ourselves. Camus feared regimes, such as Communism, that attempted to deny the spiritual aspect of life. Denial of spiritual and sensory life can lead only to desperate and tyrannical leadership. This denial would also separate us from each other, and cause a generalized lack of interest in public life and eventual abrogation of the importance of public space, essentially taking the social concept out of "socialism."

Camus argued that rebellion, "in order to remain authentic, must never abandon any of the terms of the contradiction that sustains it" (p. 285). "Refusal and acceptance, the unique and the universal, the individual and history balance each other in a condition of acute *tension*" (p. 273). To illustrate the similarly unending opposition within rebellion, he used the example of the tension between equality and liberty that exists within any democracy: "Absolute freedom mocks at justice. Absolute justice denies freedom—To be fruitful, the two ideas must find their *limits* in each other" (p. 291). As a master needs his slave and the slave his master, rebellion must be truly free but also should be limited and balanced with a reasoned moderation. Otherwise, this rebellion can threaten to run to its limits and devolve into exhaustion or, worse, tyrannical power: "[According] to Camus, if the absurd is not to degenerate into moral nihilism it must rehabilitate itself in the light of revolt and that if revolt is not to deteriorate into a regime of tyranny and oppression, it must remain conscious of its origins in the absurd premise" (Foley, 2008, p. 4).

Robert C. Solomon[6] (2006) makes the point that Camus effectively used the character of Meursault in *The Stranger* not only as an expression of individual struggle in a meaningless world, but also, more importantly, to show how much humans rely on their ability to reflect, dissect, and evaluate their thoughts and decisions and how, throughout the novel, his antihero declined to consider the value of his feelings. Solomon speaks to this second point when he shows how for Camus, experience and

reflection formed a universal dualism, a dialectic:

> So *The Stranger*, I want to suggest, is a book of phenomenology, but it is in particular a book about the problematic relationship between the phenomenology of experience, and the phenomenology of reflection. Meursault, one might say, lives his experience, albeit shockingly limited, without reflection. This, I want to suggest, is what makes him so "strange" to us. (p. 12)

Solomon challenges the scholarly debates on the "honesty" of Meursault about his feelings. He asserts that Camus's Meursault was neither lying in his indifference to the truth (Conor Cruise O'Brien, 1970), nor was he simply being painfully "truthful" (Camus's [1942/1983] own commentary on *The Stranger*) to his emotions. Solomon takes on the very way we understand the idea of feeling, or emotion. Solomon argues that "[t]he emotions...sustain the 'fundamental projects' of our lives" (p. 113). He believes that our ability to judge a situation is essential to our forming emotion related to it. That is, he believes that we access what we know as feelings only during the process of, or once we have considered the value of, an experience. Solomon argues that Meursault failed to exhibit actual feelings (at least in the first half of the book) because feelings need to be processed and assessed, and Meursault lived only in experiences. Consequently, he could not have been anything so deep as "truthful," "because he never reaches that (meta-) level of consciousness where truth and falsity can be articulated. Moreover, he does not even have the feelings, much less feelings about his feelings, to which he is supposed to be so true" (p. 15).

Solomon also points out that this duality in Camus's philosophy is parallel to Sartre's (1937/1960) earlier ideas about reflective versus prereflective experiences. Sartre's argument was similar to Heraclitus's claim that one can never cross the same river twice. It also resonates with to Heisenberg's "Uncertainty Principle," which states that we can never get as close as we would like when observing atoms because the closer we look, the more we change what we are attempting to understand. The precise examination of some phenomena is thus impossible and self-defeating. In the field of quantum physics, the result is that if you achieve an exact assessment of one characteristic of an atom, you simultaneously lose the ability to gauge another key characteristic. This can be viewed as a metaphor for life.

Sartre believed that once we leave the purely prereflective state and we infuse our experiences with the reflection of history and science and morality, we have forever altered the original experience, and possibly

diminished the power of knowledge. This idea is important to Camus's project, because he believed that life plays out in dualities and that experience and reflection create each other; they should also limit each other so as to sustain rebellion. Individual aesthetic rebellion was, for Camus, the sole response to the meaninglessness of our external worlds and to the tyranny and injustice that plague modernity. Rebellion demonstrates our connection to, and reflection in, the struggles and celebrations of all others, and thus works toward a universal and humanist understanding of justice. It also opens access to vital intuitive, not reason-based, knowledge.

Camus and the Eternal Tension between Reason and Desire

The Enlightenment began with what social theorist Max Weber (1930/2002) termed "the disenchantment of the world," which stressed that society be grounded in science and technology. This rationalization of society signaled for Weber a loss in spiritual life. The overwhelming scientific and technological advances in modern life and the acquisitive individualism of capitalism combined to create an increasingly pragmatic and rational, modern Western man. Following Weber, sociologist C. Wright Mills (1959/2000) elaborated the ruling ideas and persistent legacies of the Enlightenment tradition:

> Our major orientations—liberalism and socialism—have virtually collapsed as adequate explanations of the world and of ourselves. These two ideologies came out of the Enlightenment, and they have had in common many assumptions and values. In both, increased rationality is held to be the prime condition of increased freedom. The liberating notion of progress by reason, the faith in science as an unmixed good, the demand for popular education and the faith in its political meaning for democracy— all these ideas of the Enlightenment have rested upon the happy assumption of the inherent relation of reason and freedom. (p. 166)

Romanticism became the first "re-enchantment program" to challenge the main tenets of the Enlightenment. The Romantic Movement challenged the primacy in society (and in our collective knowledge base) of reason, science, technology, and industry by defending the vital importance of sensuality, instinct, spirituality, and poetry. In fact, in the view of the Austrian experimental and conceptual artist and theorist Peter Weibel (2005), intellectual movements thereafter have repeatedly attempted to overcome this "crisis of disenchantment." He

explains that "the dispute between enlightenment and absolutism, between sensualism and spirituality, between rationality and religion is evidently not over: It continues, albeit under different presuppositions and conditions" (p. 1020). He is pointing here to the same recurring primal dialectic in the human condition that Camus (1951/1991) grappled with—the conflict between our desires and our rational thought, our desire to live in poetry and our inclination for order and pragmatism, our capacity for empathy and our inevitable tendency toward selfishness.

These tensions are all part and parcel of the same larger division between the self that plays out on the personal level but is equally present on the political and economic levels as well. In a liberal democracy, and in its natural spouse, capitalism, this fundamental human conflict is encouraged—by the system, whose aim is to be rational and pragmatic. Olivier Todd (2000) emphasizes Camus's trust in aesthetic knowledge and in the phenomenology of experience, even early in his life, as can be seen in his quote from Camus (1933/1968): "I put Dreams and Action ahead of logic, because I see logic as pure intelligence, empty and to be despised (Todd, 1997, p. 21). For example, when Camus (1933/1968) compared the Europeans, and specifically the French, to the Algerians who inspired and invigorated him, he accused the French of being "civilized," or too reliant on reason, and implied they could learn from the creativity and sensuality of his favorite African nation: "The opposite of a civilized people is a creative one" (p. 89).

Similarly, Camus exalted the moderation by which the Greeks had lived: "Equity, for them [the Greeks], supposed a limit, while our whole continent is convulsed by the quest for a justice we see as absolute" (p. 149). In the same essay, Camus pit the Greek sense of limits, and acceptance of ultimate ignorance, against the egoist and power-hungry Roman conquerors. He indicted the souls of these Roman leaders as vulgar and compared them with his fellow Europeans: "Our reason has swept everything away. Alone at last, we build our empire on a desert. We turn our back on nature, we are ashamed of beauty" (p. 150). Further on, Camus drew on one of his recurring themes, that of the vital difference between revolution and rebellion. It is the moderation itself, exemplified by a connection to the universal human condition that creates the limited freedom of visionary creation: "Both the historical mind and the artist seek to remake the world. But the artist, through an obligation of his very nature, recognizes limits the historical mind ignores. This is why the latter aims at tyranny while the passion of the artist is liberty. All of those who struggle today for liberty are in the final analysis fighting for beauty" (p. 152).

Camus's (1951/1991) analysis of rebellion as exemplified in the artistic vision begins with a discussion of man's natural and inevitable desire for order in a world without absolute meaning. This crisis of existentialism, the very problem of attempting to understand the value or significance of our own existence, has plagued man since the beginning of time and is inherent to our species. That this problem even exists, and that it is at the foundations of the philosophical endeavor, is evidence of man's natural desire to understand his place in the greater world and his need to seek his own freedom. It is in rebellion from the justice that is accepted in everyday society, said Camus, that we attempt to forge a path to a more true freedom. This is a healthy human drive that propels civilization forward. It is this rebellion that should be encouraged, but it is required that it also be internally limited by the only measure of justice that Camus espoused—empathy stemming from the recognition of the common ties among all of us. The rebel should seek freedom without taking away the freedom of others; without allowing one rebel's quest for freedom to devolve into tyranny. This necessary rebellion is a breath of fresh air for the rebel, but that breath can blow up into flames as it gathers the steam of actual political force and the desire for total revolution. "The novel is rebellious because it refuses reality. It is not an evasion; it is an obstinate effort to refuse the world as it is, and through its recreation, to find man's destiny therein" (Hanna, 1958, p. 140).

This reasoning can be taken a step further. Camus was wary of the power of rebellion. Without moderation, rebellion can become revolution, and it is revolution—when one ruling power is actually replaced by another—that he feared, for it reins in the freedom of rebellion and shapes it to the liking of the new regime. I maintain that it is useful to move away from the tragedies of totalitarian revolution in the twentieth century, to a focus on individual moral and spiritual rebellion and revolt. Art, as Camus suggested 50 years ago, is a natural companion to rebellion. By allowing it to prosper freely and consistently in the public lives of Americans, we can hope to release more and more individuals into the exhilaration of their own personal rebellion while limiting the ability of any one rebel to control the future of any other. This is not a call to limit revolution—for such limiting, there is always a place in history. It is, rather, an encouragement for personal revolution to take precedence over societal revolution.

John Foley (2008) contends that Camus was not an existentialist and thus is very much misunderstood. Foley writes that Camus, in line with existentialists like Kierkegaard, believed that there is lack of meaning in the world. But he did not believe that one had to ascribe meaning despite this truth, nor that life is worthless. Rather, this acknowledgment of

meaninglessness provided a revolutionary new perspective on our lives. Foley says that Camus's solution for the problem of nihilism lay in a revolt of limits, mediated by the very same absurdism that gives birth to nihilism: "[According] to Camus, if the absurd is not to degenerate into moral nihilism it must rehabilitate itself in the light of revolt and that if revolt is not to deteriorate into a regime of tyranny and oppression, it must remain conscious of its origins in the absurd premise" (p. 4). Although Camus may not be best characterized as an existentialist, he was concerned deeply with lifting the veil from existential fallacies and seeking within individual liberated creative experience, a source of empathy and true power and justice.

It was important to Camus that there are no moral absolutes, yet his insistence on limits is a defining feature of his philosophy. He believed that the only necessary moral foundation for a just society is the recognition of a common bond among all people, a bond based on such universal experiences as empathy and suffering. "The rebel pursues unity not through religion or morality per se, but through the assertion of human solidarity based on a common human condition. This principle of human solidarity constitutes the basis of the unity[7] desired by the rebel, a unity Camus sees articulated in syndicalism and in certain forms of social democracy, such as the Scandinavian model" (p. 76). Camus believed that the rebellion needed to overcome alienation and engage such unity must be one of internal moderation: "The idea of a 'philosophy of limits' neatly evokes both the limit beyond which the rebel insists the master not pass, and the sense that the values on behalf of which the rebel rebels are not absolute values" (p. 79). Further elaborating on this point, Foley writes, "Crucially, according to Camus, legitimate rebellion seeks neither absolute justice nor absolute freedom, but seeks to institute a regime of relative values, wherein relative justice and relative freedom can be enjoyed" (p. 85). For Camus, absolutism in any sense was a fallacy to avoid. Absolutism invites teleology rather than open evolution and tyranny rather than public forum.

Reimagining Individualism as Unity and Community

Camus (1951/1991) wrote that rebellion reveals our true nature, which is an understanding of our commonalities and the ultimate spiritual unity within the human condition: "Every act of creation by its mere existence, denies the world of master and slave" (p. 224). The act of creation thus allows for the emergence of Marx's (1844/1978) concept of "species being," or the idea that within each individual exists the totality of the

human species, that within each of us is the whole. This idea, not unlike Rousseau's (1762/1993) reverence of societal unity asserts that our inter-connectedness as human beings should carry more weight in political society than does the predominant preference for the plight of the indi-vidual citizen. Both Marx and Rousseau saw capitalism—for Rousseau, the original introduction of property into society—as a corruptive and competitive force that feeds on a focus on individual life. A funda-mentally social understanding of life, and of progress, threatens the individualistic foundations of the liberal capitalist system and encour-ages a humanistic alternative to an everyday existence guided primarily by science and technology.

In a quest to challenge and counteract the over-rationalized and tyran-nical forces in modern twentieth-century life, Camus asserted the power of art and aesthetic rebellion to bring about change within the individ-ual spirit. Such an inner change, which acknowledges a universal unity among living beings, could prevent the ultimate self-destruction of civi-lization. Camus believed that a revolution within individuals that stressed a universal spiritual connection among man could be accessed and pur-sued through the creative experiences of art. He explained, "Rebellious art also ends by revealing the '*We are*'" (p. 275). Later, Camus revealed the truly revolutionary component of his theory: "[T]he 'We are'"[8] para-doxically defines a new form of individualism" (p. 297). Camus argued that "[w]hen he [the rebel] comes to the conclusion that a command has infringed on something in him which does not belong to him alone, but which is common ground where all men—even the man who insults and oppresses him—have a *natural community*" (p. 16). He elaborated on the primary difference between the fruitless search for meaning in human existence and the development of individual rebellion through artistic experience. "In absurdist experience, suffering is individual. But from the moment a movement of rebellion begins, suffering is seen as a col-lective experience" (p. 22). Hanna (1958)[9] and Sagi (2002)[10] both agree that Camus's notion of rebellion suggests a universal unity among living things that supersedes material concerns: "[In] all revolt there is a meta-physical demand for unity which, going unsatisfied by the conditions of the world, attempts to build a universe which will satisfy this demand" (Hanna, 1958, p. 138). This new understanding of individual needs, and the fulfillment of those needs through relation with others, means that "[f]or the rebel, harmony is harmony with the other" (Sagi, 2002, p. 107). The goal in the revitalization of everyday life is not to deny the value of individualism, especially as exemplified in the political doctrines of individual rights and liberties, but, rather, to reenvision the concept so that it rests on the doctrine that within each of us is the collective; by

attending to our own rational, even selfish, needs, we are implicitly attending to the needs of all others, to the needs of the collective.[11]

All philosophical inquiry, at least in the Western tradition, inevitably returns to the quest for truth. People never tire of searching for "truth" in the complexities of life. Rather than seeking absolute truths through reason and science, people can locate truth by putting faith in the unconscious—in what is hidden, secondary, denied, unknown—to reveal important new truths. The German artist Joseph Beuys (Beuys & Harlan, 2004), who worked in installations, performance, and, most famously, his own concept of "social sculpture," touched on this idea when he argued for social revolutionary change through a development of the faculties of creativity and imagination: "By this I mean that such a formula would no longer necessarily be the result of thinking, as in classical philosophy, but would reflect the need for something that is attainable only through *intuition, imagination, and such higher forms of thought*" (p. 14).

Similarly, the American transcendentalists (Emerson, 1893/1921; Thoreau, 1849/2001), as well as Marx (1844/1978) and Rousseau (1762/1993), have all discussed a more communal understanding of the traditional liberal notion of individualism. The Transcendentalist Movement in the United States encouraged a retreat into solitude, to leave, at least temporarily, the stifling embrace of popular opinion and better access the ultimate unity of the human community. Emerson's (1893/1921) concepts of the "Over-Soul" and the "One Universal Mind" evidence his belief that if a person can withdraw from society (and from reason) far enough to be able to experience his own perception of ruling concepts and values, he will feel a stronger sense of unity and understanding with his fellow man, as well as with nature. Following Tocqueville, Emerson understood the need to shake Americans out of their complacent conformity, and he knew that an accessible and truly free way to "opt out" was through art, poetry, and literature. Camus (1951/1991), in a very different context, similarly believed that creating and experiencing artistic rebellion "transcends the individual, [and]...allows the *whole being* to come into play" (p. 17). In other words, they both argued that people seeking new and truly free possibilities in life should explore beyond the rational procedures, goals, and dreams of modern life and find the spiritual knowledge that nurtures human connection.

They maintained, as I do, that engagement with art enables the growth of vital knowledge through the senses and emotions. Sensory and sensuous experiences, whether in art or spirituality, are a link between ourselves and the world. The tension in political thought between Lockean liberalism and Jeffersonian republicanism is paralleled by the tension between

capitalism and socialism (or social democracy) and between apathetic individualism and community and civic-mindedness. This balancing of drives exists in our political, economic, and social lives and separates us into opposing camps. Now more than ever, the support and creation of public (placed in the outdoors) and socially interactive artwork is needed to encourage inner individual revival. Art has always held the power of reenvisioning and reawakening, as it interprets our everyday reality in new ways. This power could be harnessed for the spiritual health of individuals and for the benefit of a vibrant and participatory society. Art should be increasingly available to everyone by becoming part of our public spaces and our public lives.

Knowledge Gained from Poetry, Myth, and Emotion

Much can be learned from instinct, imagination, and fantasy. Artistic experience can connect us to these feelings, help us to access genuinely free individuality, and enable us to understand more completely our connections with and vulnerabilities to others. Bruno Bettelheim (1977) believed that the surreal and the mythical hold an important place in the intellectual and emotional development of children. He saw that children could, through the symbolism and abstraction of myths and fairy tales, access, and try to understand, painful ideas and experiences in a healthy way. Citing Greek philosophy, he wrote:

> Plato—who may have understood better what forms of mind of man than do some of our contemporaries who want their children composed only to "real" people and everyday events—knew what intellectual experiences make for true humanity. He suggested that the future citizens of his ideal republic begin their literary education with the telling of myths, rather than with mere facts or so-called rational teachings. Even Aristotle, master of pure reason, said: "The friend of wisdom is also a friend of myth." (p. 35)

Freud (1930/1961b) too reminded us that rational thought and behavior is rational only to a point; all so-called rational thought *must* confront the realm of irrationality contained within the subconscious self. In this sense, art can be viewed neither simply as oppositional to reason (as the realm of the irrational), nor only as the aesthetic or the beautiful. Rather, art can be understood *as* reason, as an alternative source of knowledge, as a more "genuine" (implying congruence along a common human bond) form of rationality. Touching on a similar idea, Beuys (Beuys & Harlan, 2004) has explained some of his philosophical motivations in

creating art, and specifically, his various "social sculpture(s)":

> For several years, I have been working with a formulation of "the aes-
> thetic" that goes back to its origins as the opposite of "unaesthetic" or
> numbness. From this perspective, aesthetic comes to mean "enlivened
> being." This not only turns the contemporary usage of "aesthetic," as
> something rather…superficial, on its head, but links such "enlivened
> being" to…the ability to respond! So this overcoming of numbness and
> enlivening of being can engage one, make one internally active, mobilize
> people's imagination. (p. x)

In accord with Novalis (1798/1997) and Schiller (1792–1794/2004), Beuys
believed that artistic experience contains the potential to create necessary
and revolutionary change in society and political life. He developed his
idea of "social sculpture" throughout his long career, both by creating
revolutionary performance and installation-style participatory artworks
and through his active and popular lecture schedule, which continued
even after his dismissal from a sculpture professorial post at the univer-
sity in Dusseldorf. For Beuys, social sculpture meant that all of life is art
and every living being, an artist. He created sculptures that redefined the
physical boundaries of classical sculpture through performance, installation,
and participatory requirements. He symbolically used natural materials in
his artwork (e.g., honey to him represented the bees' natural sense of com-
munity, and gold, which indicated strength and connectivity with nature)
to display the earth's many organically communal phenomenon, as well
as the quite natural, for Beuys, need for a sense of universal community
among people (Mesch & Michely, 2007; Ray & Nisbet, 2001). Many of
his most famous works, such as the *Honey Pump*, required human interac-
tion to make them "work." Beuys (Beuys & Harlan, 2004) believed that
twentieth-century society was in need of reform and revival, and that the
growth of individual rebellion through art and creativity could positively
affect the perspective and spirit of individuals: "It is something that Beuys,
as well as others, like Bertolt Brecht, emphasized in different ways. Both
developed a range of strategies that seek to mobilize us internally, to dis-
rupt: to 'scratch on the imagination,' as Beuys often put it, enabling us to
become internally active and engaged" (Beuys & Harlan, 2004, p. x).

Public Art as Political Aid:
The Example of Rome

Camus (1942/ 1983, 1942/1988, 1951/1991) argued that in our post-
modern era, when it is so difficult to put one's faith entirely in either
science or religion, and when reason and justice have consistently failed

to guide decisions in the social and political sphere, the creative realm is the only truly free avenue to the evolving needs and desires that create a more genuinely engaged and more humane world. It is only natural that the transcendent and transformative powers of art need to be encouraged. Public and socially interactive art is the contemporary answer to the revitalization of the many comfortable individuals in America who may accept mass opinions into their lives as their own, rather than authentically seeking their own selves. Public art not only encourages liberation and empowerment within the viewer, but it also supports a public pride in the inviting appeal of the community landscape. The story of art and Ancient Rome is valuable to mention here as rich evidence that demonstrates the power and influence that public art can have when experienced actively and consistently by members of a community. Ancient Romans, on the whole, had a consistent and enthusiastic interest in public space, public life, and public debate; the public art of the empire tangibly succeeded in building a strong community that worked as a foundation to support the longevity of the ruling structure. There is a strong correlation between the community-building power of art and the political propaganda abilities of public art. Although it did serve several purposes simultaneously, in the Roman Empire, public art was primarily employed as propaganda to ensure the power—both physical and emotional—of the state and to achieve a politically unified community. It served the stability of the emperor, as art was used to send messages that displayed their wealth and importance to gain the support and ultimate subservience of the common Roman citizens.[12]

The example of Ancient Rome is an exemplar of the power of public art to create and nurture new feelings of community pride and cohesion within the individual consciousness. In most daily activities within the city, even today, attention to beauty and detail is a part of everyday, public life.[13] That the Romans, even today, readily affix their identities as citizens on a shared pride of the art and architecture that adorns the city cannot be simply the legacy of a representative government structure (the republic, did, after all, give way to a dictatorial empire with the ascent of Julius Caesar). The Roman Empire's public displays of art—many utilitarian, some grandiose—gave all Romans a sense of unity and pride, and these markers of the community, and of the city's past glory, are still very much a part of everyday life in Rome today.

Roman emperors understood well the power of images, and the effect they could bear on political rule. Thus, they put important images of their authority on coins and monuments. Images could be used as spiritual protection, as sources of humor, and as displays of political authority.

The Ancient Romans decorated with great attention, detail, and artistry their many tools of a generally active everyday life. The most utilitarian of objects, such as the front head of an olive oil or wine press, or the weights that hung on the ends of the scales used to measure out goods at the market, were made into unique images. They usually depicted women, men, and various divinities, rather than remain simple functional shapes. This level of artistry calls attention to the beauty and pride that can be seen in even the smallest public moments of everyday life (Stewart, 1993). These were not the scales of the emperors. They were the machines used in the daily lives of the common people to measure out grain and other household items at the many markets. Although it is likely that weights, for example, were made in these unique ways in order to prevent the possibility of cheating in trade, as simplistic uniform weights—like the ones commonly used in more recent centuries—could be labeled as a certain weight but then be secretly replaced with a weight that looked the same but was of a different value.

Beyond these material needs, the imagery on these common tools served a spiritual purpose as well. When the Romans's many gods were not directly depicted, it was often animals that represented a virtue, or a god. Like Athena's wise owl, or Diana's hunting dog, Apollo's shrewd eagle, or the wild and untamed panther next to Dionysus, the many gods are most often pictured with a symbol of their particular virtue or protective power. These commonplace religious symbols provided the protection or fidelity, or wisdom or strength, that gave the Roman people a feeling of either safety or excitement. Although coins were a part of earlier civilizations, like that of the Greeks and Mesopotamians, the Roman Empire was enormous in contrast, and thus the images (on the coins) traveled further (within the ever expanding empire) than ever before. If an emperor wanted to create a new era of rule, the old images of power were the first symbols of the previous rule to be destroyed. This was similarly the case with the fall of Soviet control in the countries of Central and Eastern Europe. It has been repeated throughout history that an empire, and simultaneously its ruling figure as well, have desired to create longevity and authority through the beauty and communicative power of images.

Another unique contribution of the Roman Empire to the history of Western art is their vast imperial theft and the resulting use of the "found" art to build conglomeration structures from their pirated collections. As victors abroad, the ancient Romans acquired from the foreign peoples some of the most beautiful and influential objects that represented their cultures and histories. At home, the conquerors displayed those works in grand public fashion. New acquisitions were exhibited in

central areas to create among citizens the felt perception of a strong and expanding empire—a still-developing cultural history. In addition, the epigraphic writing that adorned much of public art in Ancient Rome was able to reach a different sector of society than did traditional literature by adorning with messages of power, authority, and community spirit the most quotidian and communal of objects.[14] Epigraphs functioned in this way as a form of public communication within public art.

A very different time and place provides ample contrast. The Communist and Fascist regimes of the twentieth century encouraged a barren aesthetic that devalued not only public spaces, but also public life. The architecture designed and built under these regimes displays an aesthetic that was considered by many to be ugly (all sharp lines and boxes, little curvature and grace), as well as uncomfortable, and uninviting. It is a great paradox of Communism that its (at least initial philosophical) intentions of building community—of *socia*lism—were quickly lost through a lack of granting of political freedoms, as well as through the discouragement of the kinship of both public life and the human community. Today, 20 years after the fall of the Berlin Wall, the countries of the former USSR still suffer greatly from the lack of inviting public spaces. Parks, squares, and streets were severely neglected and allowed to become run down. Rather than nurture *socia*lism, these regimes managed to uphold one of the prime tenets of capitalist ideology—individualism. Under Communism, people consistently stayed home, and notions of public art and a pride in public culture (certainly closer both to what Marx [1844/1978] had in mind and Rousseau's [(1762/1993] desire for a "civil religion") remained largely unexplored. Those who resisted the ruling system, especially the organizers of the 1989 Velvet Revolutions in Central and Eastern Europe—which began with the Solidarity Movement in Poland, culminated in the destruction of the Berlin Wall, and ended with liberation from decades long occupation by the Soviet Union—had to do so through largely underground rebellion, and without open and exclusive control of the public sphere. The result was that "the public" became in many ways lifeless, and the spirit of the greater community, although in existence in private, was not present in the streets.

If we jump back to the example of the ancient Romans, we can see how art in the public encouraged an enthusiasm to be in the public. Citizens of the Roman Empire followed different religions, but all contributed to the public culture of Rome (Coulston & Dodge, 2000; Hibbert, 1988; Hintzen-Bohlen, 2008; Stambaugh, 1988). The love for public life and its traditions was encouraged by those in power as an essential part of state life. In looking to the culture of the Roman Empire, I am not stressing here their celebration of, and devoutness, to the state. This idea

that the use of art in the everyday public lives of citizens encouraged an interest in, and a love of, the public is a valuable corollary argument to the main one made here that artistic experience enables revolt from the rational status quo of everyday life and awakens a true independence of thought within the individual. Art by its nature enhances life, so even "mainstream" or redundant artworks that are present in our public spaces can bring stimulation. Public art projects can, and have historically, as can be seen even just from the existence of so many sculptures in public squares that honor fallen military heroes and honored heads of state, celebrate the leaders and practices of the ruling regime and the ruling culture. Still today, the majority of public artworks that critique and challenge established ideas are guerilla efforts by lone individuals, or smaller organizations and galleries, rather than well-financed projects. Art that is housed and experienced in our public spaces presents a great opportunity—it can freely access the public at large, in the midst of their daily lives, and put before them, or involve them, in challenging activities and dialogues.

So while all art in the public serves the good of a more vibrant public life, and the good of making more interesting our public spaces, that alone is often not enough to create a true connection to our empowered independent selves. This is illustrated well with the case of the Romans—public art was largely a monument to the state and to civic life, and it also served to create beauty, and in that beauty create an essential pride in the community, but most of the examples of Roman public art do not draw attention to inner struggles, joys, and taboos. (Although some do, that is the work of another project entirely.) Largely, Roman public art was a corollary of state life, and still today, it is a reminder of the great accomplishments, and the great artists, of Rome.

When I speak of visionary art, in the vein of Nietzsche, Camus, and Marcuse, I am speaking of artworks that search for emotions and knowledge beyond current and mainstream ideas and values, both within art history and, more importantly, in society and government. These creative ideas are the result of the independent exploration of thought that art provides through its ability to turn the mind inward, and to release some of our inhibitions and societal structures in order to feel and think free of the necessary constraints of civilization, and the confines of the popular will. This was certainly not the endeavor of the Romans in making art an important part of the celebration of the state, though the example of Rome demonstrates how strongly the presence of art in the public can change the way it feels to live within that city, and within that culture. Art that is created and displayed in the public sphere produces feelings of pride and inclusion. This is valuable in and of itself, but an increase in

visionary public artworks would enable many people to access an inner strength and an interest in the world, in their everyday lives.

Conclusions

Not unlike de Sade, or Rimbaud, or similarly Thoreau and Whitman in the American context, Camus (1951/1991) argued that true individual freedom could be awakened and encouraged through creative experience. He believed that rebellion begins with the urge for justice and human dignity. Camus, fearing the violent and power-hungry excesses of the twentieth century, maintained that the way to combat these injustices was willful individual revolt through creative feeling and expression, but he warned, successful revolution can become tyrannical, therefore defeating the original purpose of the rebellion. Accordingly, his concern is not necessarily about replacing an entire government system, but rather that the rebels seek both true freedom and a perspective that balances the needs of justice with the needs of compassion.

All healthy societies need the wisdom of instinct, of nature, and of true freedom. Involvement with art creates the desire and the ability to rebel. Camus explains the link between experiencing true individual freedom through art, and the consequent empowerment, and healthy self-awareness that develops in the individual. Once this link is established, it becomes clear that people who have become more "free," who have reexamined societal ideas, become empowered by their newly found individual will. They then are inspired to participate in the collective beliefs of society, the same values of the popular will that they once swallowed whole. Camus believed that we are perpetually faced with the absurd search for meaning in our own existence. This quest inevitably fails, for there can be no "objective meaning" that we somehow have to discover. So it is absurd to continue to search in vain rather than approach our existence from the perspective of concrete experiences.

Some who are rationally or materially focused often disapprove of others' affection for philosophy, and for poetry. Instead, they encourage action, because they claim that philosophy is the antithesis of action. Marx (Thesis XI, Theses on Feuerbach, 1845/1978) said that the philosophers had only interpreted the world, and now it was time to change it. But it is too simplistic for us to believe that action is simply the opposite of thought. Camus (1951/1991) said that life moves too fast and encompasses too much for it to ever be captured by any single act of creation. Reality exists only in perpetual description, thus demonstrating that even the most exciting advances in science cannot capture the constantly changing character of human emotional and spiritual existence.

Camus reminds us that all creation is a choice, a cropping of the full picture. This is particularly true in action, whose sheer physicality constrains it to borders and limits set by space and time. It is when we read and write—to escape, to learn, and to process—that we can attempt (if only as an illusion) to transcend the often rigid borders of action in favor of traversing the streaming river of history and fantasy, of desires and dreams.

Camus determined the division between revolution and rebellion to be that between a mere shift in institutional structure and values and the almost anarchic (though still with inherent limits of the dialectic between instinct and order) individual freedom. This is the difference between merely redesigning and replanting assigned truth(s) and absolute values in a new home or system and the growth of true freedom through individual creative thought and action.

> The rebel is not someone who always says no; he or she is someone who always can say no, and who knows this. And a rebellious politics is a politics that is alive to this possibility, that remains tolerant and open to dissent and insurgency, offering manifold opportunities for the revision and reconstitution of social life.[15] Yet at the same time a rebellious politics is self-limiting; rebellious political agency acknowledges its own partiality and provisionality and proceeds with caution, anticipating the opinions, objections, and even opposition of those others with whom the world is shared. It is this ethos of openness, this refusal to privilege existing conventions, rather than any particular institutional arrangement or electoral procedure, that makes rebellious politics supremely democratic. (Isaac, 1992, pp. 141–142)

Revolution performs a lobotomy on a ruling system and fashions a transplant of its insides from the very material of the system to be replaced (the new, however new is defined in terms of its comparison to the old); this is a case of institutions succeeding institutions. Rebellion, very differently, has to do with the creation of new horizons for the mind—the formulation of a new individualism based in the spiritual collective. In accessing and re-bringing to life particularly deeply felt emotions for the world to experience, artists seek to express the unity of the whole or the universal. This is why a good book or an affecting sculpture or painting "extracts…the tentative trembling symbols of human unity" (Camus, 1951/1991, p. 267). In doing so, it moves us, creates empathetic emotion and transcendent reasoning (if this is really reasoning at all, but yet is something beyond instinct). In the perpetual crisis of our existence, in our unrelenting (even unselfconscious) desire for order and meaning where there is none, the recognition of similarity—of our features and desires

in another, in all others—in these glimpses of unity, we find at least momentary refuge from the confusion and meaninglessness of everyday and philosophical life. In a world without meaning, human unity (and unity with Nature and the inanimate too) provides great meaning. Not that spiritual unity can fully give us the order we crave (so perhaps this whole notion of meaning is suspect); but it creates conditions whereby we can look at our reflection in a mirror and see the whole world staring back at us.

It is silly, and beside the point, to attempt to separate thought and action, or to prove one's value over the other. Although each of these two realms of life has its own space and purpose, their simultaneous tension, and affinity for one another, keep them as two halves of a whole. Without visionary or rebellious thought, there cannot be visionary action. Action is what keeps us alive, makes us animal, allowing us to glimpse the purely emotive. It is as vital as breathing. Still, a life of pure action (particularly a life that aims to change and transform through action—a "political" life in the truest sense) leaves us tired and worn, unable to sense, anticipate, and alter the future. Rimbaud's (1869–1891/1975) "visionary" artist (Nietzsche [1872/1967], too, says this) balances the irrationality of Dionysian with Apollonian reason. We must process our instinct to give it strength and longevity. It was in writing about his experiences that Rimbaud became a visionary. To lose oneself entirely in thought and in the ordered reflections of the written word is as undesirable as living a dissolute, drunken existence. And perhaps here I contradict myself, or draw a circle with my words, but it is also true that there is action in thought, action in the act of writing, even in reading another's writing. The distinction between the two need not be drawn too deeply; it should be a dance, not a battleground. Action encourages us to think, and reflection encourages us to act.

CHAPTER 4

VISIONARY ARTISTIC REBELLION: RIMBAUD, DE SADE, AND THE PROGRESSION FROM CHAOTIC CREATION TO CONSCIOUS PARTICIPATION

His body! the dreamed-of liberation, the collapse of grace joined with new violence!
All that he sees! all the ancient kneelings and the penalties canceled as he passes by.

Arthur Rimbaud, *The Genie*

Ever since Socrates and Plato (Ferrari, 2000) first proclaimed their fear of the ability of visionary art to expand the imagination, and declared the threat it posed to order, politics, and, accordingly, to Plato's ideal republic, Western philosophical thought has struggled with the balance between these two realms of life.[1] In the modern era, Rousseau (1750/1993) and others have echoed Plato's view that art can be destructive to politics. The Romantic tradition formed in reaction to the domination in modern culture of a viewpoint that favored order as the ultimate goal. The dominant belief was that this goal could be reached only through the reason and science that the Enlightenment Movement and the French Revolution had brought to the forefront of modern intellectual and moral life. Provocative thinkers like Rimbaud and de Sade presented a clear need for individuals to confront their irrational selves. They argued that our instinctual emotions and desires are a source of important knowledge, both about ourselves and about society. They both recognized that many experiences can never be fully explained or understood through reason. Only by denying the language of reason can we become truly free. Without the constraints of the inherent order and limited vocabulary of reason, experiences can be felt with abandon, rather than understood with the tools of our societal-based learned rationality. This chapter explores the value of knowledge borne of the instinctual

and the sensual, as well as argues for the value of providing more access to such creative knowledge.

Art, I have been arguing, continues, and should actively be supported in this, to move out of its assigned spaces of museums, galleries, symphony halls, and theaters, in order to inject its knowledge into the public spaces of our everyday lives. There are at least two primary considerations in this task. First, an expanded definition of visionary art holds that it is the product of the dialectical relationship between sensuousness and rationality. The core spirit of rebellious art consists in a dialogue between our emotions and senses, on one side, and reason and reflection, on the other. Second, are the characteristics of "visionary" art and its potential as a transcendent force within individuals and as a progressive force in society. The general acceptance of mass opinion, and of popularly supported accounts of experiences, prevents rather than enables vital knowledge of human universality and vulnerability. The recognition of a whole universe of which we are but one part is necessary to the desire to participate in community and in politics because it alerts us to our own susceptibility to a variety of human ills and reminds us that those dangers are common to all.

In the creation of art, the intention, and the process of reflection that the artist experiences, is equal in importance, if not more so, to the aesthetic result. To look only at the end product of artistic expression is to miss the emotions and intentions that lie in the complex web of intersecting gazes involved in any artistic interaction. Art is not merely a material end product of creativity and skilled craft; it is also not simply that which is aesthetically pleasing or entertaining. These are two connected but distinct points. The first regards the importance of the artistic process (versus the result), beginning with the idea. The second refers to the transcendent properties of art and hints at the societal dangers of mainstream art. What connects these two points is the role of ideas and imagination in art-making.

Much of Plato's (Ferrari, 2000) philosophy focused on the difference between appearance and reality. He felt that all art was appearance and provided escapism from the reality of reason and knowledge, and thus also from politics. Among his many differences with Plato, Aristotle (1996) believed that art can serve a healthy function in society as a unique, and thus valuable, form for the expression of ideas and emotions about everyday realities. This classic debate on the value of art in society has been elaborated by many thinkers in modernist conceptions of the aesthetic as the beautiful (Novalis, 1798/1997; Schiller, 1794/2004), and then the sublimely transcendent, and in postmodernism's confrontation with this understanding of aesthetics, keeping in mind the constraints and

challenges of late capitalism. Historically, art has thus moved from highly mimetic or realist forms to increasingly impressionistic and abstract ones. In general terms, postmodern art movements have employed ideas of flux and impermanence, language and dialogue, interaction with the spectator, transformation of the found into art, and both the process of art and the ideas behind the art presented as the art itself.

The notion that the process of creation, and even the initial idea that spurred the creation, is valuable in itself is important to our overarching argument that public and social art, in its freedom from institutional constraints, can readily experiment with a variety of directly political, and indirectly inspirational conceptual works, using language, emotion, human interaction, sounds, sights, and smells. Public and social art in this country could be more strongly encouraged and made available, so it could serve as a positive force against a lack of community and participation. The expansion of individual, and collective, imagination—the ability to envision change and progress beyond the status quo—and the increased importance in society and political life of artistic knowledge and experience will encourage people to participate, to become more actively involved in their own everyday decisions and in the greater questions of humanity. The most direct way to create this expansion is through democratic and frequent access to the benefits of artistic experience. If art and creativity could create and maintain a stronger presence on our streets, and in our public squares, it would enable individual engagement in new and challenging ideas that explore sublimated ideas, and collapse accepted norms and misleading conceptions of difference among people. This inner reflection will lead to an interest in one's community and eventually to a desire and willingness to participate in the development of that community. Art on the streets is inherently more easily less restrained and more experimental than the often better-known work that is presented within the walls of our brick and mortar institutions of art. This public creation can be material, performative, or in the form of an idea expressed through dialogue or an interactive process. It is not necessarily its beauty or its physicality that makes the difference but, rather, its ability to disrupt, to engage, and to invert or to subvert everyday perceptions and limitations. Public art, and especially innovative and visionary projects, can and should employ their less regulated boundaries in their ability to be experimental and critical.

The Historical Progression of Art

The history of Western art has evolved along a particular narrative that can be roughly divided into three main eras of approaches to art-making

(Danto, 1983). Danto locates the beginning of this story in the fifteenth century, when art was understood as the beautiful and as direct copy, the second major period being the modern period of experimentation. The culmination of this long development is the postmodern era, when craft and popular media joined with the traditional fine arts, and it became more difficult to see the difference between "art" and "nonart." Although Danto does note that art (versus nonart) must hold and exemplify meaning, in this brave new world where art becomes primarily about philosophy, creative pluralism is the dominant credo. He does not imply that there is not plentiful worthy art being created, just that the art is being formed within less stringent philosophical and social boundaries with each year that passes. Found art, process art, pop art, mail art, and other forms of conceptual art exemplify art as philosophy.

In Danto's Hegelian framework,[2] the history of art is a teleological endeavor that develops and expands until it reaches its ultimate goal and becomes itself—until it is a philosophy. According to Danto's understanding, art and art history "died" or "ended" in the mid-1960s with the advent of conceptual and pop art. According to the conceptual movement's focus on the process and ideas within art, art could be virtually anything and could be created anywhere. Danto argues that the avant-garde in art was always seeking to invent and create the new and unexpected and that, once art had become even the process, and the idea, and the words involved in creation, and once it became clear in the 1960s that avant-garde art had become its philosophical end, it in a way then stopped growing and "ended." A primary belief behind the writing of this book is not only a belief that art is not in fact "dead," but also that by its very nature, it could never die. Art is not merely a material artifact, but rather the arena of a pushing of boundaries—creative, emotional, and political. So long as human beings question existence itself, popular beliefs, and traditional mediums, art will live and reinvent our imaginations endlessly. Still, Danto's analysis reminds us of the big picture of the progression of artistic approaches, and alongside it, the progression of humanity itself.

Danto adds that art always exists in relation to its interpretation (Houkema, 1998). Further, he writes that "we live at a moment when it is clear that art can be made of anything, and where there is no mark through which works of art can be perceptually different from the most ordinary objects" (Danto, 1998b, p. 139). This observation of the contemporary art world—that of two objects ostensibly the same in every way, one can be art and the other not—led Danto (1987) to the conclusion that the task for the philosopher of art is to identify differences between works of art and "real things" (p. 64). An object is art when the art is intertwined with

the art's (or artist's) meaning: "Craftwork is art when it is about what it embodies" (Danto, 1988b, p. 137). In other words, there must be creative self-consciousness in artistic creation. Contemporary art, in its newest endeavors and particularly in the desire to be socially interactive and public, has moved away from a focus on the material end result and toward an appreciation of the idea behind the artwork, the process of creation, and the interaction between artist and observer, and between participants. As it is more difficult to preserve and care for an object of art when it is out on the street and susceptible to crowds and poor weather, street artists employ a wide variety of conceptual and sensual tools and artistic elements that create atmosphere, sensuous experience, and critical thought. Their avant-garde methods can remain free from societal assimilation longer than artistic methods that are created with institutions and specific authorities or platforms in mind.

The Dionysian Literary Point of View

Two very different, but equally rebellious and infamous artists in late eighteenth- and nineteenth-century France, are examples of modern men who expressed the raw emotions of the Dionysian realm, both in their lives and in their words, but ultimately needed the balance of reason and reflection to achieve their desire for true freedom and lasting relevance. The libertine Marquis de Sade[3] promoted an antisocietal viewpoint that favored an individually determined and unrestrained morality, where man obeyed the law according to his "ability." The other, the young French poet Arthur Rimbaud,[4] exhausted himself seeking the truths of the modern age through the expression of unrestrained passion and experience. Both pursued sensation above all; de Sade lived his philosophy that pleasure can be pain (pain as knowledge) and that one can have (and live by) art in place of authority, and Rimbaud fully submitted his being to his self-motivated project of feeling and experiencing all the pain and beauty of the world and savoring from all experiences that is universal. These two artists staked a place for the role of the *anti* in modern life. The antipolitical tradition of the modern age was anti-community in the traditional sense of community-building—through struggle, man naturally adapts to life in a stable and safe civil society. Writers like de Sade and Rimbaud demonstrated the need to understand people as antisocial individuals. These authors believed that the project of bringing the individual, the body, and empiricist understandings of life back into modern society, with all its ability to frighten and confuse, is necessary if we are to get in touch with our own sublimated passions and thus with our natural universal relations to one another.

As Rimbaud described, to live artistically is to believe in the importance of the knowledge that is attained through instinctual and sensuous experience (1869–1891/1975). His personal revolt is not a surprise when seen in the context of the Romantic Movement, whose proponents attacked the Enlightenment because they felt that the mechanical and objective nature of Enlightenment thought stifled creativity, imagination, and spontaneity. At this time then, art and reason were necessarily on opposite sides of the spectrum. To fight against the virtue-and reason-obsessed philosophies (including those of Rousseau and Voltaire), it was necessary to bring the realm of the imagination to prominence. This meant that there was no room for compromise; instead, the brightest few believed they had to ignore the voice of reason as much as possible and live through the passions alone. True Dionysian release transcends the ordinary and creates some change within the individual immediately. Despite this important release, without the reflective "visionary" consciousness, self-destructive behavior may take the place of visionary "research" where the "quintessences" of life's many experiences are not properly savored or used to transcend the status quo of the time. Both Rousseau, a philosopher, and Rimbaud, a notorious libertine, were searching for revolutionary answers to the most essential concerns of human existence; this quest naturally employs some dialectical combination of imagination and reflection.

The Public Value of De Sade's Private Creation

Louis-Alphonse-Donatien[5] de Sade, better known as the Marquis de Sade, known for his libertine novels and his similarly libertine lifestyle, holds a rightful and pivotal place in the history of post- (or counter-) Enlightenment modernity. Although his detailed descriptions of violent sexual acts and bloody mutilations gave rise to his infamous reputation, de Sade was very much a visionary for his time. His *Philosophy in the Bedroom (La Philosophiedans la Boudoir)* (1795/1990) is a story of the sexual education of a bourgeois girl, as well as one about transgressing the morals of society, and the relationship of such transgression to violent revolutionary action. The role of the articulate and aggressive sexual educator, Dolmancé, and Rimbaud's (1869–1891/1975) notion of the poet visionary (poets are born, visionaries are created) show how transgression creates the leaders of the creative and societal avant-garde. Both thinkers understood the need for visionary artists who create art of and for the future, and seek answers to the modern age's great questions through the elements of art (unguarded passions, instinctual and sensuous experience), rather than through the tools of reason and science. Hegel (1807/1977) argued that reason constantly evolves dialectically toward a goal, but art

is best not characterized as goal oriented. Instead, we could say that art is experience oriented, sensory, and spiritual.

De Sade was primarily an artist, not a philosopher, who infamously claimed that some choose suffering because pain can be a form of knowledge (de Sade, 1795/1990). De Sade, writing almost a century before Nietzsche (1886/1989), envisioned a society where morality was understood on an individual basis, where all private and public action was "beyond good and evil." He used frequent images of sodomy, homosexuality, and other taboos of the time, to invert societal mores. The young girl's mother in the story of "Genie," whose rape and mutilation ends the story, is representative of societal rules and authority—the obstacle to natural passions and urges that is mainstream culture and the dominance of reason. Existentialist philosopher Simone De Beauvoir (Beauvoir, 1953/1962) noted that de Sade "chooses imagination," which he used as agency for both liberation and revolution. "In order to escape the conflicts of existence, we take refuge in a universe of appearances, and existence itself escapes us" (p. 80). This statement seems to echo Rousseau's (1750/1993) worry that the arts and sciences, through both university curricula and mainstream art like popular opera productions, had created a universe of mere appearances unaided by the Dionysian experiences of truly living life, of *living art*. For de Sade, the physical—the body—was crucial to inner discovery, and to good art, but was often unknown territory in societal life. Beauvoir reminded us that "to sympathize with de Sade too readily is to betray him. For it is our misery, subjection and death that he desires...what he demands is that...one engage himself concretely in the name of his own existence" (p. 79).

De Sade created a philosophy of extreme individual self-interest as the true expression of freedom. He believed that morality and religion (that of both monarchy and the Catholic Church), along with empathy and ideas of human unity, were all societal constructs that worked only to limit our expression of self-interested desires. De Sade believed, too, that society was in need of the knowledge and expression of true freedom. He argued that man should naturally allow the freedom of nature to provoke him, rather than to conform to the rules and values of our false gods. He encouraged the experience of pain and suffering for the very reason that society is constructed to ameliorate our discomforts and injustices. He endeavored to feel and understand the ideas and experiences that society had collectedly banned. It is possible, though, that, as was the case with the philosophy of the American Transcendentalists, this extreme individualism is only the first step—in the withdrawal from society. The second step is to relearn our relationship to society. In so doing, we can access and understand a truly free connection to ourselves, to others, and to Nature.

De Sade (1795/1990) examined everything under the "torch of reason" (p. 126). He still employed reason in his discussions and adamant defense of the self-creation of morals and of an evolving and malleable justice system. In other words, he used reason—the very tool of society that he challenged—to formulate an argument that encourages experience with our instinctual and creative selves. Unlike Hobbes (1651/2009), who tried to restrain what he also saw as our inherent and dangerous human passions, de Sade (1795/1990) freed them and worked to justify their existence and importance, even within the constraints of institutionalized justice: "[M]an receives sensations from nature" while, de Sade said, law is always naturally in opposition to nature. He continued, "[N]ot having the same motives [nature and the law], it cannot have the same rights" (p. 126). "[I]t would be a palpable absurdity to wish to prescribe universal laws; it would be like the ludicrous procedure of a general who dressed all his soldiers in uniforms of the same size; it is a fearful injustice to expect men of different temperament to bow to the same laws" (p. 125). Here we can see that de Sade's philosophy confronts and dismisses the possibility of a natural law, is fundamentally antipolitical, and thus inherently opposed to the necessity of a Rousseauian notion of a "general will."

Pierre Klossowski (1947/1991)[6] argues that there is an interrelationship, though a distinction, between writing about the sensuous and actually experiencing it. Klossowski says that, for de Sade, once we write about an emotion or an action, we are unable merely to be descriptive, as we are already interpreting that emotion or action. In this way, sensuousness can exist only in the initial emotion or act. "For de Sade the fact the sensing, the irreducible element in perversion, does not have to be justified. It is the aberrant act issuing from sensuous nature that de Sade wishes to moralize" (p. 17). According to de Sade, we experience the aberrant when we cannot locate reason. He asserted that the aberrant is within all humans, and Klossowski makes the point that de Sade was attempting to understand and defend the aberrant by using the dominant framework of reason. George Bataille (cited in Allison, Roberts, & Weiss, 2006) writes that some critical assessments of de Sade's ideas believed that the "brilliant and suffocating value he wanted to give human existence is inconceivable outside of fiction; that only poetry, exempt from all practical applications, permits one to have at his disposal, to a certain extent, the brilliance and suffocation that the Marquis de Sade tried so indecently to provoke" (p. 19).

Maurice Blanchot (1949/2004)[7] wrote that de Sade's philosophy was one of simple self-interest. In other words, de Sade failed to experience empathy and connection with others, and was thus concerned only with his own pleasure and pain. Blanchot said that de Sade criticized both

the focus on reason and the focus on equality, which the Enlightenment had introduced, and that this revealed itself in de Sade's peculiar understanding of natural human equality. It was de Sade's claim that, because all humans are equal, no one has to help another person to have to help others (p. 10). De Sade's aggressive form of free will was a philosophy of strong visionary leaders. He believed that the powerful few could rise above society values and fulfill only their own needs and desires (p. 12). Blanchot agreed with Klossowski that de Sade employed an evil form of reason that displayed aggressive human instincts. De Sade's reasoning can also be seen here as a response to the sort of argument that Sartre makes, that one must be actively participatory in order to be committed to a political life, by which one who does not speak out to help others is essentially helping to hurt them.

Rimbaud as Dionysian Rebel

The sensuous verse of the avant-garde poets of nineteenth-century France, Charles Baudelaire and then Arthur Rimbaud and Paul Verlaine, rose from the ashes of the revolution in France, and the Enlightenment triumph of science over the church, to develop a style of poetry that leaps from one sharp sensuously detailed image to the next, often from one line to the next. Although he wrote poetry only for five years and had given it up by age 21, Rimbaud made famous this style of tactile free verse. His details were more vivid, more colorful, more sensual, and more grotesque than those of Baudelaire and even Verlaine. This "chains of images" style also worked as a linguistic device that paralleled the rapidly changing raw experience of his life, physically and emotionally. But Rimbaud really becomes vital to the story of the modern age in those lines and in those poems where he speaks of revolutionary praxis and of the liberating powers of art.

Edmund White (2008)[8] recently published a relatively short and footnote-less biography of Rimbaud. Focusing primarily on Rimbaud's personal life and on Rimbaud's art-and violence-fueled relationship with the poet Paul Verlaine, White concludes that Rimbaud's artistic experiments with antisocial and chaotic behavior, though ultimately destructive, inspired Verlaine to new poetic freedom and genius. Quite different in his approach, Neal Oxenhandler (2009) has examined Rimbaud's life and philosophy through a detailed examination of his poems. Oxenhandler successfully weaves literary analysis with historical events in Rimbaud's life, against the philosophical backdrop of modernism.

Similar to Sartre's (1937/1960) concept of the prereflective versus the reflective self, Oxenhandler's claim is that Rimbaud viewed reason as

necessary, but mechanical and not entirely reflective of our experien-
tial life: "[This] ubiquitous reason distances the speaker from the here
and now of his engagement" (p. 53). He points out that Rimbaud's
(1869–1891/1975) language in his poem "A Une Raison / To A Reason"
(one of the *Illuminations*) is more structured and less "informal or free"
(p. 53). Further, Oxenhandler postulates that it is no coincidence that
Rimbaud began to admire reason some time after his many poetically
documented experiments with rebellious freedom had likely already
begun to wear thin: "'A Une Raison' seems to mark—inauspiciously—
the midpoint in the rise and fall of Rimbaud's career" (p. 53).

Oxenhandler examines Rimbaud's interpretation of the idea of
reason:

> This poem is the drumbeat of rationalism in the service of the right action,
> a use of cognition that attracted Rimbaud, despite the deep currents of
> irrationality that stirred so powerfully in him and inspired his greatest
> poetry. The rationality of this poem is primarily political, since the pro-
> posed use of reason leads to "des nouveaux hommes / new men" and their
> "nouvel amour / new love." Reason is the faculty in us that connects us
> to an order of things in the universe, which itself can be called rational.
> (pp. 52–53)

That extract shows Rimbaud's awareness to create political change he
needed to apprehend, and even befriend, reason. It was the combination
of rationality and irrationality that created the visionary and produced a
new way of observing and understanding our world.

In a letter dated May 13, 1871, to his former teacher, Georges Izambard,
Rimbaud (1869–1891/1975) described his theory of the visionary:

> A Poet makes himself a visionary through a long, boundless, and sys-
> tematized *disorganization of all the senses*. All forms of love, of suffering, of
> madness; he searches himself, he exhausts within himself all poisons and
> preserves their quintessences. Unspeakable torment, where he will need
> the greatest faith, superhuman strength, where he becomes among all men
> the great invalid, the great criminal, the great accursed—and the Supreme
> Scientist! For he attains the *unknown*! (p. 102)

Rimbaud seems to have understood that the visionary is a univer-
sal figure: "[S]o Baudelaire is the first visionary, the king of poets, *a
real God.*...[but] the inventions of the unknown demand new forms"
(p. 104). The visionary transcends the times, and in so doing serves
a particular role in revolutionary change. Visionaries always seek to
change their conditions to propel history forward, not necessarily toward

a teleological endpoint, but to new discoveries and rebirth. Rimbaud wrote of the inception of his own transcendent journey: "Right now I'm depraving myself as much as I can. Why? I want to be a poet, and I am working to make myself a *visionary*" (p. 100).

In the poem "Tale," about a prince who has become discontent with his stable and peaceful status quo life, Rimbaud wrote, "He desired to see the Truth, the time of essential desire/ and satisfaction....Is ecstasy possible in destruction?/ Can one grow young in cruelty?" (p. 157).These lines point to Rimbaud's belief in a "truth" that liberates man as well as to his Faustian idea of creation and destruction as one, which explored pain as a potentially redemptive source of knowledge, similar to the experimentations of de Sade. These hopeful early lines led to poetry that screams revolutionary ecstasy. Included in this collection is the poem "Democracy," its entirety a fiery battle cry. Rimbaud describes the greed and exploitation of modern industry and the military, and then proclaims the manifesto for the antipolitical, antireason tradition:

> Good-bye here, anywhere.
> Enlisted with good will, we will have a fierce philosophy;
> ignorant of science, spoilt by pleasures, the flat-tire of a
> world that advances.
> This is the real march.[9] Forward, on the road! (Rimbaud, 2011)[10]

In *Second Delirium: An Alchemy of Words*, after five difficult but exciting years, Rimbaud bids farewell to his poetry and to his life of art. He explains that his mind has "turned sour." The poet is by this point in his life feeling weak—physically and emotionally spent—and disillusioned from his self-imposed journey of magic and discovery, two words he often used to describe his youth, the time of his quest to become a visionary. He sings the praises of a life of happiness, not pain, and of science, not art. "A Song from the Highest Tower" is an impassioned combination of traditional verse poetry with prose poetry. In the part sometimes viewed as a separate poem, called "Hunger," as if to emulate the chorus-verse-chorus structure of the piece, the poet sings to his newfound (or refound) home in reason and stability: "Finally O reason, O happiness, I cleared from the sky the blue which is darkness." Further along in the poem, though, Rimbaud seems to remember what he is now claiming to be leaving behind and calls for attention to the senses and to our passions: "You must set yourself free/ from the striving of Man/ And the applause of the world!/ You must fly as you can.... The fire within you,/ Is our whole duty—/ But no one remembers" (pp. 207–208).

Rimbaud here seems an old man, tired and worn, a refugee from a sort of thrilling war that has taught him a love of peace. In the late letters, his sarcasm erratically plays with his semi-madness. It is not quite clear what he means when Rimbaud announces suddenly that "[he] will become involved in politics. Saved" (p. 195).

Marx, Rousseau, and the Problem with Mainstream Art

The philosophies of de Sade and Rimbaud call for a rebellion from the social and moral restrictions of society through a connection with the disorder of instinct and sensuousness, rather than the prevailing reliance on reason and order.[11] It is interesting to consider the rebellious ideas of these two artists alongside the work of Rousseau and Marx. Although the work that Rousseau and Marx are most famous for in the Western canon does not directly concern rebellion through creativity, all of these philosophers were keenly aware of the difference between a visionary—liberated and innovative, and a mainstream—redundant and alienating,[12] artistic experience. Although all art in its very creation is a negation, or a distortion, of the given reality, this distinction between visionary and mainstream art is the difference between art that challenges the ruling ideas and rituals of society and art that is in the service of the sublimated passions of the status quo. Rousseau (1762/1993) criticized mainstream artistic endeavors for their acquiescence to the order and morality of popular culture, whereas Marx (1844/1978) differentiated between alienating experiences and healthy self-unifying ones that capture and encourage universal human connection.

Marx (1844/1978) defined "species being," as the feeling or knowledge of human unity that needs to be accessed to subvert the alienation of modern man. He described how the men who labored in the factories of modern industrial Europe had, in becoming alienated from themselves and from the objects they produced for others' use each day, become estranged from their natural but latent feeling and knowledge of universal unity with all humans. "Man is a species being...not only because he treats himself as the actual, living species; because he treats himself as a *universal* and therefore a free being" (p. 75). For Marx, species being was a vision of a world without property and capital, where the unity and wholeness of the community of man could be acknowledged and appreciated. He argued that it is not merely economics that creates alienation, but rather the conformity and complacency that is bred by the conditions of everyday life in contemporary American democracy. It is not merely species being of which we could make a goal, but also Rousseau's (1750/1993) idea of "empathy" and Emerson's theory of "oneness." All

these philosophical ideas point to the same conclusion: that a feeling of universal human community among individuals is not only valid and in need of renewal, but is also a key to solving the lack of participation in American public and political life. The ever-growing individualism among Americans needs to be balanced by more frequent interactions with visionary art, which fosters feelings of community and genuine interest in the public domain and in civic involvement.

Danto (1998b) writes:

> Hegel, thinking of philosophy as the domain of thought and art the domain of sensation, was obliged to think that art had come to an end when it became suffused with critical thought about itself. The sharp division between thought and sensation is pure Romanticism...art has in its own right become part of art's own reflection on itself. (p. 136)

The stark division between experience and reflection is a misleading characterization of human experience—as Danto argues, a misleading description of postmodernity or "after the end of art." Whereas experience by sensation is vastly different from experience by reason, art, and in particular postmodern art, joins the two realms. But instead of using reason to progress, one can employ art, or rather *be* art, to transcend. To be art is to accumulate experience without regard for moral convention or societal taboos, not to mention experience often without regard for one's own health and safety. It is to face pain; not always to create pleasure, safety, self-sustainability, the "good." To live art can be scary and difficult and often, when truly accepted, debilitating. Nonetheless, art can enlighten and reveal; it can transcend the ages and can be the catalyst for change and progress in society—the very society from which it seeks to separate itself. Art can lead us to vital and latent truths and can inspire a change in consciousness. Artistic experience leads to a reawakening of "species being"; people become not only self-aware, but also gain the potential to be connected to all others in the species and to recognize their interdependence. For Marx, it was through the alienation of labor that species being was lost for the individual, and it is through revolution (and the end of the alienation of labor) that it can be found again.

In the "Discourse on Arts and Sciences," Rousseau (1750/1993) expressed a two-pronged problem with modernity: the effects of capitalism (for Rousseau, property) on society and on our morality, and the effects of a *realpolitik* theory of governance on modern politics. Rousseau lamented that "the politicians of the ancient world were always talking of morals and virtue; ours speak of nothing but commerce and money" (p. 17). In part two of this discourse, although disdainful of and sarcastic

about both the role and the content of art in mainstream bourgeois life, Rousseau still acknowledged the importance (he said "genius") of true or transcendent art. By that very definition, he was speaking of art that is not "of its age" (it looks forward) and even specifically said that a true artist of this sort must live in poverty and struggle and should only be recognized after his death. "It is only those who feel themselves able to walk alone in their footsteps and to outstrip them. It belongs only to these few[13] to raise monuments to the glory of the human understanding" (p. 27). He cited even the great writer and fellow Enlightenment intellectual Voltaire (the two did not get along) as being guilty of censoring his own words to please the masses. This accusation is interesting in the context of his theory, not only because of his allowances for "genius" even in an essay that is a polemic against art, but also because Rousseau importantly targeted and articulated the universal problem of the repressive nature of the mainstream. In Danto's (1998b) words: "[Art becomes] an object rather than a medium through which a higher reality made itself present" (p. 130).

In Rousseau's time, the foundations of capitalism and advanced industry, and the culture that accompanied them, created a whole realm of normalizing distractions in entertainment, academia, and bureaucratic institutions. Rousseau wrote of the "end of art," or at least of the end of a mainstream appreciation for "virtuous" art. He maintained that the theaters and galleries of eighteenth-century Paris had done little more than sedate the bourgeois population into complacency. For him, art that merely entertains simply appeases the masses, and is in this sense anticitizenship (which is likewise antirevolutionary). True citizenship, according to Rousseau, requires the ability to sustain enough of a sense of universality, and to transcend and pull far enough away from the pragmatism and conformity of society, to be able to question our everyday existence and society's established rules. Status quo art (and music and poetry and even philosophy) functions in society much as big-screen televisions and oversized SUVs do—as material distractions from our species being (Marx, 1844/1978), or our natural compassion or "pity" (Rousseau, 1762/1993), and as accepted normalizing and disciplining (Foucault, 1991) forces that maintain antirevolutionary order. All these issues go far to keep the masses happy and distracted, not only from society's ills but also from the true community of man. "As the conveniences of life increase, as the arts are brought to perfection and luxury spreads, true courage flags, military virtues disappear; and all this is the effect of the sciences and of those arts which are exercised in the privacy of man's dwellings" (Rousseau, 1762/1993, p. 20).

Rousseau is often cited as the intellectual forefather of the Romantic Movement, and his many references to the lost virtues of honor and courage are a testament to this claim. But that he used such terms to show

how appreciation for community and public citizenship had given way to private, insulating, and ultimately "meaningless" luxuries, his call to arms against the conventional arts and sciences is relevant to the present day. With the masses satisfied and entertained, most of society remains staunchly in the mainstream. Mainstream art is one of the elements that the Establishment uses so that society can continue to build the very system that oppresses them (Marx's, 1844/1978, idea of false consciousness). Visionary art is a way to bring the mentality of everyday revolutionary praxis into the lives of many. It is not impossible that its rebellious rearrangements could eventually incite physical and violent social revolution, but, more importantly and more commonly, it can begin the project of changing or "enlightening" individual social and political consciousness.

Conclusions

The Modern age was certainly industrious; it not only quickly gave birth to radical philosophical departures like liberalism and democracy, but it also fostered significant reactionary ideas that threatened the newly established status quo. Rousseau was one of the first of the Modern era to point out not only that there is a difference between transcendent art and mainstream art, but also that there is special importance in history for the role of the visionary artist. While Rousseau remained convinced that the visionaries of his age were the founders of scientific rationalism, who largely marked the dawn of the Modern era, he acknowledged that there are such "geniuses" for every age. Calling on his readers to revolt against the arts and sciences, he depicted a societal condition from which there was no escape except through revolution. His was a revolt of simplicity, pragmatism, and citizenship against the culture of wealth, decadence, and self-absorption that the bourgeois class exemplified. Ordinary readers of his discourse on the evil of the arts would perhaps reflect on their own "alienation" in the culture of mainstream life. In much the same way, a citizen of nineteenth-century France who came across the novels of the Marquis de Sade or the poems of Arthur Rimbaud might be incited to attack the monarchy or members of the bourgeoisie or the many symbols of moral convention—the whole society.

Now, in the twenty-first century, what is most striking about the relationship between art and politics is the speed with which the current Establishment is able to embrace visionary art and dilute it for the masses, until it is more easily digestible through known mainstream concepts. This sucks from it its potentially revolutionary and raw emotional power until it is a hollow shell of its transcendent former incarnation. This path

of popular assimilation, now moving at increasing speeds to match the increasing levels of mechanization and globalization, can create almost immediate turnover of new and rebellious ideas. The struggle to be an artist "beyond one's own age" (to be a visionary) has become, paradoxically, both easier and more fruitless—easier, because an "age" is now far shorter than it was during the time of the Enlightenment in Europe (time seems to pass more quickly and, with it, art too). Yet looking forward has become more difficult and at times even futile. Visionary artists struggle against the antispecies-being component of the Establishment, rather than directly against material conditions. Even if the Establishment were to become entirely in the service of society, art would still address other, more primal needs. There remains an infinitely expanding role for art.

The connection that art has to the ability to change individual consciousness, and to the development of a rebellious consciousness, is vital to a stronger recognition of species being in social life. Species being is, of course, unreachable in perfect form, for the dialectic must continue, but it can be pursued so that society can change and develop. Change fosters a better understanding of the dialectic of art and reason, and the continuation of that dialectic is what keeps art alive without limit. The journey toward species being may seem teleological in that it can be seen to function as a metanarrative. But if we accept that the "goal" is unreachable (and that even a journey without a goal can be fruitful), and that the quest itself can yield a deeper knowledge of the endless tension that creates movement or change, and the necessary movements that sustain the tension, then the journey can enrich us. Art exemplifies a universal understanding among people that can be found in the place where emotion and reflection (the Dionysian and the Apollonian realms, respectively) meet in an ever-blossoming and ever-colliding partnership. The particulars of art will vary, and sometimes confound the viewer, but all powerful art provides a valuable journey using the senses, that established contact with that which is common among all humans.

Rimbaud called for living through the senses and through art. This aim requires that one live antipolitically; in other words, to live not through or for society, but rather, without it. Rimbaud believed that we could reinvent society's concepts of the everyday, so that they are true to us individually—so that we can learn them through our own experience rather than just accept them as they are collectively described. Just as Rousseau argued against the liberal individualism of Hobbes and Locke by believing that humans before the creation of society were naturally compassionate toward one another, Rimbaud also warned of the ways in which society—property, industry, and its culture—corrupts man's natural state. He was echoing Rousseau that using the tools of culture,

and often art itself, society casts a veil over its members by mass manufacturing the Dionysian elements of life. Once bureaucratic structure and order, and the whitewashing that comes with frequent repetition, are placed upon Dionysian moments, these moments lose their ability as a transcendent force and become a part of their time, rather than ahead of their time. Rimbaud preferred a sort of self-corruption wherein he adopted the individual morality system that de Sade espoused. It is likely that neither de Sade nor Rimbaud, in his artistic expressions and assertions, ever intended that his experiments and antisocietal ideas would become the foundation of an ordered society. Their private transgressions were not intended to be a public performance. Still, they both understood that by writing about their experiences—by placing their private lives in the public domain and thus into the cultural collective—they were transforming their private experiences into public knowledge. Their visionary combinations of art and thought attest to the importance of the knowledge attained through emotional and spiritual, rather than merely rational, experience.

My conclusions are again twofold. It remains an important task to increase mass access to an alternative, "visionary" way of life—to allow everyone to live by the dialectic of art—both as a response to the mechanization of contemporary life and as a tool by which to transcend our temporal conditions and enjoy the universal feelings that propel individual interest and participation. An acceptance of art as a source of knowledge leads to transcendence of the limits of society that can then foster an increase in feelings of natural universal community. When we can feel ourselves as part of something greater, as part of a whole, we have begun to transcend those limitations.

Capitalism, from its inception in the French Revolution to its contemporary sophisticated and global claims, creates and sustains the individual as a single unit, encouraged to feel compassion only for those it is allowed to love—oneself, one's family, and one's spouse. Capitalism dictates even our aesthetic tastes, as it produces the arts and sciences of convention that Rousseau, writing over 200 years ago, warned of. More recently, Foucault explained the ability of a person to reproduce himself as a subject of the state willingly as discipline and normalization. Camus (1951/1991) and Marcuse (1969) formulated theories of rebellion, and revolution, through art. It is not primarily a change in material conditions (i.e., the toppling of capitalism to make way for communism) that will bring recognition of empathy and interconnectivity. Rather, it is an acceptance and development of the eternal dialectic of instinct and reason, as exemplified by visionary art. Through the universal and transhistorical experience of art, and the empathy it engenders, people can engage a revolutionary consciousness within themselves and within society.

CHAPTER 5

THE POWER OF CREATIVE MOMENTS IN EVERYDAY LIFE: MARCUSE, REVOLUTION THROUGH ART, AND A CRITIQUE OF EVERYDAY LIFE

I have no idea to this day what those two Italian ladies were singing about. Truth is, I don't wanna know. Some things are best left unsaid. I'd like to think they were singing about something so beautiful it can't be expressed in words, and it makes your heart ache because of it. I tell you those voices soared, higher and farther than anybody in a grey place dares to dream. It was like some beautiful bird flapped into our drab little cage and made these walls dissolve away, and for the briefest of moments, every last man in Shawshank felt free.

Ellis Boyd "Red" Redding, *The Shawshank Redemption*

There is a palpable lack of enthusiasm surrounding political partici-pation, and public participation of most kinds, among Americans today. Although this is not always the case, it is all too often the case, and it is the whiff of reputation that one of the world's oldest democra-cies regularly gives off to the rest of the world. To combat this common twenty-first-century complacency, I have argued in this book that we need to seek new ways to revitalize public life in the United States. An important and accessible solution lies in the connection between visionary artistic experience, defined here as the union of free creative moments with the reflective power of reason, and the psychological desire to participate. Although there are often complex webs of conscious motivational factors that influence the desire to participate among indi-viduals, imaginative creative experiences speak to the subconscious first. Visionary artworks can stimulate and encourage feelings of empathetic vulnerability and connectedness with others that make participation in public life broadly defined, feel natural, rewarding, and exciting. This

desire to participate—to be interested, and to feel empowered to express that interest—is the true key to active citizenship.

The prevailing belief in (myth of) individualism in the United States has largely convinced us that we are able to prosper by focusing only on ourselves; "prosperous" being defined primarily through commercial pursuits and through the possession of property. Revolutionary Dionysian moments collapse previous individual conceptualizations of reality and allow for our often-latent visions of universal connectedness to become tangible, reawakened. This new sense of our own connection to others enables us to view our own needs in a new light. These new needs instill empathy for others into our feeling of being individuals and demonstrate to us our shared vulnerabilities and natural interdependence. Without the existence of society and with it, the effects that others have on our lives both directly and indirectly, so many of our emotions and values would also not exist. All of our experiences, from the fundamental processes of self identity to our feelings of happiness, or conversely, of pain or neurosis, and even the very ability and need to use our democratic rights and liberties (rights and freedoms that exist only within the context of relational behavior), would also cease to exist. Visionary creativity aids the recognition of this universal connected vulnerability. Through its ability, either directly or indirectly, to create engagement, interaction, and communication (both between the artwork and the viewer/participant, and among the viewers/participants themselves), visionary art illuminates the primacy of the human community, so that it can be contemplated alongside that of the commonly acknowledged importance of the individual.

Creative glimpses expand the boundaries of perception to create an opening in a comfortable or routine mindset. Just as flesh-and-blood revolutions need an opening (first a weakening) in the structural elements of the ruling regime in order to move forward with a higher probability of success, revolutions (re-understandings) of the mind also need that opportunity for at least momentary disorder, from which to reassess and grow. Even short-lived revolutions, coups, and strikes against a system of government, or any institution of power, are essential to the development of a social and political culture. An uprising that is quickly squashed may still begin dynamic and lasting change in the minds of individuals in society. This is true despite mainstream history's attempt to relegate many powerful revolts to "failed" status, because they were quelled and did not directly institute a new ruling order. A revolutionary attempt can never be a true failure, as its very existence as a ruffle in the status quo grants it a place in the development of that culture and its ideas. Throughout history, regardless of whether a revolt lasted minutes or years, each has contributed to

at least the beginning of a reawakening of the mind. All revolution-
ary movements engender some form of change within their respective
communities and within the collective imagination, in that they pose
questions and alternatives previously not considered or articulated, and
are sometimes even able to briefly experiment with drastically alterna-
tive public values and rules.

Once we can expand the limits of what we perceive is possible for
our lives, there is the possibility of the transformation or putting aside of
previous values and the creation of new desires and needs. This kind of
imaginative arousal can (re)awaken the human spirit—that timeless topic
of our great poems—that almost indescribable inner strength, natural
curiosity, and energy source. When there is physical attack on the govern-
ment or other authority structure, it is not the immediate result of bloody
revolt that connotes its true success, but, instead, the paradigm shift that
it introduces. The violent revolutionary moment begins change that only
the mind, and everyday action, can continue. The often-chaotic emo-
tional experience (as is the case with the climactic moment[s] of a physical
revolt) that begins the expansion of the imagination is in the visionary
(Dionysian) moment; the reflection on these new ideas that encourages
an ability to envision change, and eventually, act on such visions, is the
rational (Apollonian) integration of the moment into everyday life. As
Nietzsche (1872/1967) argued, the metaphorical bloodshed of creation
is necessary, but it cannot, and should not, stand alone. There must be a
coming together of the yin and yang of the human condition, as exem-
plified in visionary art, and this relationship, based on interaction and
complementary balance, is the key to a reawakening (or for Nietzsche, a
true revolution over passively accepted traditions) of the mind. It is with
this partnership that one can see outside of, and beyond, the norms of
the everyday.

Defining Visionary Artistic Experience

There are many different ways to approach ideas of subjectivity and
objectivity, and their overlap, in understanding art. It could be argued
that all artistic endeavors are subjective and should not be subject to
objective classifications of taste or value. There are many different types
of art; there are infinite possibilities for creations and infinite rearrange-
ments of the already known and created. From traditional art forms like
painting and sculpture, dance, and musical composition to interactive
performance, outdoor public art, mail art, gift art, dialogical art, and
various community projects. The more broad that our definition of art
has become, the more difficult it is to argue for the value of a transferrable

matrix by which to evaluate artworks against one another. Even if we decide to use a series of matrices—one for say precision (of stroke, or arrangement of notes), one for use of color, one for emotional significance—it is easy to immediately see the many difficulties such categories yield. These comparisons become near impossible when often the best artworks and artistic styles first enter society as enigmas, as less than "correct" or appealing, as revolutionary attempts to invert or subvert the reigning approaches to art. It is still more difficult to immediately ascertain the value of an artwork when often a less-than-traditionally beautiful, or technically magnificent, artwork can illicit powerful responses in individuals and in the populace at large. Often, it is time that illustrates the most affecting artworks. Art moves with time as do other aspects of our common culture. Significant changes in art mirror major changes in society, and vice versa. No one could have predicted the transformative force on modern art history and culture created by Picasso's rearrangement of body parts, or Duchamp's unaltered use of everyday objects as art in and of themselves, or Pollock's transformation of the process of spattering paint into fine art. These visionary examples entered culture as outsiders but through gaining popularity, they each forever altered our definitions of art.

While these questions could be better addressed with greater nuance in a different work, it is enough to say here that subjective determinations of "beauty" in art are linked to our individual emotive conditions and histories, and not necessarily to the merit of the artwork itself. Therefore, to say simply that any artwork that inspires emotion or a declaration of beauty by an individual, is then a "great" work of art, is entirely too loosely subjective. Still, it is clear that there are "better" works of art, as compared to lesser others, and that there are artworks and artistic styles that endure over large spans of time, and many that are naturally deemed masterpieces. There are broad guidelines for a combination of forces that create a better artwork, but none of these can be absolute or definitive. Innovation in style and approach, range and variation in technique, powerful use of imagery and color (in music, dance, and art), and an evocation of relatable universal ideas and emotions within the work are perhaps the most important variables for evaluating a work of art. Sometimes, we are moved by an artwork because it captures a moment or person particularly well, and thus transports us to that place or feeling through the work. Other times, an artwork may call attention to an issue or problem in a new or strikingly powerful way. Other times, we may look at, or listen to, an artwork, and perhaps not yearn to put it into our homes and our daily lives, but yet we may still value its relevance to change, progress, and justice.

What in this work I term "visionary" art, also referred to alternately as transcendent or rebellious or avant-garde art, is described here in opposition to conformist or mainstream or "plastic" art. There exist these two primary forms of artistic creation. The first, visionary art, challenges the overarching status quo understanding of how we live and relate to society, by provoking deeper individual engagement with the world, and encouraging energetic emotions and interactions.[1] Art, that is, on the other hand, supportive, of both the content and form that defines the boundaries of our daily existence, and enables us, as does the power of popular opinion in American democracy, to delay or even entirely avoid, a truly independent critical examination of how and why mechanisms in our lives function as they do, is a redundant "plastic" art. This sort of art has historically been employed (relatively benignly) to uphold the materialistic drives of society. In a corollary point, there also exists the more malignant use of artistic forms to create support in society for unjust decisions and regimes. There have also been many notable examples, particularly in the bloody experiences of the twentieth century, of aesthetics being employed in the service of totalitarian ideas and goals, such as the vast array of propaganda art that was created in both Nazi Germany and in the Stalinist Soviet Union. It is because art is always only *indirectly* related to politics, and to issues of ethics, that it can be employed so effectively to easily capture people's attentions and subtly convince them of new ideas. It feels tangibly different to learn of political ideas through a colorful visual image, or a vibrant emotional song, rather than through a pamphlet, book, or radio advertisement.

George Kateb's argument about the potentially dangerous character of aesthetic experience (2008a), expressed through his concept of aesthetic cravings, is a seeming foil to the main idea presented here about the positive value of art for society. His belief is that it is in fact the natural human instinct for the very same order and accord, which Camus and Nietzsche too discuss, that propels us to falsely create out of a complicated world, a dangerous order. This false unity and logic, he argues, was a leading cause of many of the worst political experiments, especially of this last century. With this notion I agree. Still, this point misses the heart of the argument progressed here. It is simplistic to reduce aesthetics, or even "vulgar" notions of aesthetics, to a desire for unity and homogeneity. In his theory, he equates aesthetics with the sort of beauty yielded by harmony and order. This is what in this work is referred to as conformist or status-quo-affirming art. I equate "aesthetics" here with a "plastic" form of art, as they attempt to create order out of a hopelessly, though in my opinion pleasurably, disorderly and vastly pluralistic world. The positive value of art that is expressed here pertains not to the harmony

and order of aesthetics, but rather to the self-awareness, innovation, and empowerment that exists within creativity and imagination, and thus within the vast plurality of liberating experiences characteristic of visionary art. When this work asserts that notions of empathy and oneness can be found in creative visionary experience, the argument is not for a perfect or forced or homogenous oneness, but rather for a source for interconnected empathy, no matter how nonlinear, that is the foundation for true justice.

It is also necessary to flesh out the nature of what I call here "experience." Experience, as it is used here, implies a ritual, or a process, captured within even just a momentary pause from our daily lives. An "experience" with art contains more than one idea. The initial Dionysian moment begins the experience with temporary spiritual pause that encourages deep emotion and self-knowledge, and later reflection creates empowerment and a desire to act on (new) feelings and ideas. Artistic experience includes participating and looking, listening, being captivated, and being moved emotionally and spiritually; these feelings during the viewing experience mirror the experience of creating art itself. Episodic experience, as differentiated from habitual experience, is a relevant distinction, but only to demonstrate that episodic experience with art can become habitual once the inner awareness of our own creative individual will is confronted. This is achieved more broadly and inclusively with art that is situated in outdoor public spaces.

From legendary German "social sculptor" Joseph Beuys, to the contemporary theorists of social and participatory art movements, their main arguments about artistic experience mirror the one advanced here as they believe that art becomes art not exclusively when the initial artist produces its foundations, but also importantly when the viewers participate—either directly (through physical interaction) or indirectly (through emotional interaction)—in the artwork. Those intangible moments when we really feel the spirit within art, when individuals gain a new and transformative recognition of their own selves, is a form of artistic creation itself. The art then flows within us. This is the experience of visionary art.

Herbert Marcuse's Revolution through Art

Marcuse's (1969, 1974) work on the political possibilities of creativity[2] and art combined Freudian psychology with a post-Marxian humanist critique of advanced capitalism, and inspired scores of largely young people in the tumultuous 1960s, to redefine their lives through artistic and cultural

freedom, according to a belief in a more just and unified world. In the decade following the quiet repression of the post–World War II years, American culture, both popular and underground, was swelling and beginning to burst at its seams. Marcuse believed, following Freud, that some individual repression is vital in order for the existence and progression of society, but that there are other repressive qualities of society—or what he terms "the Establishment", or the powers that determine the guiding trends, and the very desires of society—that were psychologically and politically unhealthy as they hindered individual liberty.[3] He argued that art could allow for endless possibilities, and thus enable not escapism from society and politics but, rather, opportunity for individual resistance, revolt, and liberation, through creativity and imagination.[4] Kellner (Marcuse, 2007) quotes Marcuse as saying that art can take us back in time as much as it can envision the future, and propel us into the still unknown: "Marcuse sees social change prefigured in artistic subcultures and in the productions of artists and intellectuals" (p. 13). In an interview between himself and Richard Kearney, Marcuse said, "Art, therefore, does not just mirror the present, it leads beyond it. It preserves, and thus allows us to remember, values which are no longer to be found in our world; and it points to another possible society in which these values may be realized" (p. 228). Here he distinguished between art as an adaptive force that conforms to the constraints of mainstream culture and art as a protest and negation of the accepted reality.[5]

Marcuse, like Camus before him, struggled with the injustices and political horrors that were taking place around him and yearned to find a philosophical way to the creation of a more just and cooperative society. Marcuse (1969) believed that the unifying and healing life power of Eros needed to overcome the destructive, aggressive, and self-destructive death drive of Thanatos in society, which he had witnessed take over the world at several times in his life. Specifically, Marcuse argued for a "radical transvaluation of values [that] involves a break with the familiar, the routine ways of seeing, hearing, feeling, understanding things so that the organism may become receptive to the potential forms" (p. 6), and thus the individual, equipped with these new possibilities, could develop an interest in participation and in (revolutionary) change. His notion of a radical transvaluation meant that art was the tool by which to transform accepted and routinely employed ideas, behaviors, and beliefs. These cultural and aesthetic transformations would result in the transformation of society itself: "The strong emphasis on the political potential of the art which is a feature of this radicalism is first of all expressive of the need for an effective *communication* of the indictment of the established reality and of the goals of liberation. It is the effort to find forms of communication

that may break the oppressive rule of the established language and images over the mind and bodies of men—language and images which have long since become a means of domination, indoctrination, and deception" (Marcuse, 1972, p. 79).

Marcuse believed that, as a system, capitalism is a self-affirming prison. He argued that capitalism yields immediate material satisfactions that serve only to create new needs and desires for more material satisfactions.[6] This is not unlike Tocqueville's (1835/2002) thesis on the self-limiting nature of American democracy. Marcuse's critique of advanced capitalism is linked to a critique of modern democracy. In a sense, Marcuse's arguments are specific to the politically tumultuous 1960s and to the twentieth century, but there is a timelessness to his assertion that true individual liberation, which seeks unity with all others, can be attained through interactions with, and expressions of, the aesthetic or creative realm. It is in this aesthetic realm that people can expand their imaginations. Marcuse believed that art's realization is ultimately political struggle, or praxis.

Marcuse, not unlike Camus, and in a different context Nietzsche too, believed that in order to create the foundations for true justice in society (and in this sense, recreate the social order), it was necessary to take a step back, rearrange, reinvent, and revolt against established reality and the ruling ideas of the Establishment. Once this liberation is achieved, and once a more "natural" understanding of justice, understood as universal empathy, has emerged within the individual, the development of the "new society" could begin. He was insistent that this still-unknown future world could not be determined, in all its details, upon the initial move toward significant change; the "new society" would develop from the bottom-up, rather than be placed upon a people. The primary nature of this new humanist society, besides its reliance on empathy among individuals, is that it evolves through the involvement of interested and willful citizens who are guided by the teachings of artistic experience. Marcuse believed that art was a positive force in society through its very negation of the established reality, and in this way, of the established structures of power and morality.

Marcuse's project was heavily focused on resurrecting the life-building power of Eros in everyday life, and in the mechanisms of societal justice and governance. He believed that Eros, accessed in the creative and life-affirming abilities of art, could redefine the terms of societal relations. It makes sense that in the context of the mid-twentieth century, Marcuse believed that the forces of Thanatos had overpowered the knowledge of Eros in society, a variety of violent horrors had ensued around the world, and now life itself had to be revived.

As Nietzsche and Camus both argued, Marcuse (1970a) believed that art and imagination are dependent on the union of the Dionysian and Apollonian drives. "In the work of art, form becomes content and vice versa" (p. 40). The form that an artwork employs, captures the Dionysian moment of instinct and emotion, and its content is akin to the Apollonian reflection. Their eternal dialectical dance keeps visionary art perpetually critical. In Marcuse's (1970a) terms, content works within the established reality, whereas form is able to create a new reality, even though their perpetual interaction is inherent. In his philosophy, Marcuse feared destructive and angry forces and believed that they should be replaced by the life energy of Eros. The influence of Eros is always the goal when seeking justice and community, yet we must not completely eradicate every natural desire for destruction, because a black and white world where only "the good" exists is also a repressed, and again, dangerously ordered world. Most important is the need to encourage people, "satisfied" by the desires and material goods determined by popular opinion, to experience both the chaos and the true freedom of creativity. Genuine, empowered, and curious interaction with the world enables a more vibrant society, where individuals feel more naturally connected to each other. That connection is guided by Eros.

Again following Camus, Marcuse believed that creative rebellion is a confrontation with, and an expression of, a unifying understanding of human codependency. This latent unity exists within individuals and in the spaces between all people. Marcuse asserted, "The aesthetic is more than merely 'aesthetic.' It is the reason of sensibility,[7] the form of the senses as pervaded by reason and as such the possible form of human existence. Beautiful form as the form of life is possible only as the totality of a potential free society and not merely in private, in one particular part or in the museum" (p. 129). He elaborated, "No matter how much Art may be determined, shaped, directed by prevailing values, standards of taste and behaviour, limits of experience, it is always more and other than beautification and sublimation, recreation and validation of that which is" (p. 143). Marcuse was pointing here to the distance that art naturally keeps from reality. Although art is a human creation and is thus embedded in the desires and behaviors of its time, its form is one of reflection, commentary, distortion, and enhancement. Art is displayed in the particular, but it is an expression of that which is universal—the "other" force in life that challenges our immediate concerns with the tugs of universal and communal experience.

Marcuse wrote extensively on how one can attain liberation from the constructs of everyday reality through spiritual and sensual connections to the latent knowledge of universal humanity. He (1970a) believed that art—can be a liberator of repressed and taboo "dimensions of reality"

(p. 19) because "[t]he *nomos* which art obeys is not that of the established reality principle but of its negation" (p. 73). By "established reality principle," Marcuse was referring to the prevailing societal obstacles, which visionary artists constantly seek to overcome. Visionaries create the aesthetic dimension, which "may require them to stand against the people" (p. 35), or oppose mass opinion and the status quo. Douglas Kellner writes: "Although Marcuse projects an ideal of the merging of art and everyday life, and the overcoming of alienation through spiritual integration into a just community, he is aware that the development of bourgeois society created new forms of alienation which were reflected in the artist novel. In his dissertation, he often discusses artistic revolts as conscious rejections of bourgeois society and capitalism that were destroying previous forms of life and were generating new obstacles to overcoming artistic alienation" (Kellner, 2007, p. 13).

Marcuse also argued that not even socialism and its institutions could ever dissolve the tension in the dialectic relationship between that which is universal, and our experiences of the "particular," or what we can also understand as, respectively, the Dionysian realm and the Apollonian realm (Marcuse, 2007, pp. 71–72). This is the union that can never be absolved or resolved, as both of its poles are perpetually created and recreated in life's experiences and emotions. Its fluctuating tension maintains art's central role in our life because in art the new, the strange, and the impossible can always be created in its freedom to rearrange, transform, and present to us a new way, a new possibility. Our universal experiences of human existence can be explored and elucidated through powerful moments of creative expressions. Truly independently conceived individual ideas begin change within. Art's role is fundamental to progress and to ultimate societal order, as well as to the more immediate goals of increased participation and feelings of genuine interest and inclusion in our public spaces, in civil society, and eventually in even the mechanisms of procedural democracy (Dahl 1956/2006). We need to increase support of public and social artistic endeavors, so that this vital knowledge of visionary art can be tapped into more frequently and more broadly, and by more people, in the democratic forum of the streets, rather than in the sometimes intimidating arenas of the art museum and other cultural institutions.

The Power of Public and Social Art to Empower Individuals, Aid Community, and Transform Society

Several important recent arguments develop the value of art for political life and create a supportive foundation for assertions of art's central role in the (positive) transformation of individuals and groups.[8] Frances Borzello

(1987), working from a historical view on industrial Britain, has argued that art can encourage community, education, empowerment, and even refinement. For Jacques Ranciere (2009), art is political in its ability to challenge and transform everyday reality. Within the realm of art theory, a variety of voices comingle in the debates surrounding "collaborative"— meaning that the artwork relies on participation beyond the traditional notion of the sole artist—and "relational"—that the art, often a "moment," a series of moments, or an event, is both experienced *and* made as a collective or community—approaches in art. From the pioneering work of Nicolas Bourriaud (1998), to Grant Kester (2004), Claire Bishop (2006), and Cher Krause Knight (2008), theorists of art have focused, from various perspectives, on the ways in which the newest movements in contemporary art that stress interaction and communication, particularly in public spaces, enhance these positive effects of art. Borzello[9] argues that in addition to art's obvious aesthetic value in its creation of atmosphere, it has also often been used to aid society and politics.[10] She holds that art has been used in Britain since the 1870s to educate, encourage, and refine both the criminal and those neglected in and by society. In late nineteenth-century Britain, "[a]ll shared a basic belief that bad environments led to bad people and that bad people led to bad environments. Art had the power to break this circle. Reformed by art, the people would improve their way of life, and once reformed there would be no chance of their ever again being gripped by vicious habits or dragged down by hopeless surroundings" (p. 32). Although it is clear that "criminal" encompasses a wide variety of behaviors, and that many a criminal is a permanent danger to society, and often to themselves as well, this argument speaks to the many imprisoned everyday for lesser crimes, where rehabilitation has the possibility to change their lives. Further still, she points to the power of public art that is shared by a whole community. The celebration of creativity and a shared culture that all could take pride in, and learn from, was in Britain an important key to uplift and empower those who had been disillusioned by society's ills, and to foster feelings of community by creating genuine connections among citizens across class divides: "Culture was to be the means of achieving this dream of a united society in which rich and poor stood side by side instead of eyeing each other with hostility. As Barnet said, "There can be no real unity so long as people in different parts of a city are prevented from admiring the same things, from taking the same pride in their fathers' great deeds, and from sharing the glory of possessing the same great literature" (p. 32). Although this presents a strikingly utopian viewpoint, the underlying argument that art can do a considerable amount to lift the spirit, the empowerment, the self-love, and the ability to connect with others, in a wide variety of people, is certainly a valuable one.

Jacques Ranciere, known for his early work on Marx as a student of Louis Althusser, has in recent years become one of the most salient and popular figures in aesthetic theory (Davis, 2006). The focus of his many studies on the politics of aesthetics is a reconsideration of the relationship between art and politics, an insistence on the importance of aesthetic experience in contemporary society (Ranciere, 2004), and a defense of modern aesthetic theory for a rejuvenated conception of politics: "Politics, indeed, is not the exercise of, or struggle for, power. It is the configuration of a specific space, the framing of a particular sphere of experience, of objects posited as common and as pertaining to a common decision, of subjects recognized as capable of designating these objects and putting forward arguments about them" (Ranciere, 2009, p. 24).

Ranciere's project, in the tradition of Camus and Marcuse, seeks to revitalize and reformulate our understanding of aesthetics. He argues that aesthetics is inherently political because it is by nature in a realm separate from both politics and reality: "[T]he politicity of art is tied to its very autonomy" (p. 26). This statement is not unlike Tocqueville's observation that religion played such a pivotal role in American political life for the very reason that it was consciously separated from politics. Following Lyotard (1984), Ranciere (2004) believes in an aesthetics that serves the political function of creating opportunity for revolt in society. He links this modernist notion of the sublime aesthetic as a way to transcend the constraints of society, with contemporary art that focuses on interaction as art:

> Art is not, in the first instance, political because of the messages and senti-ments it conveys concerning the state of the world. Neither is it political because of the manner in which it might choose to represent society's struc-tures, or social groups, their conflicts or identities. It is political because of the very distance it takes with respect to these functions, because of the type of space and time that it institutes, and the manner in which it frames this time and peoples this space. (p. 23)

Knight (2008) draws on the contemporary art practice of relational,[11] and dialogical (Kester, 2004) aesthetics, to assert the necessity of participation in public art. She, too, argues that the observer of an artistic act is vital to the creation of the art itself. She broadly discusses a definition of public art that focuses on its function in society, a history of public art projects in the United States, and, most interestingly, offers an analysis into the current populism,[12] or lack thereof, of our cultural institutions, from the traditional museums to commercial outdoor spaces like Disney World. She is less concerned with evaluating and comparing the artistic value

of different public art projects, and rather focuses on the depth of public involvement in the artworks. "A museum becomes most fully public when it prompts us to examine our aesthetic tastes, cultural beliefs, and social practices, and when a variety of visitors feel comfortable and properly equipped to actively partake in such investigations" (Knight, 2008, p. 62). As Kester (2004) has similarly argued, "Conceiving 'art as communication,' new genre public art seeks to move beyond metaphorical investigations of social issues with the hopes of empowering often marginalized peoples."

Kester (2004) aims equally to defend dialogical art as a distinct form of art practice and attempts to develop a theory in support of his own idea of a dialogical aesthetic.[13] He identifies the "new" genre of the public art of the 1990s, which had its basis in community life, aimed to connect people across various social divides and exemplified theories of "relational aesthetics." He locates the roots of those developments in art, in the social, conceptual, performance-based, and feminist avant-garde artworks and happenings of the 1960s and the 1970s, which widely expanded definitions of art. He argues that this dialogical art practice uses the "interactions with collaborators and audience members" as the medium of the artwork. This means that the communicative interactions involved in this type of artwork are both the tool by which to create the art, and the actual holders of the artwork.

Kester (2004) begins his argument by explaining why it is necessary to defend such communication and interaction-based art practice. He argues first that it is a mistake to cast aside artwork that is not shocking or opaque, as is the tendency with modernist notions of the artistic avant-garde (Lyotard's, 1994, notion of the sublime).[14] He says that there has been a "gradual consolidation in modern and postmodern art theory of a general consensus that the work of art must question and undermine shared discursive conventions" (p. 88). He explains how avant-garde art developed as a challenge to, and as a relief from industry, science, and the market, and that it was intended to shock the audience out of their everyday routines and expectations. Challenging Lyotard's basic premise regarding the creation and experience of art,[15] Kester argues that, whereas Lyotard differentiates between shocking and easy art, he does not question the definition of art as something that is created by the artist, and fails to see that the interaction between artist and viewer could be the art itself (Kester, 2004, p. 87).

Along similar lines, art critic Ted Purves (2005) has studied contemporary artists' creations of "gift-based" projects, such as the creation of free-commuter bus lines, medicinal plant gardens, community newspapers, democratic low-wattage radio stations, and various other free services as

creative offerings. He cites, for example, Ben Kinmont's self-defined "street actions," which offered strangers free housework. This creation of a generous relationship, particularly among strangers, is the aesthetic as well as the social value of the artwork, inasmuch as these realms have merged within the concept of "new-genre" art. Many will ask, how can these projects that sound a whole lot like community-service initiatives, be art? These community-oriented conceptual projects do achieve much of what their more directly political and social counterpart programs do, but they make creative choices according to a different motivation. While "new-genre" artists believe that the immediate social assistance of the projects is of obvious value, they seek to create access to the interesting experience of knowing that the service you are using is provided not by a government or even a nonprofit, but rather by other people in acts of community and kindness. There is a certain sensuality to sharing without common reason, to trading helpful services and generosities with perfect strangers in our adult lives. The example of the free-commuter bus line illustrates how the immediate social aid is accomplished with the availability of free bus rides, but the experience that the creators of the project seek to produce is the one of knowing that you are riding on a form of true community transport. These projects show how all is possible in art, and that through art, we can achieve goals that seem intimidating in our everyday lives. The relationship formed in the interactive artistic act, Purves argues, compels a change within the "audience" from passive viewer to dynamic participant. These types of projects function as art in that the ideas and acts that they inject into the public stand in noticeable contrast to the world's daily routines, which run on the constraints of variables like time, supply and demand, and rationality.

Conclusions

It is true that even the "plastic", as in comfortable or redundant, experience of art can be valuable because it can aid in the reinvention of our public as well as our private environments. Through its ability to make a space different, interesting, or simply more beautiful or colorful, even redundant art can transform and make more inviting public spaces that are otherwise almost entirely without character. This creates stronger feelings of community in relation to the space, and a higher respect for the public life the space encompasses. This means that a barren dingy chunk of pavement adorned with some unimaginative geometric structure that looks like three others down the street is still better than just a barren dingy chunk of pavement. This connection between art in the public and community life is not entirely unlike the ideas behind the creation of religious art in places of worship—to create a beautiful and inviting space so that

there is more of a desire to spend time in these spiritual homes. Still, not all beautifications and expressions of creativity are "visionary," challenging, transgressive, and universally emotional artworks. "Visionary" art desires to shake participants into the incoherence of a disordered moment, and in creating disturbance within the individual, seeks to unify them, at least for a moment, both with their true inner selves and through the universal emotions released, with all others.

Surrealist philosophy provides an interesting corollary in discussions of the importance of creative explorations within the self, to society. Surrealism as a philosophical and artistic movement emerged out of Europe, with Paris as its fervent center, in the early part of the 1920s. It was borne at least partially out of the equally antirationalistic, though explicitly "anti-art," Dada movement in art and culture of the previous decade, which likewise argued that society functioned through, and relied upon, too strong a focus on rationalism and not enough on the knowledge of emotions and irrational instincts. Surrealist artists strove to create visual artworks that encouraged a fantastical or dreamlike state within both the artist and the viewer through disorienting, unusually composed images. The Surrealists, headed intellectually by the ideas of the writer Andre Breton, among others, and guided by both a Freudian and a Marxian ethos, believed that looking at art that temporarily disoriented, and aimed to reorient in a new way, the viewer with unfamiliarly juxtaposed and strung-together ideas and concepts from the everyday could encourage a search within the unconscious, similar to the style of inner discovery developed by Freudian psychoanalysis. Breton ultimately wrote three manifestos for the Surrealist Movement that expressed the movement's philosophical goals of creating a revolution in society through creating images that served to unleash the workings of the unconscious into everyday reality.

Several decades later in America, the Abstract Expressionist artists were among the first to emphasize the physical activity of painting over the accuracy of the strokes and the resulting image. Similarly to the American Transcendentalist literary and philosophical movement before them, they strove to express the important feelings and transformations involved in the process of creative experience, rather than focus primarily on the details of its material manifestation. This is the emphasis in a Dionysian philosophy—to focus on how we feel, and not on how we think. An increased presence of public and social art projects on our streets, and in our daily lives, can foster within us a brief but necessary retreat from reason and everyday concerns, and thus encourage an exploration of the sensuous and spiritual realm of life. Public and socially interactive artworks, both consciously political projects and those that empower through interaction and conceptually arousing events, are

needed to disrupt our everyday routines with creative Dionysian breaks. These breaks temporarily disorder imagined boundaries and lead to inner revitalization and reflection, and the accompanying feelings of empowerment. In these moments, freedom bursts open within the individuals experiencing them. Intellectual and moral freedom comes from access to a true individuality. This access to ourselves can uncover and invigorate within each of us (without any direct material incentives) the feelings of empathy, which, along with the individual desire for well-being, are the first building blocks of an active citizenry in a democracy, as these emotions inspire a desire to participate.[16]

Beyond the basic relationship between the beautification of public space and a heightened willingness by the public to respect, and participate more in that public space, the *visionary* art experience propels the creator, and likewise the viewer/participant, out of complacency and comfort and into liberated and thus inherently rebellious thought (and action). The goals of this work have been to examine the processes of art-making and art-viewing through a philosophical lens, to study the political role of the artistic process, and to demonstrate the importance of this political role in an invigorated democratic culture here in America—all with the aim of showing that both public and socially interactive artworks contain valuable resources for society and for politics, as they are sources of power, knowledge, and spiritual reinvigoration for the individual. Interactive art is important primarily because the "passive" viewer becomes an active participant, and public art is most vital because the artist is able to reach the most people in the most open and accessible way. There is a major current movement in art that is evermore oriented toward projects that create socially interactive experiences and toward public artworks that are created and displayed in our outdoor spaces, not in traditional four-walled institutions. And it is gathering speed as this is being written.

CHAPTER 6

RECENT EXPERIMENTS WITH PUBLIC AND INTERACTIVE ART, NEW YORK CITY AND BEYOND, 2008–2011

I believe that the artist and his art are only a part of the total human experience; the viewer in the world at large is the essential other part.

Ansel Adams, photographer

In order to provide new and challenging examples of public and socially interactive art projects to demonstrate the arguments made here, my focus has been on art in New York City, primarily because it is a major cultural center in the United States. Pick up almost any cultural publication, and evidence of the expanding horizon of art can usually be quickly found. Within just the last three years, as is demonstrated through regular searches in the cultural media for a social and political turn in artistic creation, there has been a palpable increase in the amount of art produced that is either publically displayed, or socially interactive in nature, and these are only the relatively small group of works that achieve media coverage. That this move, toward what has been termed the collaborative or "social" turn in art, (Bishop, 2006b) has been gaining attention and energy, may in part have been further encouraged by the more inclusive energy of political participation that developed in reaction to the landmark presidential election of 2008, as well as by an increasing and spreading awareness of, and deeper resistance to the ever-individualizing and ever-commodifying undercurrent in contemporary American life. The civic desires and behaviors that bloomed during the 2008 campaign, though commendable and exciting, were unfortunately not wholly sustainable indicators of American civic health.

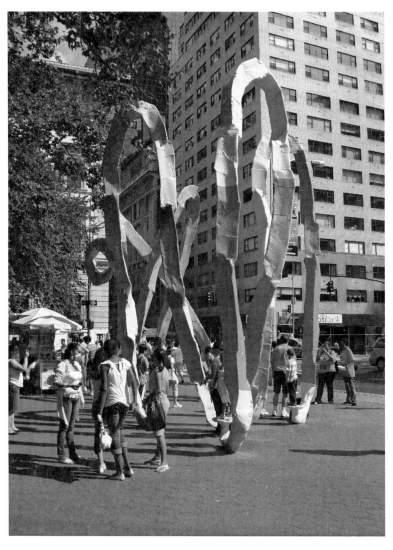

Image 6.1 "The Ego and the Id" by Franz West.

Source: Photo by Cristina Vinatoriu.

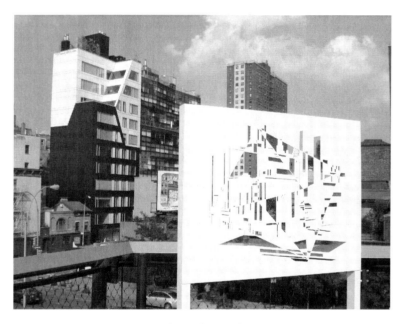

Image 6.2 "Viewing Station" by Richard Galpin.

Source: Photo by Cristina Vinatoriu.

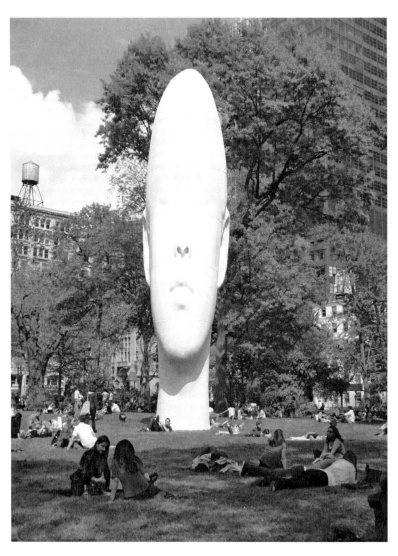

Image 6.3 "Echo" by Jaume Plensa.

Source: Photo by Cristina Vinatoriu.

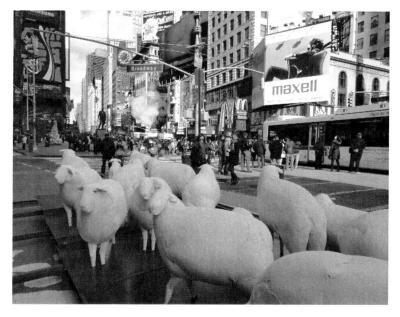

Image 6.4 "Counting Sheep" by Kyu Seok Oh.

Source: Photo by Cristina Vinatoriu.

Image 6.5 Spain Art Fest 2010.

Source: Photo by Cristina Vinatoriu.

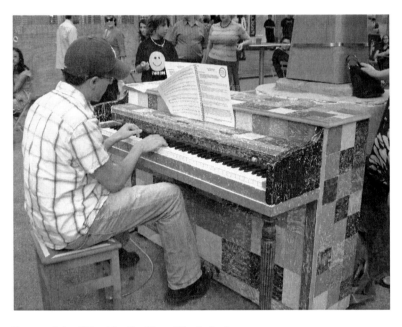

Image 6.6 "Play Me, I'm Yours" by Luke Jerram.

Source: Photo by Cristina Vinatoriu.

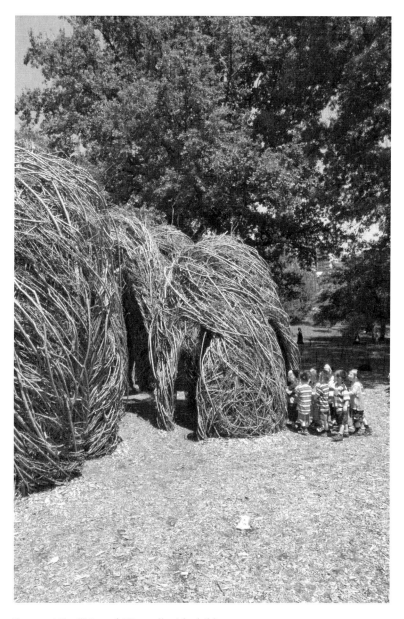

Image 6.7 "Natural History" with children.
Note: Copyright © BurckSchellenberg.

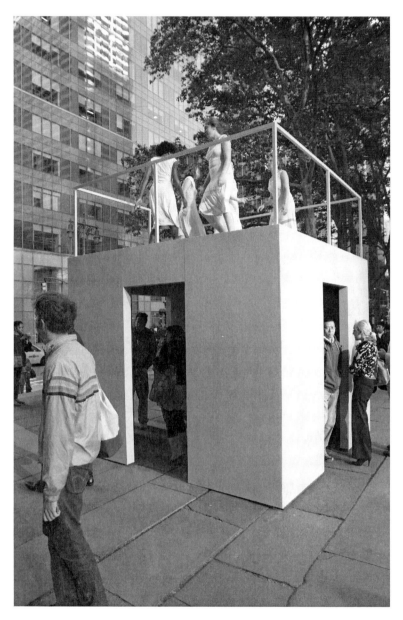

Image 6.8 Kate Gilmore, "Walk the Walk," 2010. Five-day performance piece, Bryant Park (NYC). Monday, May 10–Friday, May 14, 2010. Presented by the Public Art Fund.

Note: Photo copyright © BurckSchellenberg.

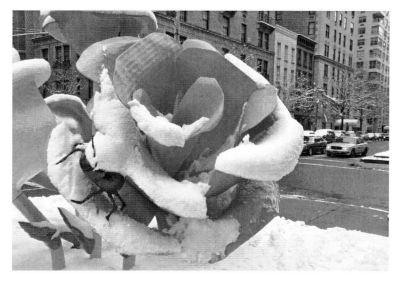

Image 6.9 Will Ryman's "The Roses" on Park AVE.

Source: Photo by Trish Mayo.

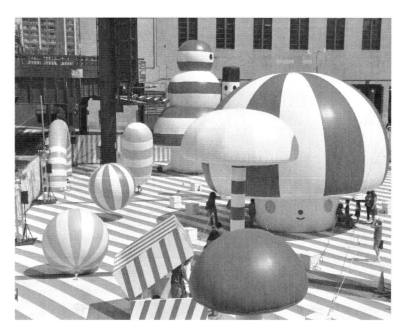

Image 6.10 "Rainbow City." Installation near the High Line.

Source: Photo by Trish Mayo.

Rather, the temporary increase in participation was centered on a charming newcomer candidate who effectively used the social media networks now prevalent in American society, particularly among the younger set, to engage a largely disengaged, comfortable, and complacent citizenry. This seeming steep increase in citizen participation in political life could not be maintained after the conclusion of the campaign race, perhaps partly because it temporarily hid the deeper problems of free ridership and its friend, a far-reaching focus on individual material desire. The influential midterm election two years later in 2010 drew far lower numbers of voters. The election of 2008 was an important, but ultimately hollow, demonstration of citizenship in a country where often even the most capable simply choose not to get involved. Not since the politically turbulent 1960s have large numbers of Americans left the ease and comfort of their individual experiences to initiate political or public change, outside of working in the throes of a presidential election. It is time for a resurgence of a true interest in participation on all levels, and in all aspects of our social and political lives.

Challenging art engages us in the public sphere by showing us environments, emotions, and ideas outside of our expected beliefs and beyond the immediate concerns of daily pragmatism. A potent experience with art is akin to the change that occurs inside us when we leave our daily existence and travel to an unknown land, where our most basic expectations are ignored and our concerns transformed.[1] It is disconcerting and powerfully rejuvenating when this type of self-critique is enabled. Similarly, visionary artistic experience disorders, and this chaos, produces a metaphorical clean slate within our inner selves that enables an expansion of the imagination and a space for new possibilities. Many art forms—both "mainstream" and visionary—can infuse the prosaic with beauty or entertainment value or at least the novelty of experimentation. But only truly transcendent visionary art opens the way to freedom of thought, real conceptual change, and an expanded worldview that extends individual concerns into concern for the greater human community.

Like the subversive and astonishing public interventionist artworks of Gordon Matta-Clark[2] in the 1970s (before he died tragically young), the best public artworks rearrange, transform, or otherwise highlight our shared feelings, our communal environments, or our accepted knowledge of the world. Among other still-inspirational projects, Matta-Clark famously sliced chunks out, or cut enormous holes right into the facades, and walls, and floors, of abandoned buildings all across New York City, enabling us in the public both to see the inside workings of buildings we most often take for granted, both in design and durability, as well

as allowing us to simultaneously see a building's private interior, while witnessing the outside or the "public" cutting right into that structure. His reinvented and restructured buildings created powerful visionary works that stood out rebelliously among the first generation of New York City's public art sculptures. These "sculptures" drew attention both to the vulnerability of our structures and shelters and to New York's frequent abandonment of public spaces at the time. In the spirit of both Matta-Clark as well as the geometric Bauhaus photographic approach of Moholy-Nagy, in 2010, artist Richard Galpin erected a giant white billboard with a chaos of geometric cutouts onto a corner of the raised platform park that is the recently created New York City "High Line." Through the many overlapping cut spaces, one could view the skyline beyond in a distorted abstraction resembling a collage that changed endlessly as one moved around the piece.

Directly Political Art

Politically direct art has an important place within the expansive movement in public and socially interactive art. There have been many recent examples of innovative projects that call attention to societal issues or questions. In late September 2008, *Creative Time*, which, along with the *Public Art Fund*, is one of the largest New York City arts organizations devoted entirely to promoting and funding public artworks, unveiled its timely, citywide exhibition, titled "Democracy Now! Democracy in America: The National Campaign". Its aim was both a conscious examination of the intersections between art and politics and a way to educate the public about political history and democracy through performance art. The project included a several-part performance piece by artist Mark Tribe called the *Port Huron Project*. The historical public reenactment lectures were Tribe's response to the political climate of late 2008 that, although far from the radical atmosphere of the 1960s, was freshly open to change (consider then presidential candidate Barack Obama's campaign slogan of "Yes we can!"). Both around the country and in New York City, Tribe performed six historical speeches by Stokley Carmichael, César Chávez, and Angela Davis, among others. Actors were hired to do the speaking, and Tribe finished the project by posting each performance online. He is attempting to make connections between the past and the present by echoing the revolutionary words of his parents' generation and bringing them to the contemporary public realm, where he asserts that the current political climate is "less outspoken." He has revived the radical voices of America's history, Tribe says, because "[a]ccess to our shared history is crucial for the functioning of democracy." His artistic purpose centers around his belief

"in politics that question not only the means but the very assumptions upon which our society governs." Various other contemporary artists—including Jeremy Deller, Omar Fast, and Allison Smith—have also produced artworks that involve this idea of reenactment as public performance (Blumenkranz, 2008).

The *Port Huron Project* was part of one of the most expansive ventures in *Creative Time's* 34-year history and was, in its emphasis on a directly critical politics, reflective of both the excitement and potency of the 2008 presidential campaign and the radical fervor of the late 1960s and the early 1970s, such as the inspirational 40-years-past demonstrations at the Democratic National Committee in Chicago. The project was an endeavor by artists to stimulate a grassroots political movement by reviving historical radical arguments and the voices of those who created them. The larger "Democracy Now! Democracy in America: The National Campaign" project sponsored five "town-hall meetings" and protest-performance art pieces across the country. The project culminated at the end of September 2008 with a seven-day exhibition at the Park Avenue Armory, including work by more than 40 artists and an ongoing lecture series. With similar attention to social and political concerns, but on a smaller scale, a 2009 blurb in *New York Magazine* described a public art project that created a portable living space for our public spaces that resembled a small tin garage. The work was originally part of the "House of Cards" show at the Invisible-Exports gallery, and the makeshift home will now remain in the Brooklyn Navy Yard in New York City for a year. Made from scraps of garbage and placed on the street for public consumption, it highlighted the enduring problems of homelessness and the societal and governmental efforts, or lack thereof, to provide enough shelter for the homeless. To see such a portable shack in our everyday life is a stark reminder of how little we actually need in order to live, and how so many people around us do not even have access to such a humble source of shelter. That the shelter itself was so striking in its cobbled-together appearance, and that it made use of waste to create a home of sorts, easily caught the attention of passersby.

On the Lower East Side of Manhattan, situated between the Bowery Mission homeless shelter and the New Museum of Contemporary Art, was for a short time in November 2008, an exhibit by Filip Noterdaeme (Kopel, 2008). The artist constructed a small wooden podium-like table (similar to a puppet theater) and affixed it with a sign that read "Homeless Museum of Art (HOMU)," below which was the phrase, "The Director is IN." He placed a small chair adjacent to the structure. The artist, costumed as the "Director," spoke to passersby in one-on-one "encounters," in which the performance, in Noterdaeme's words, "open(s) up minds and

eyes to these complete separate realities." Many people stopped to speak to the artist, most often of their experiences inside the nearby museum as well as about its proximity to the Bowery Mission, which has been providing shelter to the city's homeless population since 1879. The artist successfully explored the controversial issues behind a rapidly changing urban landscape by showing how the Bowery, a traditionally destitute area that had recently been heavily gentrified as a result of the installation of the New Museum, maintains a symbolic juxtaposition with the homeless shelter's presence against the almost unnerving backdrop of the shiny new looming building.

While these are excellent examples of how public and socially interactive art can be used to directly educate and raise awareness in individuals, there are countless, equally important, and perhaps more common, examples of public art projects that achieve their political goals by virtue of their distortions of the everyday. These are projects that aim to heighten emotional and bodily awareness, not necessarily of any particular social or political issue but, rather, of people's accepted ideas and assumptions, their sense of what is a public space and how they relate to that space, and to the public community within it. For example, since January 2008, the artist known as Poster Boy has creatively manipulated more than two hundred underground subway posters in New York City and has likewise turned MTA stations into his own public galleries. His pieces are conceived on the spot, and his "improvised mash-ups recall...the cut-and-paste aesthetic." Although his alterations to the posters are subversively political in their inversions and rearrangements of advertising messages and images of popular culture, perhaps his true art is in the process of speedy and public creation. He makes his spontaneous pieces while people are waiting for their trains, and his work is often ripped down by authorities, sometimes before he has even completed it. His mission is the formulation and encouragement of a decentralized art movement, with no copyright or authorship attached to works, thereby giving the artworks entirely over to public and social life (Raftery, 2008).

Transformation of Public Spaces with Art

Beyond awareness of our physical environments, among the density and diversity that is New York City, there are constantly evolving experiments with the social and performative aspects of our daily routines. In the summer of 2009 alone, countless smaller projects that focused on bringing the emotions and concerns of the private sphere into the public realm, as well as several key city-funded public art initiatives,

significantly changed the visual and experiential landscape of the city in mere weeks. Among these was the major construction project that resulted in the birth of the "High Line," built as a public promenade on top of a long-abandoned railroad track high above the Chelsea neighborhood in the city. Since the trains stopped running there in the 1980s, the space had gone unused. The city's transformation of this public space created an instant community of those eager to fill the new public playground with interaction and creativity. From this tumult of activity, a public art project inspired by the renovation of the space itself sprung to life. One woman who lives in an apartment that now overlooks the new High Line created a series of cabaret theatre performances on her fire escape. She regularly invites various friends to perform opera alongside her artistically displayed "laundry installations," which provide an exciting visual environment for the music that spills down into the crowds of passersby (Green, 2009a). In another area of the High Line in June and July of 2011, the artist collective of *Friends With You* created an outsized fantasy playland of puffy swaying balloons of cartoon people and animals they called "Rainbow City." Passersby could simply detour only a few steps from their regular routines and become quickly lost in the playground where one can walk into and jump onto almost anything they encounter. Smiles were across so many faces as people ran around and talked with strangers in this slice of a more playful and youthful alternate reality. Out of breath and many actually glowing, participants left to go on with the rest of their day in an exhilarated mood, and many said they returned often for a little reprieve from their routines.

The other major public space to receive a much-needed makeover in New York City in the summer of 2009 was the long-neglected Governors Island. The small island in the East River began as a military base but was recently transformed into an oversized and constantly in action experiment in social art. The public art organization *Creative Time* developed a variety of outdoor artworks and experiences, indoor installations, and film screenings that melded together to create the feeling that one was wandering through one cohesive interactive and stimulating artwork. The experience of being among the high density of public artworks on the small island is further enhanced by the beautiful city beaches, and the miniature golf course that is itself an artwork as each hole was designed by a different artist (Smith, R., 2009).

In parallel fashion, in the spring of 2009, artist Roxy Paine transformed the naturally performative space that is the magnificently open rooftop of New York's Metropolitan Museum of Art into a dense, movement-filled steel forest. His installation, titled *Maelstrom*,

appropriated the heavy materials that hold up the city and literally twisted them into the organic tangles of a natural landscape that echoes some wild vegetation-filled place far beyond Manhattan. The effect was both transformative and mystical, like being in an urban secret garden. Although this is not a truly public space, as it is within the museum, it is an open (both physically and artistically) space that eludes tradition (Siegel, 2009b).

Marilyn Minter's five-minute video called *Green Pink Caviar* was shown during the week of April 24, 2009, as part of *Creative Time's* video screenings (Siegel, 2009a, p. 65) in Times Square—the center of New York City tourism and a major midtown meeting point. Her brightly colorful video was shown alongside other short films by artists Patty Chang and Kate Gilmore.[3] An enormous HD screen, borrowed from MTV, lit up the bustling intersection with these artists' striking images, yet seemed to fade in contrast to the massive installations of flashing lights with brand names and streaming advertising videos that fill what seems like every inch of possible airspace in Times Square. *Creative Time's* project is not only a display of new and otherwise gallery-bound artworks in a very public space, but also an inherent protest in the display of these pieces in a particularly throbbing center of commerce. The art here is sensually captivating—it instantly distracts the mind from the desire to acquire material things and pulls the spectator into a realm of momentary disorder and emotion. Perhaps after the experience has passed and daily work has again begun, it provokes thoughtful critique that may begin with the very contrast between the everyday and the visionary and creative.

Jenny Holzer has been making public and socially based artworks for decades. She tends to highlight words and phrases, often filled with existential warning, or political or social commentary, or controversial and thought-provoking ideas. In 2009, the Whitney Museum of American Art ran a major exhibition of her work dating from the previous 30 years (Purves, 2009). Her artistic philosophy centers on confronting people with a vision of penetrating phrases in their daily lives. In earlier work, in 2007 in Rome, she used light to project the words: "I want peace right now. While I'm still alive. I don't want to wait. Like that pious man." To protest and bring awareness to the wartime atrocities against women during the genocide in the former Yugoslavia in 1993 and in 1994, as part of her project *Lustmord*, she wrote on human skin phrases like, "I am awake in the place where women die" and "My nose broke in the grass my eyes are sore from moving against your palm." She calls all these phrases her "truisms" (Purves, 2009), such as the more general, "You can't get away from yourself" and "Abuse of power comes as no surprise." Many critics

believe that, beginning with her work in the 1980s, which ran her "tru-isms" on ticker-tape billboards, she has created her own genre of public art—that of direct communication with the intent to inspire awareness and critique. She is said to have "invent[ed] a new form of public address that advertised the necessity for thought itself" (Purves, 2009).

Despite the creation of avant-garde work, the tentacles of society are always grasping for more material to twist into its likeness. Even about the challenging and controversial Holzer, it has been said that, although she began her career by co-opting society's arenas for communication with her "truisms" she and her techniques have now been co-opted, as the general public has democratized her creative process and made public their own truisms by way of Twitter and other online forums (p. 234). Her most recent work, in the Whitney show in 2009, continued her desire to communicate and raise awareness through the dissemination of penetrating phrases, but without the aid of technology. In these new pieces, inspired by the secrecy surrounding America's involvement in the war in Iraq, she relied instead on a more traditional art form to cre-ate pristine oil paintings of declassified government documents obtained through the Freedom of Information Act. Holzer reflected on these works in a 2009 interview, "I thought paintings, which tend to be stud-ied and conserved, could keep information before people. And when I had it right, the hand-rendered oil backgrounds were appropriately grave and emotional" (Purves, 2009).

Across the pond, an artist with an only gradationally different approach to the intersections between art and politics—the Parisian street artist known as JR—has painted enormous photographic portraits of the less privileged and homeless residents of various neighborhoods around the city, confronting everyone with amplified faces of community members on building walls (Wood, 2011). He has developed similar projects in other parts of the world as well.

Some works, usually noncommissioned ones, take on an even more spontaneous form. In 2009, at the New Museum downtown and at the Museum of Modern Art (MoMA), there were several experiments with performance art that involved artists laying down and sleeping in the middle of the gallery space. Museumgoers ended up experiencing both the art they paid to see when entering the institution and the gue-rilla confrontation of the obstructive public art performance. The same performance—to configure the human body as a physical obstacle with mysterious intent—has played out in several public venues and streets by a few anonymous social art experimenters. Despite where it was per-formed, the seemingly passive performance resulted in inspiring new communications among those watching (and stepping over the artists).

Participants confront politics in the broad sense, in their experience with and approach to the disruptive spectacle of an obstacle.

Uncommissioned and Sometimes
Unwanted: Other Graffiti Work

Since its early heyday in the 1970s and in the 1980s, graffiti street art has inspired lovers as well as detractors. The debate usually involves choosing between the "defacement" of public spaces and property, and the beauty and awareness that is created from street art. Graffiti has a long history, particularly in New York City, and has become more accepted by the mainstream establishment in recent years, as many street artists gained international acclaim. New York City artist (he rather calls himself a curator) Michael Anderson has for decades collected graffiti stickers—the small stickers, stuck on walls and other surfaces, bearing tags and phrases that are ubiquitous around downtown New York. His collection numbers around 40,000 stickers. In a recent testament to the submission of even graffiti—a self-declared guerilla art form—to the tentacles of mainstream society and commerce, the boutique Ace Hotel in Manhattan commissioned 4,000 stickers from his collection to be installed in their lobby (Kurutz, 2009). Although Anderson claims to be preserving art that would wither away left on the street, some of the artists disagree. One, Steve Powers, says that "stickers are meant to be ephemeral, not to be poached and hoarded" (Kurutz, 2009). It is interesting that once street art reached the point where it became more often praised than criticized, at least among the cultural elite, it was literally lifted from the street and placed either into institutions of art or, perhaps even more antithetically, into places of business.

The Move toward the Performative and
the Conceptual

There has been in recent years a collective "smell in the air" of a social and public turn in art that is lingering and maturing, as well as an institutionalized interest in performance art, and a resurgence in performative conceptual art projects in the form of "happenings." This has seemed to coincide with both the economic recession, as well as the turn of the first decade of the twenty-first century. *The New York Times* art critic Holland Cotter argues that "[c]ubism, was, initially, far less a style (though it became that) than a way of rethinking art's place in the world. To some artists at the beginning of the 20th century

that place felt uncertain. Photography's recording eye had made realist painting redundant. At the same time, with old social, scientific, religious and political certainties giving way, the very definition of reality was up for grabs" (Cotter, 2011b). We are at a strikingly similar point of overlapping traditions and debates—where the beliefs and behaviors of modernity still intermingle with postmodernity, but postmodernity often blurs with post-postmodernity. The movement toward more interactive and public art is moving in tandem with larger changes in our understandings of our world, and of our relationships within it. There is strong evidence of this, in several different arenas.

In the several different "gilded" ages in America's post–Civil War history—the final decades of the nineteenth century, the jazz age of the 1920s, the conformist 1950s, and the divisive 1980s—where a glimmering elite class casts a "gild" over all of society with convincing glamour, but a vital undercurrent of a less privileged (or in the case of the 1950s, a less traditional) under class, exists to provide tension. It is possible that this current recession era is another of these particularly "gilded" moments in our history, where economic, and along with it social and cultural, forces diverge from a center and develop in parallel momentum. In support of this, the current US Federal Reserve Chairman Ben Bernanke softly agreed in an interview with the television program *60 Minutes* on December 5, 2010, that indeed the gap between the rich and the poor in America was widening, and that this trend was troubling.

Increasingly, contemporary (post) postmodern continuations of mid-twentieth century avant-garde movements like performance and living art, experiments with conceptualism, outsider or "folk" art, and the many strains of avant-garde dance and theatre, are gaining value within the more mainstream institutional art experience and are very much alive in the free spaces of the outdoors, and in the small theaters and galleries of all stripes that reside on the fringes of mainstream creative life.

There are many examples of this. Through its freedom to enrich everyday life and break down the boundaries of reality, art invokes fantasies and possibilities. But some artworks attempt to reawaken and reconfigure people's minds in a more in-your-face way. Big Art Group, created by Caden Manson and Jemma Nelson, based in New York and appearing off-off-Broadway, is a live-art ensemble that combines performance with video projections to create an experience where viewers simultaneously watch a live show and a movie of the very same show as it is happening. The group performs loud, tangled, chaotic works that engage the audience (such as *SOS,* in March of 2009) by putting spectators under

a "spell" during which they hope viewers will reimagine and revital-
ize their thoughts and their lives. "Big Art aims for something more
alchemical than mere entertainment." Manson spoke of ways to make
"a combination of actions that literally changes the future...like infect-
ing the audience with a certain set of contexts for their conversations"
(Shaw, 2009). Manson explained that he wanted the performers and the
audience "to think about celebration, specifically the kind of pagan ritual
that creates the 'new' through sacrifice."

In another example of a recent work that used spectator involvement
and atmospheric immersion to encourage contemplation of universal
human questions, Japanese conceptual artist On Kawara put on display
the subject of one of his most fundamental inner contemplations, in an
interactive gallery show in New York. Kawara has had a self-professed
obsession with time since his earliest works from the 1960s. It was then
that he began his ongoing series, "The Today Paintings," where he
paints only the date on which that painting was made. If he is not able
to finish one of these paintings on the day it was begun, he destroys it
and begins anew the next day. *One Million Years*, his most recent work,
from February 2009, employs two volunteers per hour (one man and
one woman) to sit in an enclosed glass and plaster box inside the David
Zwirner gallery and recite a progression of years, running either a mil-
lion years forward or backward in time (Saltz, 2009h). This exercise,
both listening and actually reciting, forces even inactive participants to
consider and reconsider time, and their relationship to the passage of
time. The performance of reading the dates pushes the volunteers to
form the sound of the years from their own voices, using physicality to
heighten the experience.[4]

Around the same time that the New Museum was planning, and
then opening, its cutting-edge doors in the bellows of the Bowery, the
MoMA, many say a fairly direct representation of New York's insti-
tutionalized art world, began to seek and even encourage less tradi-
tional forms of art-making, and in particular socially and interactively
based, as well as conceptually and performatively oriented, artworks.
Though even the stalwart Metropolitan Museum of Art uptown has
dipped its toes into the intimidating waters of conceptual art, when it
displayed Damien Hirst's infamous shark in formaldehyde sculpture,
back in 2007, on a three-year loan.

In a Chelsea contemporary art gallery, the artist Christian Marclay
set up an exhibition of a video that was in perpetual play mode for 24
hours a day. The 24-hour film/event, known as "The Clock", involved
a moving collage of snippets from film and television history, aug-
mented by a reading of the time (in both real time and film time),

each minute, and sometimes second. As the work is about both try-
ing to understand time, and the *feeling* of the passage of time, viewers
were encouraged to stay minutes or hours, or even all night (Kennedy,
2011b).

Also in a New York City gallery in spring 2011, the artist Terence
Koh created one of his endurance-based, and quietly political, move-
ment performances. In the new piece, Koh took an oath of silence and
walks around, and sometimes crawls or lays down completely on the
gallery floor, every moment that it is open, which is five days a week
for eight hours a day. Although he does not explicitly request audience
interaction, there has been some audience participation in the solemn
work (Smith, 2011c).

At the Baryshnikov Arts Center in New York City, the Japanese
American dancers and performance art duo Eiko and Koma created
"Naked: A Living Installation," a fluid, slinky, organic sliding around
of their two naked bodies in an almost painful slow crawl to and from
each other, among leaves, feathers, and various foliage. This work also
allows the audience to remain a passive audience, but the sheer closeness
and vulnerability of the performance creates inclusivity, dialogue, and
intimacy (Sulcas, 2011b).

In April 2011, another performance piece that linked corners
between conceptual work and theatrical work, by the American artist
Robert Whitman who is well known for his work with experimental
theater in the 1960s, stimulated interested viewers/experience-ers in
two geographic locations at once. This piece, called "Passport," hap-
pened at exactly the same time, in both Beacon, New York, at the
Dia Art Foundation and the Alexander Kasser Theater at Montclair
State University in New Jersey. At each location, those present were
shown images from the performance taking place at the other location,
essentially creating a bridge between locations, and more importantly,
between the people watching the performances, as well as an immedi-
ate dialogue. His work has always pursued interaction and involvement
on the part of the viewer, and he often made this happen through
physical arrangements of the viewer, such as his 1960 piece "American
Moon," where he forced audience members into different tunnels, so
that each viewed the performance from their different vantage point.
This 2011 work of Whitman's links action taking place in two different
places, exploring the concept of instantaneous connectivity essential
to modern technology, from the Internet itself to social networking
sites and the other digital connectors, but through a more varied and
physical, rather than individual small-screen-based, experience, simply

by creating the interconnected performances so that one was indoors but in a theater setting, and one outdoors in a park setting (Kennedy, 2011f).

Interaction in Art

In observing the newest trends in contemporary art, critic Jerry Saltz has explored the fruitful relationship between art and the environment in which it is presented. He would likely agree with the contention that galleries and museums are places of ritual and reawakening. From artists like the creators of the Big Art fringe performance group to academic voices like that of Carol Duncan, many have attempted to show that viewing art is a creative process in and of itself, and that it is possible to elevate the experience of viewing art to that of a spectacle, a transformation of mental space. Saltz (2009c) describes a newly established gallery space inside a former boiler factory in Brooklyn as "using the extraordinary human and architectural infrastructure already here" to give the art extra life. He explains that "too much purity, architectural or aesthetic, is bad for art right now…art needs to feel more connected to the world." Presenting artworks in reconceptualized spaces rather than in bare, whitewalled, cube-shaped rooms provides a personal or historical context for the works. The Tenement Museum on the Lower East Side of Manhattan is one of the larger institutions to experiment successfully with this added element. Its small, cramped exhibition spaces emulate the conditions of life that the museum attempts to recreate. The Holocaust Memorial Museum in Washington, DC, also tries to draw visitors into the horrific suffering and unspeakable sadness of the historical event that it brings to life.

Of interest, too, are the exhibition spaces that do not so directly correlate to the objects on display but rather serve as either a contrast to the art on display or complement it with an unexpected connection. In this sense, when the space creates a feeling that is distinct from the primary focus of the exhibit, then the final presentation of the art becomes cross disciplinary and more stimulating for viewers. In a social and economic environment that desperately needs to protect and invigorate ties of community, it is evermore vital to create an experience with art that reminds viewers of the life around them. Either the room displaying the art should disappear as one is left alone to experience the art, or the space should enliven the works with added dimension, so to encourage an inner gaze into the self and into one's needs and vulnerabilities that reflect, and thus connect us, to all others.

Beginning with the infamous "happenings" of the 1960s and the conceptual turn of the 1970s, to the articulation of a theory of "relational aesthetics" and the complementary community revitalization projects of the late 1990s and to today's mix of directly political and conceptually interactive works, the concepts of community, communication, and relational behavior have been employed as the art itself. The interactive performance art movement began to prosper in America in the heady and open-minded 1960s, with the work of artists such as Yoko Ono, who once wore an enormous tangle of cloth layers and invited the audience to cut all the fabric off of her body in a slow ritual until she was nude. This creative paradigm continued with Gordon Matta-Clark creating his *Food* restaurant inside a SoHo gallery in the 1970s, and contemporary social artist Rirkrit Tiravanija, who, working in the same vein as Matta-Clark, prepared his own Thai curry for gallerygoers in 2007 in New York, as part of an interactive project called *Free*. The movement has evolved into the most recent projects in this realm, which include, among many others, Kate Levant, a Yale student artist who created a running blood drive inside a gallery; Eduardo Sarabia, a Los Angeles artist who set up a working tequila bar in a gallery space; and Bert Rodriguez, the artist who offered willing participants a free therapy session and simultaneously poured its murmured sounds throughout the gallery space.

Making a performance out of capturing the performance of life is another approach when employing the audience as a key element of the artwork. The work of experimental British artist and filmmaker Mike Figgis, creates a self-reflective atmosphere among subjects/viewers. In his mid-2009 gallery show he created a direct reflection of the audience, adding an element of immediacy in the reflection. He picked a high-traffic designer store in the SoHo neighborhood of New York City and took photographs of both famous and not-so-famous locals shopping over the course of two weeks. He printed all the photos in the store right after they were shot. At the end of the two weeks, he installed the resulting collection of candid portraits in the Milk Gallery exhibit space. Figgis wanted to show that most galleries and museums frame and display works that are "a little dead" as they capture moments long gone. While there is much to learn and feel from historical and universal moments exemplified in an artwork, and life can be found even in that which is "dead," Figgis's works are fresh and immediate, like just-past reflections in a mirror or the memory of a celebration while still in revelry—an embrace of instant nostalgia (Nelson, 2009). This perspective enables visitors to the gallery to see themselves from the outside, and to look with distance at the party they are experiencing, all in the context

of an institutional display of art. It encourages viewers to remember that they themselves can be art in action—in other words, that they have a creative will to become acquainted with, and to nurture. This realization can lead to the type of questioning and self-assessment that results in deeper self-awareness, which is essential to the development of one's own creativity. A creative will is also a political will, for creativity displays the power of the individual to create change, and thus inspires interest in public life and its reform.

In March 2011, the New York painter Eric Fischl "became fed up with the isolation of traditional museum and gallery venues"[5], and announced the development of a privately financed moving museum and performance theater, titled "America: Now and Here". Set inside an armada of large trucks that planned to make frequent stops in many towns across the United States to open their rear doors to viewers and participants of all ages, the theatre aimed to bring the unfiltered joy of art to as many people as possible. Six eighteen-wheelers of art will be a part of this "Great American Art Trip." There will be a nonvehicular preview of the project, and then the trucks—full of live music, live poetry, installations, paintings and photographs, and performances—will be set to start their journeys in fall 2012. The focus of the project is both creative and political in nature. Fischl aims to bridge gaps between what he sees as mass alienation of people in a post-9/11 world, to foster inclusivity with and through art, and to bridge gaps that Fischl sees "between what artists are trying to do and how what they make ultimately gets used" (Kennedy, 2011e).

In a similar vein, though on a more grassroots level, Mark Krawczuk, founded the Lost Horizon Night Market with Kevin Balktick. They unveiled their diverse and energetic "happening" in Brooklyn, New York, in 2009. A roaming ephemeral late-night market of art and performance displayed and enacted in a collective of temporarily parked trucks, interacts with neighborhood locals. Unlike the Great American Art Trip though, each of the Night Market trucks is independently run by both individual artists and creative groups, and they all get together every three to four months and set up shop as the Market. Admission is always free, and the creative action begins around 9:30 p.m. and usually runs until about 2:30 a.m., at which point the trucks pack up and surprisingly quickly disappear into the night. The creators said that the Market ideas has already spread to San Francisco and is being considered by artists in Boston, Pittsburgh, Detroit, and Portland, Oregon (Bruder, 2011).

In another experiment with providing people free access to the tools of art, British artist Luke Jerram, sponsored by the nonprofit organization

Sing for Hope, created a traveling worldwide interactive public art experience that highlights both the power of music in our outdoor spaces, as well as the belief that everyone is an artist, and that art is everywhere. "Play Me, I'm Yours" is an interactive outdoor art project that was created in New York City in both the spring of 2010 and again in 2011. This project consisted of 60 pianos, each painted in a different burst of colorful designs, dispersed in a variety of public spaces all over the city. He has installed his pianos in many cities across the world and has not yet paused in spreading his interactive art. YouTube is filled with examples of beautiful musical moments, by a wide variety of momentary musicians, caught on tape.

Some large-scale public sculptures are more innovative and engaging than most, and thus they stand out in the sea of redundant hunks of steel or resin that fill so many of our malls and office parks. Large sculptural objects and installations not only literally enlarge and thus highlight people, places, and ideas, but these figures are impossible to completely ignore in our otherwise mostly comfortable public spaces, and thus can easily transform a public, largely unchanging space. Many notable large sculptural interventions have energized New York. Three recent works were particularly noticeable as creating a true transformation of the spaces that they each dominated. The first, enormous-sized, snake-like, rainbow-colored sculptures were equipped at their foundations with built-in stools where passersby could sit or stand and look up to contemplate the sky as it was cut through by the colorful tentacles of the sculptures. Artist Franz West called these sculptures "The Ego and the Id," and they were installed in Central Park from 2009 through 2010. Artist Jaume Plensa's "Echo" in Madison Square Park, up for the summer of 2011, was a white, vastly oversized, modern sculpture of a head that presided over the rolling greens in front of it invitingly, maternally and spiritually. The artist Will Ryman's giant installation along Manhattan's Park Avenue (Spears, 2011b) brought curvy fantastical sculptures of pink and red roses and the various bugs that enjoy the taste of roses, to the otherwise gray and boxy design of the grand uptown avenue, from the winter through the spring of 2011.

In Times Square, as an extension of the expansive annual contemporary art fair in the form of the Armory Show, large playful sculptural works by five artists populated the busy open areas of the central New York hub. The crowded foot traffic marched alongside a tightly knit flock of oversized, soft-looking sheep made from heavy paper, which grazed quietly, a giant bronze mouse that seemed to be crawling out from the underworld of a subway station, and not far from that, an oversized luminous glass female figure presided over the square

(Kennedy, 2011c). Also in Times Square in 2010, the Spain Art Fest brought innovative live performance and interactive works to the commercialism and celebration of popular culture that regularly thrives there. One piece involved the artists laying down and crawling, painted in a chaos of lines and shapes that matched exactly with the mess of lines and shapes that were scrawled onto an enormous tarp on the ground amidst crowds of people. Viewers became participants as they were invited to lay with the artists and create a human canvas that kept continuously changing.

Institutional Examples of the Inclusive and Interactive Turn in Art in the United States and Abroad

There have also been several major examples around the world of art institutions taking interactive and performative, if not exactly public, directions with their collections and exhibitions. This social focus in the exhibition of art implicitly acknowledges art's ability to express universal concerns, and encourages an experience with art where the artwork is actively in dialogue with its surroundings, its time, and its audience. Many of the newest curators in the upper echelons of the art world have embraced the idea that where and how you experience art is transformative in itself. This idea can be seen in the increasing numbers of smaller alternative spaces showing interactive pieces and in the acceptance of performance and interaction-based artworks in traditional art institutions. These trends work to improve the problems of exclusivity that traditional museums face, as well as to draw attention to the diverse ability of artworks to actively engage those around them.

Important to the institutional contribution to the wider turn toward social and interactive art—which is itself an increased attention to the "public" as social and interactive art inherently aims to but more inclusive, even when not carried out in the public outdoors—is the concept of "radical curation." This approach can exist in many incarnations. It is possible to create engagement by the sheer placement of art objects. Rather than group according to genre, color, or date, it is possible, and evermore commonplace, to place two very different artworks or artists side by side. This can create natural conversation, or interesting discord; often one piece can shed light on, or educate us, about the other. In a similarly subversive move, one can place the art object in a place not specifically designated for art, such as a lobby, a coat check, or a restaurant, or the more wild—on a van, on a train, or in a hospital. These types of trends have been moving in line with the greater trend in the art world toward increasingly including performance art in major retrospectives

and in the "collections" of major institutions of art around the United States, and around the world.

In a somewhat unique example, the new Russian center of contemporary art in Moscow, located in a monolith of an abandoned Communist-era warehouse, demonstrates well how smaller museums that are showing contemporary art, are keeping with social and interactive tendencies in the newest art ideas. These institutions are using atmosphere-creating spaces that, rather than simply displaying the art, give the artwork a place to live and continue to create.

This new trend away from the conventional museum style of presenting art and reconceptualizing previously used, often historical spaces, into homes for the newest ideas in art is well exemplified by Lismore Castle Arts, the project of William Cavendish, Earl of Burlington. He and his wife, Laura, dedicated a long-unkempt section of their family castle, located in remote corner of Southern Ireland, to a summer exhibition space for performative, conceptual, and interactive projects. "I wanted to do something that was a bit more ephemeral, not so acquisitive," William explained. An interesting example of work like this is that of Brooklyn artist Corey McCorkle, whose Lismore Castle project involved his all-day brewing of wild dandelion wine made from the plants on the castle grounds, in order to perform the transformation of an undesired plant into "something ceremonial"—a reconfiguration of an ordinarily unnoticed object into a useful and beautiful one, with a focus on interactivity between his projects and the visiting spectators. Touching on the issue of supporting and displaying spontaneous, interactive works of art such as this one, London gallerist Iwan Wirth has said of Lismore Castle Arts, "It displays a deep, intimate commitment to art that museums no longer are able to have" (Reginato, 2009, p. 98). William agrees: "We are not bound in the way that institutions and commercial galleries are . . . we can offer the artists a chance to do something out of their normal cycle" (p. 98).

A continent away, in November 2008, the Los Angeles County Museum of Art hosted an event titled "A Machine Project's Field Guide to the Los Angeles County Museum of Art," which, as its name implies, encouraged its audience to explore freely the "natural habitat" of the museum (Finkel, 2008). In the words of its creator, Mark Allen, "Los Angeles has so few public spaces where people can gather, we wanted to treat the museum as a sort of park, creating these pockets of social activity. . . . Visiting a museum can be like visiting a very rich person's house, where you feel pressure to admire the furniture. We wanted this to feel more like hanging out with friends" (Finkel, 2008). As Margaret

Wettheim, cofounder of the *Institute for Figuring* who was invited to set up a workshop as part of the discovery-filled multi-layered event, observed, "It's also about breaking down the wall between artist and audience. We don't want to pontificate from on high" (Finkel, 2008). "Machine Project" philosophy rests on this democratic ideal, and on the belief that "noninstitutional" takeover of institutional venues creates a valuably open atmosphere for the art. Also in Los Angeles, Jeffrey Deitch's appointment to head the Museum of Contemporary Art (MOCA) there sets a precedent in the institutional art world that links the academic or educational world of the museum with both the commercial side of art exhibition (Mr. Deitch famously ran a pair of cutting-edge galleries in downtown Manhattan for years) and the social and public turn in art (he has heavily supported social and public projects, even to the detriment of sales, as many of these types of work are not easily sold).

Since Deitch officially took over the management and development of the deeply suffering MOCA in Los Angeles in the spring of 2010, many in both the art and style worlds have watched his every move and have awaited the opening of his first exhibition. The curious art lovers and critics, as of April 2011, were rewarded with "Art in the Streets," the first major American museum exhibition focused entirely on street art, and drawn together by Deitch. The focus in the exhibit is street art primarily defined as contemporary graffiti, or the creative vandalism as art that many say began in the gritty subways of New York in the 1970s and grew into a movement that spread rapidly by the 1980s and the 1990s and still thrives today. The exhibit is, by all accounts, fun, colorful, arresting, and physical, a coming together of art, creativity, style, and everyday life and public space. Does the fact that Deitch inaugurated his tenure at the museum with "an ephemeral and often outlaw art form" indicate too that the art world in general, at the major institutional level, is consciously embracing not only the type of art—performative, ephemeral, outsider, and conceptual—that is both difficult to capture in a traditional institutional setting, but also often defies the traditional markets valuations, as well as engages with a museum audience in a more inclusive, interactive, and dynamic way? (Trebay, 2011).

This exhibit has again raised the ever present, now 40-year-old controversy of whether graffiti is even art, and more often perhaps, that if one accepts graffiti art to be "legitimate" art, then where can one draw the line between creative vandalism and just plain vandalism? Local police argued, during the first few weeks of the show being open, that vandalism had increased in the area, and they cited the exhibition

itself—the glorification of such behavior—as the culprit behind the increase in these crimes. Deitch, speaking on behalf of the museum, responded that these criminal reports had been exaggerated and offered to send museum employees to paint over any local occurrences of vandalism. Still, the internal dispute within the overlap between the art and graffiti worlds is not resolved by this major exhibit, though it does make a precedent for displaying such street art as an institutionally accepted form of art, one that can inspire community awareness through its focus on free, unregulated art in our very public spaces. It is still unclear as to what degree this major exhibition will ultimately impact the graffiti and other forms of street art movement, and the nature of the art world itself (Nagourney, 2001).

The MoMA, New York, as Institutional Trendsetter

In 2009, in recognition of the need for greater creative inclusion and institutional representation, and the quandary of exhibiting ephemeral works of art, New York City's MoMA began to more actively support and exhibit both performance art and female art and artists (Orden, 2009). In late January 2009, MoMA launched a two-year-long series of live performance pieces that planned to conclude in 2010 with a retrospective devoted to Marina Abramovic, the self-described "grandmother of performance art." This series grew out of the private Performance Workshops that the museum had quietly begun to hold in March 2008.

Pipilotti Rist's multimedia installation show, which opened in January 2009, is both overtly feminine as well as so stimulating to the senses that when in the middle of it, one feels they are part of a performance (Saltz, 2009a, p. 69). Jerry Saltz commented that "MoMA is-even with this [the Pipilotti Rist show] and the current Marlene Dumas survey—a place where very little work by women is on view. Rist's installation comments on and reacts to this misogyny. . . . MoMA seems to swell and stir to new life" (p. 69). The environment that Rist creates for MoMA in her work combines raw, feminine video images of red and pink, with an open, inviting visual and tactile womb (in the form of an oversized circular couch that dominates from the center of the room and is accompanied by dramatic, blood-colored walls and draperies) in which to experience the bleeding world on the screens. Given the societal restraints placed upon institutionalized artworks, Saltz reported, "A widely circulated rumor has it that MoMa asked Rist to edit out the red between the legs. . . . In classical terms, the Dionysian is still more fraught than the Apollonian. Thinking about this installation

without the blood is like thinking about life without blood" (p. 69). This would-be censorship is an indication both of the regulation that institutions commonly place on artworks in their possession and the still-existing, but slowly changing, differences between showing art in a museum and creating art in the streets. There have been signs that institutions are attempting to bridge this gap by increasing the diversity of artwork they display and to take part creatively (and carve a place for themselves) in the greater movement in social, interactive, and publicly based art.

In June 2008, the MoMA purchased its first work of live performance art, artist Tino Sehgal's *Kiss* (2003),[6] and thus heralded in a new age in the art world that signals an acceptance of a wider definition of art by the art establishment, and a recognition of the wider move to involve people more actively in viewing art (Orden, 2009, p. 70). Sehgal believes that we need to leave behind unsustainable and overused object-based art and rather focus on the living art of human relations (Lubow, 2010). With the launching of this exhibition, the museum is tasked with preserving ephemeral art, which in the case of the *Kiss* is undocumented (in the piece, couples dance, touch, and kiss for two hours, recreating famous kisses of the cultural past, moving freely through the large space) and proceeds without a script or manual. Instead, the guidelines are passed on orally. Accordingly, MoMA obtained the piece through an oral contract. "The artist will explain its workings to a curator; he or she will pass it on, down the road; and MoMA will have the rights to reproduce the performance forever. (Sehgal's *Kiss* is an edition of four; two other museums have bought it so far. And it can be lent, like a painting)" (Orden, 2009, p. 70).

With this new era, the MoMA aims also to ensure the preservation of the revolutionary work of the first generation of performance artists, now 40 years in the past. In view of that, the museum also purchase 31 video works by many of these performance pioneers.[7] The heart of these debates about performative interactivity has focused on the question, framed by the curator of the Rist show, Klaus Biensenbach: "How do you create, conserve, preserve a moment?" In some cases there is nothing material to purchase, only the idea of a particular experience. The Tate Modern in London and the Walker Art Center in Minneapolis, among others, have also faced this same daunting task in 2009 and 2010.[8]

In another example of the MoMA's desire to embrace, or at least experiment with, performance art as museum draw, the fluxus artist Alison Knowles created an early 2011 performance piece for the museum that was perhaps most noticeable, for its lack of noticeability. The performance is called "Identical Lunch" and has been performed many times

since 1968. In the piece, a random small group of strangers, who have all signed up to take part in the everyday life as art work, sit at a table in the middle of the second-floor cafeteria in the museum, seemingly eating lunch together. The entire scene though looks subtly transported from the 1950s, with the table standing out in blue Formica, and the lunch in front of each person simple and nostalgic—tuna and buttermilk—and exactly identical to all the others seated at the table. The idea behind the performance is several layered. First, there is the idea that the work often blends completely into its surroundings, and that the repetition and homogeneity of content allows room for documenting all of the slight differences during the variety of times the piece is performed, and for taking notice of the most quiet moments of the everyday. The recreating of the piece alone, with friends, with strangers, in foreign countries, et cetera, creates a continuity of action that can create connectivity and communication through our ability to relate to different ones, or to each one (Kennedy, 2011a).

To further support this point: "During the last year the Museum of Modern Art has reinvented itself as a Museum of Performance Art." *The New York Times* art critic Karen Rosenberg argues that the MoMA had in recent years embraced the exhibition of performative artworks, but until February 2011, only as a special exhibition, while the winter of 2011 brought "Staging Action: Performance in Photography Since 1960," the first inclusion of performance artworks and ideas in its permanent collection. For the most part, this exhibition looks at works where performances were created for, and captured by, the camera. It raises questions of how a performance changes when it is photographed (and how photography is different also from moving picture) versus when we experience it/ see it / hear it / smell it directly. Further, the issue of how important it is to the feeling we get from the work, that the performance in a photograph was deliberately made to be photographed, or the question of how a performance changes when it goes from being experienced in one moment, and in one physical space, to the situation where a photograph of that same performance is posted all over the place for many others to see (Rosenberg, 2011b).

Yet another example of the MoMA's efforts to invent new styles of exhibition in order to invigorate the artgoing public by including not only performative works, but also imaginative conceptual ones as well, in both its temporary and permanent repertoire, is the spring 2011 exhibit "I Am Still Alive: Politics and Everyday Life in Contemporary Drawing". The name is both a nod to the work of influential Japanese conceptual artists On Kawara (in 1970, he sent out a series of telegrams to friends

all over the world, with only the words "I am still alive"), and an inclusive show of conceptual works that employ the idea of drawing in some way, with the result that "drawing" ends up being very loosely defined (Rosenberg, 2011c).

Through the MoMA's Performance Exhibition Series, their 2011 exhibit, "On Line: Drawing through the Twentieth Century," museumgoers can stand mere feet away from powerful studies on movement, such as the dance of Anne Teresa De Keersmaeker, which uses a square of soft sand as though it were a piece of paper to dance lines into, in a performance that combines the body, the canvas of the sand, and the proximity to the people milling about. This performance, as is the case with other performative works exhibited at MoMA, can be viewed with formal audience seriousness (sit very close, in the "front row"), or from afar, or in snippets as you walk by, or as background noise and movement, as you chat in a far corner. This ability to have different experiences with the artwork raises some interesting questions and opportunities for performative, as well as interactive and publically exhibited (outside of the museum, on the street) art (Sulcas, 2011a). Although these performances did not take place in public spaces (this would be ideal), their acceptance into respected institutions demonstrates a changing understanding of the experience of art in general that is beneficial to the creative reawakening of individuals.

Invigorating Effects of the Recession of 2008—on Public and Social Art

In still another indication that the creation of art, particularly social and public art, is intimately linked with its environment and thus political life, the deprivations of the recent recession have encouraged both our public culture and the art world to give primary attention to public spaces and to community building. Because collectively Americans tend to favor individual acquisition of material goods, it took the power of this recession to tear even a small hole in society's tightly knit relationship with the importance of money. Americans' general disillusionment with the financial realm made for greater consideration of both spiritual and sensuous needs. During the March 2009 record stock market lows, "A Day Trading" installation popped up at the Museum 52 gallery and, for its four-day run, encouraged visitors to barter and swap personal goods, services, and talents. Peter Simensky, the artist who created the interactive installation, also made his own "neutral" currency bills with which he "bought" the artworks and objects he most liked and at the end of each day at "A Day Trading" displayed them in the gallery space downstairs.

(Artbeat.com, 2010). The living, dialogical sculpture of sorts worked both as satirical commentary on the financial crisis and as an opportunity to experience firsthand an alternative, social and need-based, version of market interactions.

Similarly, the difficult economic realities that the recession created, the cultural turn it spurred toward a life less geared to private possession, and the collective reminder that money can be here one day, and gone the next, drew public attention to the enduring value of community and the satisfactions found in that which cannot be possessed or assessed monetarily. In line with this revitalized cultural appreciation for all that is traded and shared according to use value rather than market value, as well as for pointed experimentations with ideas of currency, the "Free Store" was installed on a nondescript corner of downtown New York City near the financial hub of Wall Street. From February 19 to March 22, 2009, artists Athena Robles and Anna Stein created a socially cooperative mini-economy where goods were traded for goods, and others "bought" with the global currency termed "World Bills," which was both offered and accepted by the project. The stated goal of the project was that the "Free Store aims to reinforce and build connections based on trust and mutual exchange among the people of and visitors to Lower Manhattan. The project is designed to be a model of community and financial support that could also be used in other cities around the world" (Artlog.com, 2009).

Along the same lines, the artists behind "free public rentals," a website that arranges the trade of community and personal services among people, created their site to be an expression of the idea that interactive sharing can be art itself. The project designers also believed in the need to foster public exchange and communication, and they recognized that much of our social lives revolve around the purchase of goods and the daily chores of our lives. These services for barter range from a walking partner to "plant petting" to the reading of bedtime stories.

In these humbling times, there has been ample discussion of how the high-priced, insular art world fares during a recession. Outside of the "off-the-grid" grassroots art interventions that have tended more and more to appear as interactive performance-based works, the lack of cash flow in the economy has forced some adjustments among those who hawk art. Some critics have said that the art boom was a great loss to the quality of art being produced and appreciated. They argue that art had begun to pander to the masses, and though many were finally buying art, this trend detracted from the quality and authenticity of the art itself. In an art world that revolves around the major commercial art fairs, like the Armory Show, Art Basel, Pulse, and Scope, a

lack of wealthy buyers has resulted in fairs' and galleries' selling more traditional and less challenging artworks and in their taking emerging artists' works (which tend to be more difficult to sell) off the gallery walls (Peers, 2009). Yet artists always make work, and great art, as we say of the truth, will always prevail and make itself known. The lack of financial support that has created a narrower and more challenging niche for art has also deprived many artists, especially younger ones and those who produce challenging or controversial art, of their livelihoods and career opportunities. Many art galleries, unable to sell their product, closed in 2009, as well as in 2010. Fortunately, there are so many artists creating exciting and confrontational moments on the streets of New York City every day, that one can experience the most emerging movements in art on their way to work. "Something that may be crucial for art right now may be an artist's ability not to want to know or dictate what's coming next…[as] an open embrace of the confusion…while the market is dying, art is in the process of being reborn" (Saltz, 2009d).

Conclusions: Reclaiming the American Heritage of Community through Art

The visionary inventor Buckminster Fuller devoted both his scholarly and his personal life to the public and democratic accessibility of ideas, to interdisciplinary pursuits of knowledge, and to the need for human connections across ideological and geographic divides. He believed in and lived a life that revolved around striving for clarity when explaining challenging ideas in order to draw more people in. "He argued that if complex science wasn't easily comprehensible to a child, it was in danger of faulty logic" (Carlin, 2008, p. 53). He was an advocate of both the value of community, and the preservation of the individual, and recognized that only when we nurture the individual can we truly connect with a diversity of individuals, in the form of community. He famously designed living units that were not only self-sustaining but were also meant to be simply constructed by the average citizen. He both wanted to make visionary experiences more open and available, and he explored creative goals through a very consciously cross-disciplinary lens. His philosophy is a guiding light for both the inspiration and goals of this work.

In the summer of 2008, the Whitney Museum of American Art in New York City hosted a retrospective on Fuller's work and showed, among many other examples of his philosophy, a video called *Buckminster Fuller Meets the Hippies in Golden Gate Park*. In this short film, Fuller

engages long-haired men and women seated on grass in a conversation about how they relate to, and feel about, the "spiritual constraints of his geometric designs" (p. 53). His genuine concern in this situation demonstrates his belief that our physical spaces, our visual world—the art and architecture around us—has a direct relation to how we think and to how we feel. Further, that he expressed worry in his work that strong lines and hard angles could limit the spiritual or emotional life of people shows a unique attention to everyday experience and the role of public spaces within that experience.[9] Specifically, he brought attention to the power that a nurturing public environment has in the promotion of both the individual capacity to imagine change and in the encouragement of human connectivity.

His work is in line with those thinkers who have argued that experience with art is ritualistic and transformative. His lifelong pursuit was to design physical environments that were inviting, communal, and accessible, and where even the very lines of the buildings that created the space were considered important parts of the experience of being there. This is again testament to the notion that public space *does* matter in an important way to public life, to the quality of everyday experience, to societal communication, and to the development of an active public sphere.

This project has endeavored to draw together the importance of public art, with the value of socially interactive and engaging art. Art in the public is important primarily because the public is important. Beyond this, more challenging and engaging works in the public would enable not only contact with art for as many people as possible, but also contact with visionary art that is infinitely more powerful and encouraging than the more redundant "comfortable" pieces that busy municipal bureaucrats often choose.

The primary characteristic of visionary art is that it is self-reflective—creating art, even if only in the imagination, involves both sensuousness and reflection. In other words, such art is conscious of its transcendent qualities; it is the coming together of universally experienced emotions with reason. Art can also express an approach to life. In this sense, to be artistic is to embrace an emotional and sensuous, yet dialectical and reflective, worldview. Creative release enables us to begin to experience *true* art in its instinctual revelations, but it is the visionary conception that Dionysian instinct must engage Apollonian reason in a transcendent dialogue that allows us to create and experience new and affecting art. From the increased contact with visionary art that publicly displayed and enacted works encourage, an increased number of people can access the

desire for what is an inherently rebellious participation—in that it is a truly free individual moment of reflection, apart from the widespread arms of popular opinion—that experience with unique and challenging art ultimately encourages. The liberating aspect of experience with public and interactive visionary art means that through the art, individuals gain access to free space to think entirely for themselves—to begin to consider new approaches on their own terms. It is this experience of empowerment that this book wants to call attention to. This is one of the greatest rewards visionary art grants—that of independent contemplation of oneself, and of others. It is certainly not the point here to force art down the throats of those who resist it. The goal is to increase knowledge about the possibilities contained within transformative art and creativity and to encourage all individuals to try it for themselves.

There is a corollary argument to this that has been thrown around in discussions that attempt to resolve the free-rider problem of political life in this country. The belief that the most effective way to "convince" people to participate in the public sphere more actively—whether in their communities, in the political process, or in their own lives—lies in the conditions imposed by an overarching authority, such as the government's offering financial or otherwise material incentives for civic acts like voting. This is akin to saying that the best way to deter smokers from continuing their dangerous habit is to place a tax on cigarettes. Likewise, there have been recent discussions among the American public that the cure to our national obesity problem (the current statistics being that more than 26 percent of Americans are officially obese) is a so-called fat tax, whereby fast food and soda—what many claim is at the root of the weight problems—would carry an extra tax that would deter consumers from choosing to buy fast food rather than a more healthy alternative (Bittman, 2010).

This argument, that if we could only provide a valued (and tangible) incentive to those who participate, we would be more likely to get a faster and more significant response than if we work more slowly to genuinely inspire people with political possibilities, is somewhat misleading and only serves to supports the status quo. We need a new approach to confront the problem of low participation in this country, and supporting public and social artworks brings much-needed attention to the true freedom of our creative and sensuous lives. The knowledge gained from such access to the spirit can open inner doors within individuals to develop new empathy for the plight of others, and ultimately, to view political life as foundationally empathetic. In other words, you can catch a fish for a man, but if you teach him to fish, he will catch many fish and teach others to do the same.

To bring experience with art into the structure of a mandatory system, like that of our justice system for example, where one could potentially be "fined" into making art as part of a community service sentence, could be effective as far as creating new experiences with art, but it slightly misses the point. The overarching idea of this book is to bring art into the lives of as many people as possible simply by creating distractions and interventions in their everyday lives that make art and creativity accessible, interactive, and provocative. Analogous to this point would be to offer art therapy to prisoners and introduce it to them through an inspirational and challenging performance that would make them want to get involved and take that class, rather than having to do so because a judge deemed it so. Rather than force art appreciation on people, the best works of public and socially interactive art attempt to communicate, include, and genuinely excite through the creation of feelings of both inclusion and invigoration.

In this work, I make a call not only for the creation of more public artworks, but perhaps even more importantly, for the creation of "better" public artworks. Jerry Saltz has written that "90 percent of all public sculpture is bad because it's chosen by committees and bureaucrats, that no one even knows what public art should do anymore. The vast majority of outdoor sculpture is geometric, corporate-looking work or silly, figurative plop-art" (Saltz, 2010e). This is not an unfair argument. I think we have all seen boring blobs of material in the middle of some manicured public park, and wondered to ourselves if all public art really looks the same, or if it just seems that way. Art that is in the public and in central and unavoidable places in particular is the most democratic way to reach out to vast amounts of people everyday. This new decade, this new century, rife with artistic experimentation and the building momentum of a public and interactive art movement, is a spectacular opportunity to use public art in the service of individual empowerment and fulfillment, societal health, and engaged and widespread public and political participation. The movement in art toward the interactive and the public that has been quietly flourishing in pockets of artistic communities for decades has in recent years been building to a crescendo.

The works included in this movement employ alternatively or in mixed fashion, the open, communal, and mundane characteristics of public spaces, and the excitement and inclusivity of interaction. These two approaches can be viewed together in that they each aim to increase the depth and diversity of our perceptions of both ourselves and the world. The contemporary artist Vik Muniz, in describing his own feelings on the intersections of art and political life, reminds us all of one of

the greatest purposes of art and creativity: "My experience with mixing art with social projects is that [that's] the main thing is [just like] taking people away for, even if it's for a few minutes, away from where they are and showing them another world, another place, even if it's a place from which they can look at where they are. [You know] it just changes everything. [Wouldn't this be] an experience in how art could change people" (Harley & Walker, 2010).

NOTES

Introduction

1. Hannah Arendt (1998) describes the public in several ways: the very appearance of the public creates the public; the public is all that is not our private worlds; it is created by humans, not Nature; the public realm is fundamentally political (an arena in which to discuss social ideas), free (from private concerns), and based on action (the private realm, for Arendt, being that of property, which comprises labor and work, and the basic functions of our families and our bodies). Although her definitions of the public are comprehensive and useful, I disagree with her stringent characterization of the public as altogether divorced from the private realm, where everything messy—from emotions to bodily functions—remain outside the consideration of public life. This denial of the private within the public is both unrealistic, and possibly detrimental to political life. Despite her understandable concerns that work and labor have taken the place in importance of political discussions, her conclusion that the political must proceed freely and "uncorrupted" by the equalizing effects of property and the home, paints a picture of an ideal political world that fails to address our entirety as humans and as citizens.
2. In this work, I use "plastic" art to describe art that is repetitive of old forms and reflective of the status quo. "Plastic art" stands in opposition to "visionary" artworks that innovate, challenge, and excite.
3. "As our country strides the globe as a colossus, American culture is putting the rest of the world to sleep, and our own creative impulses have gone into hibernation" (Graves, 2005, p. 6).
4. "The deterioration of cultures is not exclusively an American problem. While we have perhaps pushed assimilation to an extreme, the problem is global in scope. In 1977, the great American folk song collector Alan Lomax sounded on urgent warning about the inevitable cultural 'grey-out' that would result from the destruction of traditional societies and the homogenizing influence of mass communication" (Graves, 2005, p. 7).
5. Some argue that, "American governmental support for the arts has been so weak [that these arguments are largely irrelevant]" (Graves, 2005, p. 11).

6. According to Gioia, "The one alarming note in this study is that arts participation is falling among younger adults and with it most forms of civic and social engagement."

7. Hilde Hein (1976) developed a framework that links our artistic experiences to our political life. She argues that there are three main theories associated with this relationship: the contrapuntal theory, which uses art to conserve the status quo by appeasing citizens into conformity; the propaedeutic theory, which argues that art is the foundation on which we build the structure and order that defines our lives; and finally the propulsive theory, which says that art functions as a critic of existing reality and is the discoverer of new forms for the future. Hein characterizes her view as accepting ideas from all three theories, while emphasizing the development of a truly "self-determining and self-transcending" self (p. 150). I struggle with Hein's conceptualization of what she calls traditional contrapuntal theories of art. She argues that these theories characterize art as an outlet for the inevitable disorder that ultimately sustains the stability of existing daily life. In speaking of the "whole", she designates the status quo and therefore labels this understanding of art as conservative. I argue that, within this contrapuntal theory, if we view the "whole" as a "universal oneness," then the disorder in art enables an ultimate order that is quite the opposite of the status quo.

8. Some of the best work in the area of the psychology of art can be found in Arnheim (1986) and Freud (1958/2009).

9. See works on how artistic experience influences political life, and on how art can be harnessed to political ends in Edelman (1996), Hein (1976), and Schiller (1794/2004), among others.

10. See works on the transformative properties of creative experience in Booth (1997) and Fischer-Lichte and Jain (2008), among others.

11. See some of the excellent works that discuss both the theory and the practice of public art over the last two decades in Finkelpearl (2001), Hein (1996), Knight (2008), and Mitchell (1992).

12. Henk E. S. Woldring, in his studies on social justice as a work of art, argues, "We have already seen that beauty is a kind of good. Something beautiful may be called good not only because it gives pleasure when known but also because it fulfills a human need; thus, we desire what will satisfy our need" (cited in Ramos, 2000, p. 289).

13. See works that link civic engagement, community, and art: Corbitt and Nix-Early (2003), and the highly interesting data born of the 2002 Survey of Public Participation in the Arts: (NEA, 2007) and the 2008 Survey of Public Participation in the Arts: (NEA, 2009).

14. "[Art is] produced in and for the established reality, providing it with the beautiful and the sublime, elevation and pleasure, Art also dissociates itself from this reality and confronts it with another one: the beautiful and the sublime, the pleasure and the truth that Art presents are not merely those obtaining in the actual society." (Marcuse, 1972)

1 Everyday Rebellion: Using Tocqueville to Argue the Need for a Revitalization of American Society and Democracy through Art

1. Many texts provide interpretations of Tocqueville's *Democracy in America*. From examinations that place Tocqueville in the context of the history of political and democratic thought (Wolin, 2004; Drolet, 2003; Allen, 2005; Maguire, 2006; and Rahe, 2009, among others) to those that explore various applications of Tocqueville's ideas to social and political concerns today (Masugi, 1991; Edwards, Foley, & Diani, 2001).

2. See some of the exceptional works on Tocqueville's life, and on the story behind his enormously popular and influential *Democracy in America*, such as George Wilson Pierson's (1959) classic *Tocqueville in America*, Hugh Brogan's (2007) *Alexis de Tocqueville: A Life*, and Joseph Epstein's (2009) *Alexis de Tocqueville: Democracy's Guide*.

3. Slavery, and other structural inequalities, not included.

4. Both Drolet (2003) and Wolin (2003) have made reference to Tocqueville's active but conflicted life as a politician.

5. Wolin (2003) further asserts, "[P]ostmodern despotism consists of the collapse of politics into economics and the emergence of a new form, the economic polity.... At home, democracy is touted not as self-government by an involved citizenry but as economic opportunity" (p. 571).

6. Mark Warren (2001) argues that Tocqueville overgeneralized the effects of associations on democracy, and that this resulted in a too simplistic state-society model that fails to take into account that not all types of associations have the same effects on democratic life. Warren seeks to identify which associations are the most inclusive, and which best promote civic interest, participation, and leadership.

7. Paul Rahe (2009) likewise agrees with Tocqueville that the "drift" toward soft despotism by way of a yield to administrative and popular authority is natural in a democratic society and must be constantly defended against. He sees this human desire for guidance as rooted not only in the ideas of Tocqueville, but also those of Montesquieu and Rousseau. Further, he concludes that America today has indeed given up true liberty for administrative control and argues that Americans must embrace a new revolution that aims to reverse this yielding of freedom to a central government, albeit his argument is of a distinctly libertarian nature: "[L]et our virtue be individual responsibility" (p. 280).

8. Conservative scholar Michael Ledeen (2001) sees great value in Tocqueville's assertion that the various elements of American democratic life are kept in balance, excessive individualism avoided, and liberty protected, by a combination of Americans' strong religious beliefs, and by their desire for a decentralized government that encourages local governance and an active role in voluntary associations. He argues that American democracy has evolved significantly from the world described in Tocqueville's observations close to two centuries ago. He asserts that today's political life is

distinctly and self-consciously separate from religious life and belief. This move away from religion in the public threatens the precarious balance of relationships that Tocqueville described. Ledeen also cites the importance of associational life but does not identify a decrease in voluntary public participation (a claim often made in contemporary democratic theory) as a threat to liberty.

9. Matthew Maguire (2006) argues that Tocqueville identifies the expansion of imaginative capability within individuals as the way to counteract the oppressive power of popular opinion in a democracy.

10. This is not unlike Herbert Marcuse's (1969) "Great Refusal" arguments of the 1960s.

2 The Coupling of the Dionysian and the Apollonian: Nietzsche and Transcendent Art

1. This dominant view was heavily reliant on Johann Winckelmann's (1764/ 2009) *The History of Ancient Art.*

2. Rampley (2000, p. 216).

3. The first study of its kind to appear in English.

4. In 1993, the Whitney Museum of American Art in New York City exhibited a show titled *Abject Art: Repulsion and Desire in American Art.* Included in this genre of creativity is extreme performance art that employs various forms of the abject, such as a deceased body or rituals of cruelty or suffering, as well as the use of bodily fluids, such as blood, feces, urine. Some of the notable artists whose works were exhibited in this show are Louise Bourgeois, Carolee Schneemann, Cindy Sherman, Kiki Smith, Robert Gober, and Paul McCarthy, among others. Some artists have employed abject materials and ideas to provoke and transcend the comforts of our everyday lives; others are conscious of the simple shock value and even humor that may be contained in the abject. Although theoretically the abject is significant, and while some artworks are able to capture the transcendent moments of abjection, many others seem too easy, "plastic'" imitations of truly subversive experiences, and often their effect is silly and trite, rather than transformative (Cotter, 1993).

5. Notably, Stauffer and Bergo (2009), in their recent work on the links between Nietzsche and Levinas, argue that despite the seeming opposing nature of the ethical thought of the two thinkers, there are important overlaps between them: "Both [thinkers] radically reevaluate the traditional ground of ethics and morality, and, further, both are united in their appreciation of the risk that nihilism poses to ethics and to life in general" (p. 1).

 Similarly, von Vacano (2007), examining the similarities between the political theories of Machiavelli and Nietzsche, argues that for both thinkers "truth is to be approached from an artistic perspective" (p. 111).

6. Nietzsche officially proclaimed the "death of god" in *The Gay Science* (1882/1974).

7. Witt (2007) argues that in Nietzsche's final works the importance of the Apollonian drive is reduced, in comparison with its valuation in his first work, although he affirms that "Nietzsche never abandoned his anti-Aristotelian stance, which privileges suffering over action and the aesthetic over moral" (p. 26).

8. This connection between art and political health is distinct from the view described by Jeanne M. Heffernan (2000) in her examination of art as a political good, where she highlights Maritain's ideas regarding the relationship between art and politics. Quoting Maritain (*Art and Scholasticism*, 1924), Heffernan asserts that "[a]rt plays a critical role in the life of virtue: art teaches man the pleasure of the spirit and frees him from a preoccupation with pleasures of the flesh" (p. 42).

9. Caroline Levine (2007) writes of the turn in the 1960s: "Turning rebellion into a devious kind of conformity, advertising took the edge off the unsettling power of radical and dissenting outsiders" (p. 17).

3 Camus and the Transformative Nature of Art: The Invigorating and Community-Building Experience of Public Art

1. For an excellent overview of Camus's philosophy of rebellion see Friedman (1970).

2. Marcuse (2007) wrote, "It is always concerned with history but history is the history of *all* classes. And it is this generality which accounts for that universal validity and objectivity of art which Marx called the quality of 'prehistory' and which Hegel called the 'continuity of substance' from the beginning of art to the end—the truth which links the modern novel and the medieval epic, the facts and possibilities of human existence, conflict and reconciliation between man and man, man and nature" (pp. 229–230).

3. Although the term avant-garde is highly debated, Levine emphasizes the original roots of the word, meaning the front line or vanguard. By the 1870s and 1880s, the label began attaching itself to artists who were a deliberate group of outsiders—"celebrating the margins, advocating an overturning of conventional aesthetics. More specifically, they were reacting against conservative art sponsored by national academies.... Within this context they praised art that was embattled, filled the term with its original military connotation...artists saw themselves not only as innovators, but as warriors against the status quo, doing battle with the present in the name of the future, provoking radical change through rupture and destruction so that a new world could come to take the place of the old" (pp. 5–6).

4. Duncan argues that since art museums first began to be funded and built in the late eighteenth century, they have ever increasingly grown in size, number, wealth, and power as "sites of cultural activity" (p. 1).

5. She uses their conclusions as the basis for her more far-reaching arguments. Bourdieu and Darbel argue that their work shows how vital class is to the ritual of the art museum. Duncan does not disagree with the sociologists, but she does examine the ritual experience of the museum more fully and with attention to more than just the class relations that are enacted within its walls.

6. Solomon is best known for his work on existentialism.

7. "[His]" refusal to "take sides" can be interpreted as the action of an "independent radical" (Foley, 2008, p. 84).

8. "Works from *The Rebel* era represent a subversion of Cartesian solipsism, placing 'we' before 'I' and culminating in the development of the concept of solidarity" (Sagi, 2002, p. 1).

9. Hanna identified key overlaps among the ideas of Nietzsche, Kierkegaard, and Camus. He suggested that they all worked in opposition to the modern world of reason and technology.

10. Where Sagi founded the university's program for hermeneutic and cultural studies.

11. Dave Beech (2004), one of the three members of the critical and public and socially minded art collective *Freee* based in England, notes similarly, "Collaborative independence…is a form of independence that does not delude itself that autonomy (self-determination) is equivalent to isolation (the myth of the self-created self). The 'self' of self-determination is understood, within collaborative independence, to be co-produced with others."

12. Under the empire, commoners—free Roman citizens—still had some political influence as a few aspects of society were still influenced by the vote (although the Senate was by this point, largely symbolic).

13. Much of the great art in Rome is housed not in world-renowned museums like the Vatican, but in the many churches scattered around the city. From the Bernini sculptures and Caravaggios in the great Santa Maria del Popolo, to the Velasquez paintings that adorn the front nave of even the humble chapel near the Piazza da Spagna, transcendent artworks can be found not within crowded and regulated museums, but in quiet and public churches. This placement of art enables truly public access to them.

14. Epigraphy is the study of epigraphs or inscriptions, in order to study the culture in which they were created.

15. Ian Shapiro (1990), *Political Criticism,* Berkeley and Los Angeles: University of California Press, pp. 265–298.

4 Visionary Artistic Rebellion: Rimbaud, De Sade, and the Progression from Chaotic Creation to Conscious Participation

1. "For complex reasons, philosophers have feared art (rather in the way in which, fearing female sexual power, society has evolved ways of keeping women in their 'place')" (Danto, 1998b, p. 134).

2. Hegel's (1807/1977) "end of art" thesis.

3. Two excellent biographies of de Sade are Bongie (1998) and Gray (1999).

4. There are many first-rate studies of both Rimbaud's literary project, and of his personal life. See Rimbaud (1975), Oxenhandler (2009), Steinmetz (2002), and White (2008).

5. According to Lawrence W. Lynch (1984), he was originally to be christened Louis-Aldonse-Donatien by his parents, but owing to a mix-up he was named Donatien-Alphonse-Francois. Only after 1792 did he adopt the name Louis-Alphonse-Donatien.

6. Klossowski was a literary critic who published in George Bataille's *Acephale* in the 1930s. His texts on de Sade and Nietzsche were widely influential on French postmodern philosophy.

7. This text consisted of two extended essays, one on each of the writers. Blanchot examines de Sade's philosophy in "De Sade's Reason." This essay appeared in *Les Temps Modernes* and in part reviewed Klossowski's (1991) *De Sade, My Neighbor*.

8. White is a novelist and prominent writer of gay nonfiction since the mid 1960s.

9. In other translations, it is the "real progress" and "real advance."

10. Translated from the French, as accessed on July 27, 2011, at: http://un2sg4.unige.ch/athena/rimbaud/rimb_sai.html#1.

11. "Today's rebels want to see, hear, feel new things in a new way: they link liberation with the dissolution of ordinary and orderly perception" Marcuse (1969, p. 37).

12. Alienating in the sense of supporting a separation between individuals, and a separation between one's daily experience and one's truly free inner self.

13. Of course, Rousseau was talking specifically about the Enlightenment greats, Bacon, Descartes, and Newton, whom he called "teachers of mankind."

5 The Power of Creative Moments in Everyday Life: Marcuse, Revolution through Art, and a Critique of Everday Life

1. "[C]ritical art is a type of art that sets out to build awareness of the mechanisms of domination to turn the spectator into a conscious agent of world transformation" (Ranciere, 2004, p. 45).

2. The notion of creativity is linked intimately with that of art. The twentieth-century writer Arthur Koestler, in his *Act of Creation* (1964/1990), argues that creativity—let us define it here loosely as the creation of new ideas—can, and often is in modern society, repressed by the dominance and strength of rational thought, action, and moral codes. It is when we can release ourselves from the bonds of rationality that we can access the highest levels of creativity.

3. "Only if...the scientific and artistic imagination direct the construction of a sensuous environment, only if the work world loses its alienating

features and becomes a world of human relationships, only if productivity becomes creativity, are the roots of domination dried up in the individuals. No return to precapitalist, pre-industrial artisanship, but on the contrary, perfection of the new mutilated and distorted science and technology in the formation of the object world in accordance with 'the laws of beauty.' And 'beauty' here defines an ontological condition—not of an *oeuvre d'art* isolated from real existence ... but that harmony between man and his world which would shape the form of society"(Marcuse, 2001, pp. 138–139).

4. In Douglas Kellner's introduction to *Marcuse: Art and Liberation* (2007), he elucidates the most common criticism of Marcuse's philosophy, that it enables escape from, not interaction with, society. Referring to Timothy J. Lukes's work, he writes: "[H]is book *The Flight into Inwardness* (1985), also affirms 'the central role of aesthetics in Marcuse's work,' agreeing with Katz concerning the primacy of aesthetics in Marcuse. Lukes claims that Marcuse's work leads into a withdrawal and escape from politics and society in aesthetic 'flight into inwardness.'" (Marcuse, 2007, p. 2).

5. "As part of the *established* culture, Art is *affirmative*, sustaining this culture; as *alienation* from the established reality, Art is a *negative* force. The *history of Art* can be understood as the *harmonization of this antagonism*" (Marcuse & Kellner, 2007, p. 143).

6. "Capitalist progress thus not only reduces ...the 'open space' of the human existence but also the 'longing,' the need for such an environment. [Capitalist progress] militates against qualitative changes even if the institutional barriers against radical education and action are surmounted" (Marcuse, 1969, p. 18).

7. Art and sensuality as a new form of reason.

8. "What I really want to do is to be able to change the lives of a group of people with the same material that they deal with everyday. [...] When you talk about transformation ... this being the stuff of art ... transforming materials and ideas" (Harley & Walker, 2010).

9. British writer on art and society.

10. Blake (2007) examines how historically the arts, public life, and the state have interacted in America. Gerald Raunig's (2007) text on the relationship between art, activism, and revolution examines revolution through a historical lens.

11. Simply put, this is art that involves interaction between the art, the artist(s), and the audience.

12. "Populism is not communal, although it calls for deeper awareness of our social relations. It is also not anti-individualist; in fact at its fullest, populism encourages independent exploration, development of personal viewpoints, and critical interrogations of our public and private selves. Ultimately, populism advocates for the free will and informed decision-making of individuals" (Knight, 2008, p. 110).

13. There has been an ongoing dialogue between Kester and Claire Bishop. Although they agree that art is inherently linked to political life, they

disagree about the value of the "social turn" in art. The crux of their disagreement lies in Kester's belief that Bishop is too exclusionary about what constitutes art, and Bishop is critical of what she views as Kester's resistance to both "shocking" art and to making necessary comparisons of the end value of various artworks (as opposed to assessing an artwork based solely on its process and intentions). Kester believes there is great social value to all interactive and communication-based art projects, which directly bring people into contact with others, and thus create opportunity for empowerment and participation in social and political life through art. Bishop argues that he does not distinguish between direct community action as art (which she believes should be termed something other than art) and art that *indirectly* engages community action.

14. "In short, there is the idea that links political subjectivity to a certain form: the party, an advanced detachment that derives its ability to lead from its ability to read and interpret the signs of history. On the other hand, there is another idea of the avant-garde that, in accordance with Schiller's model, is rooted in the aesthetic anticipation of the future. If the concept of the avant-garde has any meaning in the aesthetic regime of the arts, it is on this side of things, not on the side of the [45] advanced detachments of artistic innovation but on the side of the invention of sensible forms and material structures for a life to come. This is what the 'aesthetic' avant-garde brought to the 'political' avant-garde, or what it wanted to bring to it—and what it believed to have brought to it—by transforming politics into a total life programme" (Ranciere, 2004, pp. 29–30).

15. "Modernist faith had latched on to the idea of the 'aesthetic education of man' that Schiller had extracted from the Kantian analytic of the beautiful. The postmodern reversal had as its theoretical foundation Lyotard's (1994) analysis of the Kantian sublime, which was reinterpreted as the scene of founding distance separating the idea from any sensible presentation" (Ranciere, 2004, p. 29).

16. Barbara L. Fredrickson (2007) concludes that positive emotions are the active ingredients that allow people to be optimistic and resilient. Feelings persuade us to speak or act; encouraging the emotions of empowerment in our public spaces is vital to the goal of participation. She argues that the answer to both the lack of positivity and the lack of participation among Americans lies in "[p]ut[ting] emphasis on the power of relationships and small-scale pragmatic action, rather than on making policy or protests. In some ways we've become a culture of what psychologists called 'learned helplessness,' and as we wait for others to solve our problems, the problems get harder to solve. But resilient people don't wait; they think their actions make a difference in the world. Any changes that would happen from the 'prosperous way down,' could . . . allow people to have more frequent positive emotions, greater connection to the people in their lives, the natural world . . . as opposed to 'work, achieve, work,

achieve.' The satisfaction and pride that you get out of creating something, growing something, is huge" (Chase, 2009).

6 Recent Experiments with Public and Interactive Art, New York City and Beyond, 2008–2011

1. It is appropriate to mention here the democratizing digital force of Google, and its recent foray into the experience of art. As Google's latest cultural innovation, their Google Art Project, launched in winter 2011, allows any Internet visitor to freely and easily navigate through—literally, by virtually walking into and around museum exhibit rooms—the interior spaces of 17 different museums in both the United States and Europe. While the project is still a work in progress, as can be seen when in some rooms the paintings are blurry and hard to see, while in others, many of the captivating world-famous artworks can be viewed inch by inch in such explicit detail that you wouldn't even be able to see such intimacy with brush strokes if you were in front of it in person. The project inevitably turns our collective attention back to the question that has brought the art world and the technology world into the most frequent and rich conversations. This is the issue of how different, and how valuable, an experience with art is, which is not had in physical person, but rather viewed through a digital medium, such as the computer screen image of a website, or perhaps the live-action feel of a webcam, or now, Google's Art Project. I was recently in Rome and was again reminded of the tactile feeling of standing in front of a large artwork, and being Rome, this was often a commanding Renaissance painting. To look up at it feels somehow "real" in a world that is increasingly virtually experienced; often you can still smell the oil paint, touch with your eyes the dimensions of the cracks in the old wood canvas. It is usually going to be inspiring to look at an inspiring work of art, but to really "feel" that artwork, often physicality is key (Smith, 2010c).

2. See http://www.davidzwirner.com/artists/4/selected_works_6.htm

3. In her striking and chaotic works, the feminist (as she is sometimes labeled) video performance artist Kate Gilmore aims to highlight both human existential struggles and the distinctly feminine struggles of our time. In her most recent work, part of a group video project in Times Square sponsored by *Creative Time* this past spring, she fights to break her head through a too-small hole in a sheet of plywood. In other works, she struggles to place heavy objects onto shelves dripping with paint, and in another, she drops herself to the bottom of a deep ditch and attempts to crawl out. She regards her work not only as a protest to some of the unfair struggles of women in society, but also as a homage to determination (LaRocca, 2009).

The artist Patty Chang similarly creates, and stars in, films and performance works that explore feminine roles and their particular challenges,

as well as the cultural differences within this, in provocative, and some-
times controversial, ways.

4. Jerry Saltz (2009h) wrote about his experience as a volunteer for this
ongoing performance work and kept a running diary of how he felt and
thought during the exercise. It is clear from these notes that he was very
invigorated by the performance, engaged with the reading, and con-
sumed with thought about time and how the performance presented
time.

5. Halperin, Julia: "Make Way for the Art Truck!: Eric Fischl on Mixing
Art, Poetry, and the Transformers to Tackle Post-9/11 America",
Artinfo.com, retrieved: July 11, 2011. Published: April 27, 2011. http://
www.artinfo.com/news/story/37555/make-way-for-the-art-truck-eric
-fischl-on-mixing-art-poetry-and-the-transformers-to-tackle-post
-911-america/

6. Sehgal's *Kiss*, along with other works, constitutes the entirety of the
unique architectural structure of the Guggenheim Museum, January
29–March 10, 2010. It is Sehgal's first work in an American museum.

7. Artdaily.org: "MoMA Deepens Commitment to Collecting, Preserving, and
Exhibiting Performance Art", retrieved: July 9, 2011. Published: March 1,
2009. http://www.artdaily.org/index.asp?int_sec=2&int_new=29298

8. In March 2008, the MoMA started scheduling private workshops to
establish some guidelines for preserving and displaying temporary art.
These meetings addressed everything from "the discrepancies between a
performance and its remnants to legal quirks to the appropriateness of an
institution's owning work created to subvert institutions" (Orden, 2009).

9. Yayoi Kusama is a Japanese artist who came of age in the 1960s era of
happenings and early conceptual experiments. In August 1969, she
gained notoriety for her "Grand Orgy to Awaken the Dead" perfor-
mance, where she and her likewise naked assistants danced into New
York's MoMA's sculpture garden and proceeded to paint each other in
large, brightly colored polka dots. Kusama is famous for working only in
polka dots and in their inverse of negative space dots. This creative asser-
tion yields some questions: What is the effect of shapes in everyday life on
the individual spirit? For example, do circles imply continuity and unity,
with the possibility of eventual existential crisis in the lack of perceptible
limits or boundaries? Similarly, while sharp corners can clearly stake out
the corners of a landscape, allowing for more immediate comprehension,
they may resist the flux that is human life through the force of its lines.
Can shapes, and more generally, the way we physically structure our
public spaces, help to encourage the need and capacity for participation
(desire to improve public life), and pride (belief that public life is a valu-
able good), in public life among citizens?

BIBLIOGRAPHY

Alexandrian, S. (1997). *Surrealist art*. (G. Clough, Trans.). New York: Thames and Hudson. (Originally published 1970).

Allen, B. (2005). *Tocqueville, covenant, and the democratic revolution: Harmonizing earth with heaven*. Lanham, MD: Rowman & Littlefield.

Allison, D., Roberts, M. S., & Weiss, A. S. (Eds.) (2006). *Sade and the narrative of transgression*. Cambridge, UK: Cambridge University Press.

Arendt, H. (1998). *The human condition*. Chicago, IL: The University of Chicago Press. (Originally published 1958).

———. (2006). *On revolution*. New York: Penguin Books.

Aristotle. (1996). *The politics and the constitution of Athens*. (S. Everson, Trans.). Cambridge, UK: Cambridge University Press.

Arnheim, R. (1986). *New essays on the psychology of art*. Berkeley: University of California Press.

Artbeat.com. (2010). *A day trading*. Retrieved March 21, 2010, from the *Artbeat* website: http://www.nyartbeat.com/event/2009/6F3F.

Artlog.com. (2009). *Free store opening*. Retrieved August 4, 2009, from the *Artlog* events website: http://www.artlog.com/events/2710-free-store-opening.

Banksy. (2010). *Exit through the gift shop*. UK: Paranoid Pictures.

Barber, B. R. (2008). *Consumed: How markets corrupt children, infantilize adults, and swallow citizens whole*. New York: W.W. Norton & Company, Inc.

Barnard, A. (July 11, 2009). A violent end for a symbol of vulnerability. *The New York Times*. A13.

Baudelaire, C. (1989) *The flowers of evil*. New York: New Directions Publishing Corporation. (Originally published 1857).

Baudrillard, J. (1994). *Simulacra and simulation*. (Shelia Faria Glaser, Trans.) Ann Arbor: University of Michigan Press. (Originally published 1985).

Beauvoir, S. (1962). Must we burn de Sade? (S. de Beauvoir & P. Dinnage, Eds.). *Marquis de Sade: An essay by Simone de Beauvoir with selections from his writings*. London, UK: John Calder Publications Ltd. (Originally published 1953 by Grove Press).

Beech, D. (2004). *Independent collaborative hospitality*. Retrieved February 1, 2010, from http://www.dave.beech.clara.net/ich.htm.

Benjamin, W. (1970). The work of art in the age of mechanical reproduction. (C. Cazeaux, Ed. [2000]). *The continental aesthetics reader*. New York: Routledge.

Berman, S. (2001). Civil society and political institutionalization. (B. Edwards, M. Foley, & M. Diani, Eds.). *Beyond Tocqueville: Civil society and the social capital debate in comparative perspective, 32–42.* Hanover, NH: London University Press of New England.

Berwick, C. (Mar. 10–17, 2008). The *Facebook* biennial. *New York Magazine,* 139–142.

Bettelheim, B. (1977). *The uses of enchantment: The meaning and importance of fairy tales.* New York: Random House/Vintage Books.

Beuys, J. & Harlan, V. (Eds.) (2004). *What is art?: Conversation with Joseph Beuys.* East Sussex, UK: Clairview Books Ltd.

Bishop, C. (2005). *No pictures, please: Claire Bishop on the art of Tino Sehgal, Artforum International.* Retrieved April 1, 2010, from The Free Library website: http://www.thefreelibrary.com/No+pictures,+please:+Claire+Bishop+on+the+art+of+Tino+Sehgal-a0132554959.

————. (Ed.) (2006a). *Participation.* Cambridge, MA: MIT Press.

————. (Feb. 2006b). *The social turn: Collaboration and its discontents, Artforum International,* 179–185. Retrieved April 1, 2010, from The Free Library website: http://www.thefreelibrary.com/The+social+turn:+collaboration+and+its+discontents.-a0142338795.

Bittman, M. (Feb. 14, 2010). a sin we sip instead of smoke? *The New York Times,* Week in Review. 1; 4.

Blake, C. N. (Ed.) (2007). *The arts of democracy: Art, public culture, and the state.* Washington, DC: Woodrow Wilson Center Press.

Blanchot, M. (2004). *Lautreamont and Sade.* Palo Alto, CA: Stanford University Press. (Original work published 1949).

Blumenkranz, C. (Sept. 28, 2008). Radical speak—Performance artist Mark Tribe breathes new life into old politics. *New York Magazine,* 66.

Bongie, L. L. (1998). *Sade: A biographical essay.* Chicago, IL: The University of Chicago Press.

Booth, E. (1997). *The everyday work of art: How artistic experience can transform your life.* Naperville, IL: Sourcebooks.

Borzello, F. (1987). *Civilising caliban: The misuse of art 1875–1980.* London, UK: Routledge & Kegan Paul.

Bourriaud, Nicolas. (1998). *Relational Aesthetics.* Dijon, France: Les Presse Du Reel.

Brogan, H. (2007). *Alexis de Tocqueville: A life.* New Haven, CT: Yale University Press.

Bruder, J. (Apr. 24, 2011). All the world's a stage, even the back of a truck. *The New York Times,* Art. AR23.

Cahn, S. & Meskin, A. (Eds.) (2008). *Aesthetics: A comprehensive anthology.* Oxford, UK: Blackwell Publishing.

Camus, A. (1958). *Caligula and three other plays.* (J. O'Brien, Trans.). New York: Alfred A. Knopf, Inc. (Originally published 1944).

————. (1968). *Lyrical and critical essays.* (P. Thody, Ed.; E. C. Kennedy, Trans.). New York: Alfred A. Knopf, Inc.

————. (1975). *The plague.* (S. Gilbert, Trans.). New York: Vintage International. (Originally published 1948).

————. (1983). *The myth of Sisyphus and other essays.* (J. O'Brien, Trans.). New York: Alfred A. Knopf, Inc. (Originally published 1942).

————. (1988). *The stranger.* (M. Ward, Trans.). New York: Vintage International. (Originally published 1942).

————. (1991). *The Rebel: An essay on man in revolt.* (A. Bower, Trans.). New York: Vintage International. (Originally published 1951).

Carlin, T. J. (Aug. 14–20, 2008). Buckminster fuller: Starting with the universe. *Time Out New York,* 53.

Carrier, D. (Dec. 1998). Danto and his critics: After the end of art and art history. *History and Theory, 37* (4), 1–16.

Carvajal, D. (Jan. 24, 2011). "This space for rent": In Europe arts now must woo commerce. *The New York Times,* Arts. C1; C7.

Casale, R. (July 5, 2009). Bathroom reading. *The New York Times,* Sunday Styles. Retrieved July 11, from *The New York Times* website: http://query.nytimes.com/gst/fullpage.html?res=9F04E1DB1438F936A35754C0A96F9C8B63.

Cazeaux, C. (2006). *The continental aesthetics reader.* New York: Routledge.

CBS News. (Dec. 5, 2010). Fed Chairman Ben Bernanke's take on the economy. *60 Minutes.* Retrieved May 23, 2011, from *CBS News* website: http://www.cbsnews.com/stories/2010/12/03/60minutes/main7114229.shtml.

Chase, L. (Apr. 2009). Do worry. Be happy. *Elle Magazine,* Beauty/Psychology, 216, 222–225, 290.

Cooper, D. (Ed.) (1998). *Aesthetics: The classic readings.* Oxford, UK: Blackwell Publishing.

Cooper, L. (2008). *Eros in Plato, Rousseau, and Nietzsche: The politics of infinity.* The Pennsylvania State University Press.

Corbitt, J. & Nix-Early, V. (2003). *Taking it to the streets: Using the arts to transform your community.* Grand Rapids, MI: Baker Books.

Cotter, H. (Aug. 13, 1993). Review/art; At the Whitney, provocation and theory meet head-on. *The New York Times,* Arts.

————. (Sept. 12, 2008). Finding art in the asphalt. *The New York Times,* Arts. E27; E33.

————. (July 18, 2009). *The collected ingredients of a Beijing life,* Arts. Retrieved July 23, 2009, from *The New York Times* website: http://www.nytimes.com/2009/07/15/arts/design/15song.html.

————. (Feb. 16, 2011a). Careful reading between the lines is required. *The New York Times,* Arts. C1; C5.

————. (Feb. 11, 2011b). When Picasso changed his tune. *The New York Times,* Weekend Arts. C27; C29.

Coulston, J. & Dodge, H. (Eds.) (2000). *Ancient Rome: The archeology of the eternal city.* Oxford, UK: Oxford University School of Archeology.

Dahl, R. A. (2006). *A preface to democratic theory.* Chicago, IL: The University of Chicago Press. (Originally published 1956).

Damien Hirst's Shark on display at New York's Metropolitan Museum for three years (Oct. 16, 2007). Metropolitan Museum of art press releases. Retrieved July 9, 2008, from MET Current Press Releases website: http:www

.metmuseum.org/press_room/full_release.asp?prid={3687750 c-300604D83-8BD6-8FC5CB67FCA6}.

Danto, A. C. (1983). *The transfiguration of the commonplace: A philosophy of art.* Cambridge, MA: Harvard University Press.

———. (1987). *The state of the art.* New York: Prentice-Hall.

———. (1998a). *After the end of art: Contemporary art and the pale of history.* Princeton, NJ: Princeton University Press.

———. (1998b). *Beyond the Brillo box: The visual arts in post-historical perspective.* Berkeley: University of California Press.

———. (1998c). The end of art: A philosophical defense. *History and Theory. 37,* 4.

Danto, A. C. & Lang, B. (1984). The end of art. *The death of art: Art and philosophy, Vol. 2.* New York: Haven Publishing.

Davis, B. (Aug. 17, 2006). *Ranciere for dummies.* Retrieved Jan. 5, 2010, from the *Artnet* website: artnet.com.

De Luca, M., Parent, M., & Ross, G. (1998). *Pleasantville.* USA: New Line Cinema.

Debord, G. (1977). *The society of the spectacle.* (F. Perlman & J. Supak, Trans.). Detroit, MI: Radical America and Black & Red.

Degen, N. (Aug. 18, 2005). *The philosophy of art: A conversation with Arthur C. Danto.* Retrieved Jan. 5, 2010, from *The Nation* website: http://www .thenation.com/doc/20050829/danto.

Detrick, B. (Mar. 3, 2011). A feverish warm-up to the art fair. *The New York Times,* Arts. E9.

Dewey, J. (2005). *Art as experience.* New York: Penguin Group. (Originally published 1934).

Dissanayake, E. (1990). *What is art for?* Seattle: University of Washington Press.

———. (1995). *Homo aestheticus: Where art comes from and why.* Seattle: University of Washington Press.

Drolet, M. (2003). *Tocqueville, democracy and social reform.* New York: Palgrave Macmillan.

Duncan, C. (1995). *Civilizing rituals: Inside the public art museum.* New York: Routledge.

Edelman, M. (1996). *From art to politics: How artistic creations shape political conceptions.* Chicago, IL: The University of Chicago Press.

Edwards, B. & Foley, M. W. (1998). Civil society and social capital beyond Putnam. *American Behavior Scientist, 42,* 124–139.

Edwards, B., Foley, M. W., & Diani M. (Eds.) (2001). *Beyond Tocqueville: Civil society and the social capital debate in comparative perspective.* Hanover, NH: University Press of New England.

Eisner, E. W. (2002). *The arts and the creation of mind.* New Haven, CT: Yale University Press.

Elster, J. (2009). *Alexis De Tocqueville, the first social scientist.* Cambridge, UK: Cambridge University Press.

Emerson, R. W. (1921). *The American scholar self reliance compensation* (O. H. Smith, Ed.). New York: American. (Originally published 1893).

————. (2000). *The essential writings of Ralph Waldo Emerson*. New York: Modern Library.

Epstein, J. (2009). *Alexis de Tocqueville: Democracy's guide*. New York: Harper Collins.

Finkel, J. (Nov. 30, 2008). Art subversives storm the museum. *The New York Times*, Art. 27.

Finkelpearl, T. (2001). *Dialogues in public art*. Cambridge, MA: MIT Press.

Fischer-Lichte, E. & Jain, S. I. (2008). *The transformative power of performance: A new aesthetics*. New York: Routledge.

Foley, J. (2008). *Albert Camus: From the absurd to revolt*. Montreal, QC: McGill-Queen's University Press.

Foley, M. & Edwards B. (Jul. 1996) The paradox of civil society. *Journal of Democracy, 7* (3), 38–52.

————. (Mar./Apr. 1997). Social capital and the political economy of our discontent. *American Behavioral Scientist, 40* (5), 669–678.

Foucault, M. (1991). *The Foucault effect: Studies in governmentality*. (G. Burchell, C. Gordon, & P. Miller, Eds.). Chicago, IL: The University of Chicago Press.

————. (1995). *Discipline and punish: The birth of the prison*. (A. Sheridan, Trans.). New York: Second Vintage Books edition, Random House, Inc. (Originally published 1975, English Translation 1977).

————. (1998). *Aesthetics, method, and epistemology*. (J. D. Faubion & P. Rabinow, Eds.). New York: New Press. (Originally published 1994).

Fowlie, W. (1946). *Rimbaud, the myth of childhood*. London: D. Dobson Ltd.

————. (1953). *Rimbaud's illuminations: A study in angelism*. Westport, CT: Greenwood Press.

————. (1967). *Rimbaud: A critical study*. New York: Grove Press.

————. (1994). *Rimbaud and Jim Morrison: The rebel as poet*. Durham, NC: Duke University Press.

Frank, J. (Mar. 19–25, 2009). Vandal squad debate. *Time Out New York*, Own this city.

Frank, T. (1998). *The conquest of cool: Business culture, counterculture, and the rise of hip consumerism*. Chicago, IL: The University of Chicago Press.

Fredrickson, B. (2007). *Positivity: Groundbreaking research reveals how to embrace the hidden strength of positive emotions, overcome negativity, and thrive*. New York: Crown/Random House.

Free store opening. Retrieved May 22, 2009, from Artlog website: http://www.artlog.com/events/2710-free-store-opening.

Freud, S. (1955). Totem and taboo. (J. Strachey, Ed. and Trans.). *The standard edition of the complete psychological work of Sigmund Freud, v.* 13, 1–161. London: Hogarth Press. (Original work published 1913).

————. (1961a). The future of an illusion. (J. Strachey, Ed. and Trans.). *The standard edition of the complete psychological work of Sigmund Freud, v.* 21, 5–56. London: Hogarth Press. (Original work published 1927).

————. (1961b). Civilization and its discontents. (J. Strachey, Ed. and Trans.). *The standard edition of the complete psychological work of Sigmund Freud, v.* 21, 64–145. London: Hogarth Press. (Original work published 1930).

Freud, S. (2009). *On creativity and the unconscious: The psychology of art, literature, love, and religion.* (B. Nelson, Ed.). New York: Harper Perennial Modern Thought Edition. (Originally published 1958).

Friedman, M. (1970). *Problematic rebel: Melville, Dostoievsky, Kafka, Camus.* Chicago, IL: The University of Chicago Press.

Garner, D. (Jan. 8, 2010). Tune in, turn on, turn page. *The New York Times,* Weekend Arts. C29.

Gillespie, M. A. & Strong, T. B. (Eds.). *Nietzsche's new seas: Explorations in philosophy, aesthetics and politics.* Chicago, IL: The University of Chicago Press.

Glass, J. M. (1993). *Shattered selves: Multiple personality in a postmodern world.* Ithaca, NY: Cornell University Press.

Goldblatt, D. & Brown, L. B. (2004). *Aesthetics: A reader in philosophy of the arts.* Boston, MA: Prentice Hall.

Golomb, J. (1995). *In search of authenticity: Existentialism from Kierkegaard to Camus (Problems of modern European thought).* New York: Routledge.

Gramsci, A., Hoare, Q., & Smith, G. N. (1971). *Selections from the prison notebooks.* New York: International Publishers Co.

Graves, J. B. (2005). *Cultural democracy: The arts, community, and the public purpose.* Urbana: University of Illinois Press.

Gray, F. du P. (1999). *At home with the Marques de Sade: A Life.* New York: Penguin.

Green, P. (Jun. 25, 2009a). "West side story" amid the laundry. *The New York Times,* Home. D3.

————. (Dec. 10, 2009b). Is it art or their shoes? *The New York Times,* Home. D1; D6; D7.

Halle, H. (Mar. 19–25, 2009). Jonathan Horowitz: And/or. *Time Out New York,* Arts, 52.

Hanna, T. (1958). *The thought and art of Albert Camus.* Chicago, IL: Henry Regnery.

Hardt, M. & Negri, A. (2000). *Empire.* Cambridge, MA: Harvard University Press.

Harley, K. & Walker, L. (2010). *Waste land* (Vik Muniz). USA: Almega Projects /O2 Filmes.

Hartz, L. (1991). *The liberal tradition in America.* New York: Harvest Books.

Heffernan, Jeanne M. 2000. *Beauty, art and the polis* (Alice Ramos, Ed.). Chicago, IL: Amer Maritain Assn Inc.

Hegel, G. W. F. (1977). *Phenomenology of spirit.* (A. V. Miller, Trans.). New York: Oxford University Press.

Hein, H. (1976). Aesthetic consciousness: The ground of political experience. *Journal of Aesthetics and Art Criticism, 35,* 143–152.

————. (1996). What is public art? Time, place, and meaning. *Journal of Aesthetics and Art Criticism, 54* (1): 1–7.

Heller, Á. (1987). *Everyday life.* London, UK: Routledge Kegan & Paul Ltd.

Heller, Á. (Mar./Apr. 1999) Interview with Simon Tormey. *Post-Marxism and the ethics of modernity,* 94. Retrieved January 4, 2010, from *Radical Philosophy*

website: http://www.radicalphilosophy.com/default.asp?channel_id=2190 &editorial_id=10186.

Heller, Á. & Fehér, F. (1989). *The postmodern political condition*. New York: Polity Press/Columbia University Press.

Heller, E. (1990). *The importance of Nietzsche*. Chicago, IL: The University of Chicago.

Hibbert, C. (1988). *Rome: The biography of a city*. New York: Penguin Books.

Hinderliter, B., Kaizen, W., Maimon, V., Mansoor, J., & McCormick, S. (Eds.) (2009). *Communities and sense: Rethinking aesthetics and politics*. Durham, NC: Duke University Press.

Hintzen-Bohlen, B. (2008). *Art and architecture: Rome*. New York: H. F. Ullmann, Langenscheidt.

Hobbes, T. (2009). *Leviathan*. Oxford, UK: Oxford University Press. (Originally published 1651).

Hoekema, D. E. (Winter 1998). Review of *Danto's State of the art: The philosophical disenfranchisement of art*. Revising cubism. *Art Journal, 47*, 4.

Hofstadter, A. & Kuhns, R. (1976). *Philosophies of art and beauty: Selected readings in aesthetics from Plato to Heidegger*. Chicago, IL: The University of Chicago Press.

Hollingdale, R. J. (2001). *Nietzsche: The man and his philosophy*. Cambridge, UK: Cambridge University Press.

Isaac, J. (1992). *Arendt, Camus and Modern Rebellion*. New Haven, CT: Yale University Press.

Iwano, Masako. (2003). Art as part of daily life—a cross-cultural dialogue between art and people. *The Journal of Aesthetic Education, 37* (4), 114–121. Retrieved January 21, 2011, from Project MUSE database.

Johnson, K. (Jan. 14, 2010). Tamer cats at modern art's high gates. *The New York Times*. C33.

Judt, T. (2007). *The burden of responsibility: Blum, Camus, Aron, and the French twentieth century*. Chicago, IL: The University of Chicago Press.

Kandinsky, W. & Sadler, M. T. H. (1977). *Concerning the spiritual in art*. New York: Dover.

Kateb, G. (1994). *The inner ocean: Individualism and democratic culture*. Ithaca, NY: Cornell University Press.

———. (2002). *Emerson and self reliance*. Lanham, MD: Rowman & Littlefield Publishers, Inc.

———. (2008a). *Patriotism and other mistakes*. New Haven, CT: Yale University Press.

———. (2008b). *Utopia: The potential and prospect of the human condition*. Piscataway,NJ: Aldine Transaction.

Kaufmann, W. (Ed.) (1992a). *Basic writings of Friedrich Nietzsche*. New York: Random House.

———. (Ed.) (1992b). *Tragedy and philosophy*. Princeton, NJ: Princeton University Press.

———. (Ed.) (1994). *Religion from Tolstoy to Camus*. New Brunswick, NJ: Transaction.

Kemal, S., Gaskell, I., & Conway, D. (Eds.) (2002). *Nietzsche, philosophy and the arts*. Cambridge, UK: Cambridge University Press.

Kennedy, R. (Feb. 3, 2011a). Art at the MoMa: Tuna on wheat (hold the mayo). *The New York Times*, Arts. C1; C6.

———. (Feb. 17, 2011b). Flock around "the clock." *The New York Times*, Arts. C1.

———. (Mar. 2, 2011c). Sheep in Times Square. *The New York Times*, Arts. C3.

———. (Mar. 4, 2011d). Street artist is granted a wish and wants your help. *The New York Times*, Arts. C2.

———. (Mar. 31, 2011e). Culture, rolling into towns on big rigs. *The New York Times*, Arts. C1.

———. (Apr.15, 2011f). Two points of view, far apart. *The New York Times*, Arts. C27; C30.

Kester, G. H. (2004). *Conversation pieces: Community and communication in modern art*. Berkeley: University of California Press.

Kino, C. (Feb. 20, 2011). Letting his life's work do the talking. *The New York Times*, Art. AR28.

Klossowski, P. (1991). *Sade my neighbor*. (D. W. Smith, Ed.). Evanston, IL: Northwestern University Press. (Originally published 1947).

———. (1998). *Nietzsche and the vicious circle*. (D. W. Smith, Ed.). Chicago, IL: The University of Chicago Press. (Originally published 1969).

Knight, C. K. (2008). *Public art: Theory, practice and populism*. Oxford, UK: Blackwell.

Koestler, A. (1990). *The act of creation*. New York: Penguin. (Originally published 1964).

Kopel, L. (Nov. 3, 2008). A museum with no exhibits, but plenty of ideas. *The New York Times Magazine*. A28.

Kristeva, J. (1984a). *Powers of horror: An essay on abjection*. (L. S. Roudiez, Trans.). New York: Columbia University Press.

———. (1984b). *The revolution in poetic language*. (L. S. Roudiez, Trans.). New York: Columbia University Press.

Kurutz, S. (Aug. 2, 2009). Peel slowly and see. *New York Magazine*, Arts. 65.

LaRocca, A. (May 3, 2009). Head-on collision: Fearless Kate Gilmore turns accidental chaos into seriously fun art. *New York Magazine*, Art Section.

Lash, S. & Lury, C. (2007). *Global cultural industry: The meditation of things*. Cambridge, UK: Polity Press.

Ledeen, M. (2001). *Tocqueville on American character: Why Tocqueville's brilliant exploration of the American spirit is as vital and important today as it was nearly two hundred years ago*. New York: St. Martin's Griffin.

Lefebvre, H. (1991). *Critique of everyday life, Vol. 1*. (G. Elliott & J. Moore, Trans.). New York: Verso Books. (Originally published 1947).

Lerner, D. (1958). The grocer and the chief. (D. Lerner with L. Pevsner, Eds. [1958, 1964]). *The passing of traditional society: Modernizing the Middle East*. New York: The Free Press of the Macmillan Co. (Also published as an article in *Harper's Magazine*, 1955).

Levine, C. (2007). *Provoking democracy: Why we need the arts*. Malden, MA: Blackwell.

Locke, J. (1988) *Two treatises of government*. (P. Laslett, Ed.). Cambridge, UK: Cambridge University Press. (Originally published 1689).

Lubow, A. (Jan. 15, 2010). Making art out of an encounter. *The New York Times*, Magazine. MM24.

Ludovici, A. (1971). *Nietzsche and art*. New York: Haskell House Publishers.

Lynch, Lawrence W. (1984). Sade and his critics, *The Marquis de Sade,* 122–132. Farmington Hills, MI: Twayne Publishers, Gale.

Lyotard, J.-F. (1984). *The postmodern condition: A report on knowledge*. (G. Bennington & B. Massumi, Trans.). Minneapolis: The University of Minnesota Press.

———. (1994). *Lessons on the analytic of the sublime*. (E. Rottenberg, Trans.). Palo Alto, CA: Stanford University Press.

MacGowan, C. (Ed.) (1991). *The collected poems of Williams Carlos Williams, Vol. 2: 1939–1962*. New York, NY: New Directions Publishing Corp.

Maguire, M. W. (2006). *The conversion of imagination: From Pascal through Rousseau to Tocqueville*. Cambridge, MA: Harvard University Press.

Marcuse, H. (1964). *One-dimensional man: Studies in the ideology of advanced industrial society*. Boston, MA: Beacon Press.

———. (1969). *An essay on liberation*. Boston, MA: Beacon Press.

———. (1970a). *The aesthetic dimension: Toward a critique of Marxist aesthetics*. Boston, MA: Beacon Press.

———. (1970b). The problem of violence and the radical opposition. *Five lectures*. Boston, MA: Beacon Press.

———. (1972). *Counter-revolution and revolt*. Boston, MA: Beacon Press.

———. (1974). *Eros and civilization: A philosophical inquiry into Freud*. Boston, MA: Beacon Press.

———. (2001). *Towards a critical theory of society*. (D. Kellner, Ed.). New York: Routledge.

———. (2007). Art as form of reality. *Art and liberation: Collected papers of Herbert Marcuse, Vol. 4*. (D. Kellner, Ed.). New York: Routledge.

Marini, J. (1991). Centralized administration and the "new despotism." (K. Masugi, Ed.). *Interpreting Tocqueville's democracy in America*. Savage, MD: Rowman & Littlefield.

Maritian, Jacques. (2003). *Art and scholasticism with other essays* (J. F. Scanlan, Trans.). LLC: Kessinger Publishing.

Marx, K. (1978). *The Economic and philosophical manuscripts of 1844*. (R. C. Engels, Ed.). New York: W.W. Norton. & Company, Inc. (Originally published 1844).

Masugi, K. (Ed.) (1991). *Interpreting Tocqueville's Democracy in America*. Savage, MD: Rowman & Littlefield.

Mesch, C. & Michely, V. (Eds.) (2007). *Joseph Beuys: The reader*. Cambridge, MA: MIT Press.

Mills, C. W. (1956). *The power elite*. New York: Oxford University Press.

———. (2000). *The sociological imagination*. New York: Oxford University Press. (Original work published 1959).

Mitchell, W. J. T. (Ed.) (1992). *Art and the public sphere*. Chicago, IL: The University of Chicago Press.

Morris, A. (Jan. 10, 2010). *How Cedar Bridge came to be a homeless city in the woods.* News & Features. Retrieved January 11, 2009, from *The New York Magazine* website: http://nymag.com/news/features/63047/.

Nagourney, A. (Apr. 23, 2001). Admirers call it art, but the police call it a problem. *The New York Times,* National. A9.

National Endowment for the Arts. (2007). *The arts and civic engagement: Involved in arts, involved in Life.* Washington DC.

———. (2009). *Arts participation 2008: Highlights from a national survey.* Washington DC.

Nelson, K. (Jan. 25, 2009). Things move swiftly in SoHo, style. Retrieved January 29, 2009, from *The New York Times* website: http://query.nytimes.com/gst/fullpage.html?res=9501EEDE173DF936A15752C0A96F9C8B63.

New York Magazine. (Dec. 14, 2008). Because we're highly receptive to bold, brilliant, mildly lunatic public art. *New York Magazine,* News & Features. Retrieved May 23, 2011, from *New York Magazine* website: http://nymag.com/news/articles/reasonstoloveny/2008/52935/.

New York Magazine. (May 23, 2010). Do this: Be one with the art. *New York Magazine,* Entertainment and the Arts. Retrieved May 23, 2011, from *New York Magazine* website: http://nymag.com/arts/art/features/66178/.

New York Magazine. 5 pointz profile. *New York Magazine,* Arts & Events. Retrieved May 23, 2011, from *New York Magazine* website: http://nymag.com/listings/attraction/5-pointz/.

Nietzsche, F. (1967). *The birth of tragedy; And the case of Wagner* (W. Kaufmann, Trans.). New York: Vintage. (Originally published 1872).

———. (1974). *The gay science: With a prelude in rhymes and an appendix of songs.* (W. Kaufmann, Trans.). New York: Vintage. (Originally published 1882).

———. (1977). Thus Spake Zarathustra. (W. Kaufmann, Ed. and Trans.). *Portable Nietzsche,* 103–439. New York: Penguin Books. (Originally published 1891).

———. (1989). *Beyond good and evil* (W. Kaufmann, Trans.). New York: Vintage. (Originally published 1886).

———. (1996). *Human, all too human: A book for free spirits.* (R. J. Hollingdale, Trans.). Cambridge, UK: Cambridge University Press. (Originally published 1915).

———. (2009). *A genealogy of morals.* (I. Johnston, Trans.). Arlington, VA: Richer Resources. (Originally published 1897).

Novalis (Hardenberg, von F.). (1997). *Novalis: Philosophical writings.* (M. Stoljar, Trans.). Albany: State University of New York Press. (Original works published 1798).

Novello, S. (2008). Tragedy and "aesthetic politics": Re-thinking the political beyond nihilism in the work of Albert Camus. (C. Margerrison, M. Orme, and L. Lincoln, Eds.). *Albert Camus in the 21st Century: A reassessment of his thinking at the dawn of the new millennium.* New York: Rodopi.

Nussbaum, M. C. (1991, 2002). The transfigurations of intoxication: Nietzsche, Schopenhauer and Dionysus. (S. Kemal, I. Gaskell, and D. Conway, Eds.,[2002]). *Nietzsche, philosophy and the arts.* Cambridge, UK: Cambridge University Press. 36–69.

———. (Mar. 1997). Is Nietzsche a political thinker? *International Journal of Philosophical Studies, 5* (1), 1–13.

O'Brien, C.C. *Albert Camus: of Europe and Africa.* (1970). New York, NY: Penguin Press.

Orden, E. (Jan. 5–12, 2009). Collecting smoke: How does a museum acquire art that vanishes the moment it's made? *New York Magazine*, 70.

Oxenhandler, N. (2009). *Rimbaud: The cost of genius.* Columbus: Ohio State University Press.

Peers, A. (March 1, 2009). *Arte povera: Why recession isn't good for art*, Intelligencer. Retrieved March 6, 2009, from *New York Magazine* website: http://nymag .com/news/intelligencer/55021/.

Pels, D. (1991). Elster's Tocqueville. *Rationality and society*, *3*, 298–307.

Perlmutter, D., & Kopman, D. (Eds.) (1999). *Reclaiming the spiritual in art: Contemporary cross-cultural perspectives.* Albany: State University of New York Press.

Pierson, G. W. (1959). *Tocqueville in America.* New York: Anchor Books /Doubleday.

Plato. (2000). *The republic.* (G. R. F. Ferrari, Ed.; T. Griffith, Trans.) Cambridge, UK: Cambridge University Press.

Pogrebin, R. (Jan. 27, 2011). The permanent collection may not be so permanent. *The New York Times*, Arts. C1.

Purves, M. (Ed.) (March 27, 2009). Jenny Holzer says what we're thinking. *Elle Magazine*, 234.

Purves, T. (2005). *What we want is free: Generosity & exchange.* Albany: State University of New York Press.

Putnam, R. (1994). *Making democracy work: Civic traditions in modern Italy.* Princeton, NJ: Princeton University Press.

———. (2000). *Bowling alone: The collapse and revival of American community.* New York: Simon & Schuster.

Raftery, B. (Oct. 5, 2008). Slice and dice. *The Culture Pages.* Retrieved October 11, 2009, from *New York Magazine* website: http://nymag.com /arts/art/profiles/50969/.

Rahe, P. A. (2009). *Soft despotism, Democracy's drift: Montesquieu, Rousseau, Tocqueville and the modern prospect.* New Haven, CT: Yale University Press.

Ramos, A. (Ed.) (2000). *Beauty art and the Polis.* Washington, DC: Catholic University of America Press.

Rampley, M. (2000). *Nietzsche, aesthetics and modernity.* Cambridge, UK: Cambridge University Press.

Ranciere, J. (2004). *The politics of aesthetics.* New York: Continuum.

———. (2009). *Aesthetics and its discontents.* New York: Polity Press.

Raunig, G. (2007). *Art and revolution: Transversal activism in the long twentieth century.* Los Angeles, CA: Semiotext(e).

Ray, G., Beckmann, L., & Nisbet, P. (2001). *Joseph Beuys: Mapping the legacy.* New York: DAP. Ringling Museum.

Reginato, J. (July 2009). Earl's court. *W Magazine*. 94–98.

Rimbaud, A. (1975). *Arthur Rimbaud: Complete works.* (P. Schmidt, Ed.) New York: Harper & Row.

———. (2005). *Rimbaud: Complete works, selected letters.* (W. Fowlie, Ed.) Chicago, IL: The University of Chicago Press.

Risatti, H. (2007). *A Theory of craft: Function and aesthetic expression*. Chapel Hill: University of North Carolina Press.

Ritzer, G. (2007). *The globalization of nothing 2*. Thousand Oaks, CA: Pine Forge Press.

Ritzer, G. (2010). *McDonaldization: The reader*. Thousand Oaks, CA: Pine Forge Press.

Robb, G. (2001). *Rimbaud: A biography*. New York: W.W. Norton & Company, Inc.

Rocco, C. (Oct. 12, 2008). Talk about underground movement. *The New York Times*, Arts. AR27.

Roche, J. (2006). Socially engaged art, critics and discontents: An interview with Claire Bishop. Community Arts Network: communityarts.net.

Rosenberg, K. (Feb. 11, 2007). Disappearing Act—Revisiting Gordon Matta-Clark's Lost Public Art. *New York Magazine,* Entertainment and the arts. Retrieved May 23, 2011, from *New York Magazine* website: http://nymag .com/arts/arts/all/features/27799/.

———. (Feb. 4, 2011a). Performance art for an audience of one. *The New York Times*, Arts. C27.

———. (Feb. 25, 2011b). Authorship or translation? Notes toward redefining creativity. *The New York Times*, Arts. C26.

———. (Mar. 25, 2011c). Simple truths in the matters of life and death. *The New York Times*, Arts. C30.

Rousseau, J-J. (1993). *The social contract and the discourses*. New York: Everyman's Library. (*The social contract* originally published 1762; *Discourses* originally published 1750).

Sade, Marquis de. (1990). *Justine, philosophy in the bedroom, and other writings.* New York: Grove Press. (Originally published 1795).

Sagi, A. (2002). *Albert Camus and the philosophy of the absurd*. Amsterdam: Editions Rodophi B.V.

Saltz, J. (June 30, 2008). Jerry Saltz goes chasing "waterfalls," vulture. Retrieved May 23, 2011, from *New York Magazine* website: http://nymag.com/daily /entertainment/2008/06/jerry_saltz_on_waterfalls_take.html

———. (Jan. 5–12, 2009a). MoMA's sex change: The museum's Pipilotti Rist show cheekily feminizes a bastion of masculinity. *New York Magazine*, Art, 69.

———. (Feb. 9, 2009b). Reeling in the years. *New York Magazine*, Art, 52–53.

———. (Feb. 16, 2009c). Down with the cube!, Art. Retrieved Dec. 11, 2009, from *New York Magazine* website: http://nymag.com/arts/art/reviews/54052/.

———. (Mar. 23, 2009d). After the orgy. *New York Magazine*, Art, 63.

———. (Mar. 30, 2009e). Energy to burn. *New York Magazine*, Art, 60–61.

———. (Apr. 9, 2009f). "Jesus" saves: God bless the new museum's tantalizing triennial, Art. Retrieved Dec. 11, 2009, from *New York Magazine* website: http://nymag.com/arts/art/reviews/55977/.

———. (June 15–22, 2009g). Dude, you've gotta see this. *New York Magazine*, Art, 138.

———. (Oct. 28, 2009h). Welcome to the sixties, yet again. *The Culture Pages*, 66.

———. (Dec. 6, 2009i). When the low went very high—Who said public art can't be fun?, Entertainment and the Arts. Retrieved May 23, 2011, from *New York Magazine* website: http://nymag.com/arts/all/aughts/62516/.

———. (Feb. 15, 2010a). How I made an artwork cry: In Tino Sehgal's work, the viewer gains unexpected power. *New York Magazine,* Art, 57.

———. (Mar. 8, 2010b). Change we can believe in: The Whitney biennial is thoughtful, human scaled, and blessedly low on hype. *New York Magazine,* Art, 62–63.

———. (Mar. 11, 2010c). Saltz: I made genital contact at the Marina Abramovic show, Vulture. Retrieved Mar. 18, 2010, from *New York Magazine* website: http://nymag.com/daily/entertainment/2010/03/saltz_i_made_genital _contact_a.html

———. (May 23, 2010d). In the end, it was all about you. How "Marina Abramovic: The Artist Is Present" turned the viewer into the viewed, Art. Retrieved May 29, 2010, from *New York Magazine* website: http://nymag .com/arts/art/reviews/66161/.

———. (July 14, 2010e). Jerry Saltz's *Work of Art* recap: Public shaming. *New York Magazine,* Vulture. Retrieved July 16, 2010, from *New York Magazine* website: http://nymag.com/daily/entertainment/2010/07/jerry_saltzs_work_of_art_ recap_3.html.

———. (Feb. 11, 2011a). Ask an art critic: Jerry Saltz answers your questions. *New York Magazine,* Art. Retrieved Feb. 14, 2011, from *New York Magazine* website: http://nymag.com/daily/entertainment/2011/02/ask_an_art_critic_jerry _saltz_7.html.

———. (Mar. 19, 2011b). Jerry Saltz: How a joyride in Gavin Brown's Volvo became art. *New York Magazine,* Art. Retrieved Mar. 23, 2011, from *New York Magazine* website: http://nymag.com/daily/entertainment/2011/03 /jerry_saltz_on_gavin_browns_in.html.

———. (Mar. 27, 2011c). After the drips. *New York Magazine,* Art. Retrieved April 19, 2011, from *New York Magazine* website: http://nymag.com/arts/art /reviews/unpainted-paintings-saltz-review-2011-4/.

Sartre, J. P. (1960). *The transcendence of the ego: An existentialist theory of consciousness.* New York: Hill & Wang. (Originally published 1937).

Schiller, F. (2004). *On the aesthetic education of man.* (R. Snell, Trans.). Mineola, NY: Dover Publications Inc. (Originally Published 1794).

———. (2006). *Aesthetical and philosophical essays.* Middlesex, UK: The Echo Library. (Works originally published 1792–1794).

Schoolman, M. (2001). *Reason and horror: Critical theory, democracy and aesthetic individuality.* New York: Routledge.

Schopenhauer, A. (1969). *The world as will and representation.* Gloucester, MA: Peter Smith Publisher Inc. (Originally published 1818).

Schulte, B. (Jan. 26, 2011). "Space" oddity in Alexandria. *Washington Post,* Metro. Retrieved May 23, 2011, from *Washington Post* website: http://www.washingtonpost .com/wp-dyn/content/article/2011/01/25/AR2011012506762.html.

Shaw, H. (Mar. 19–25, 2009). Focus-pocus. *Time Out New York,* Theater, 107.

The Shawshank Redemption (film, directed by Frank Darabont, short story written by Stephen King, screenplay by Frank Darabont, 1994).

Sheets, H. M. (Feb. 13, 2011). A life of melting the status quo. *New York Times*, Arts. 21.

Shelton, J. (Ed.) (1998). *As the Romans did: A sourcebook in Roman social history.* Oxford, UK: Oxford University Press.

Siegel, M. (Apr. 27, 2009a). What does goo mean to you? *New York Magazine*, Arts. 65.

Siegel, M. (May 4, 2009b). Annotated artwork: "Maelstrom." *New York Magazine*, Arts. Retrieved May 15, 2009, from Features Online: http://nymag.com /arts/art/features/56260/.

Silk, M. S., & Stern, J. P. (1983). *Nietzsche on tragedy.* Cambridge, UK: Cambridge University Press.

Smith, D. & Fowle, K. (Eds.) (2003). *To be continued: Artists' interventions into the public realm.* London, UK: BT Batsford.

Smith, D. B. (Nov. 16, 2008). What is art for? *The New York Times Magazine*, 40.

Smith, H. (2009). *Tales of wonder: Adventures chasing the divine, an autobiography.* New York: Harper One.

Smith, R. (Jun. 26, 2009). Island as inspiration and canvas. *The New York Times*, Arts. C23.

———. (Jan. 12, 2010a). A new boss, and a jolt of real-world expertise. *The New York Times*, Arts. C1.

———. (Feb. 7, 2010b). The work of art in the age of Google. *The New York Times*, Arts. C1–C2.

———. (Feb. 14, 2010c). Post-minimal to the max. *The New York Times*. A1; 23.

———. (Jan. 14, 2011a). An artful environmental impact statement. *The New York Times*. C31.

———. (Feb. 18, 2011b). Artful commentary, oozing from the walls. *The New York Times*, Weekend Arts. C25; C27.

———. (Mar. 11, 2011c). Crawling for peace in not-quite salt mine. *The New York Times*, Weekend Arts. C21; C29.

Smithsonian American Art Museum. (Sept. 26, 2008–Jan. 4, 2009). Museum label for *Georgia O'Keefe and Ansel Adams: Natural affinities.* Washington, DC.

Solomon, R. (2006). *Dark feelings, grim thoughts: Experience and reflection in Camus and Sartre.* Oxford, UK: Oxford University Press.

Spears, D. (Jan. 9, 2011a). Lee Lozano, surely defiant, drops in. *The New York Times*, Arts. 23.

———. (Jan. 16, 2011b). Pushing pedals up and down Park Ave. *The New York Times*, Arts. 21.

Stambaugh, J. E. (1988). *The ancient Roman city (Ancient Society and History).* Baltimore, MD: Johns Hopkins University Press.

Stauffer, J. & Bergo, B. (Eds.) (2009). *Nietzsche and Levinas: "After the death of a certain God."* New York: Columbia University Press.

Steinmetz, J-L. (2002). *Arthur Rimbaud: Presence of an enigma.* New York: Welcome Rain.

Stevens, M. (May 21, 2005). Curtain up: *The Gates...*, Art. Retrieved May 11, 2011, from *New York Magazine* website: http://nymag.com/nymetro/arts/art/reviews/11134/.

———. (Apr. 2, 2006). MoMA in middle age, Art. Retrieved May 11, 2011, from *New York Magazine* website: http://nymag.com/arts/art/features/16571/.

Stewart, S. (1993). *On longing: Narratives of the miniature, the gigantic, the souvenir, the collection.* Durham, NC: Duke University Press.

Stimson, B., & Smolette, G. (2007). *Collectivism after modernism: The art of social imagination after 1945.* Minneapolis: University of Minnesota Press.

Stone, J. & Mennell, S. (Eds.) (1980). *Alexis de Tocqueville on democracy, revolution, and society.* Chicago, IL: The University of Chicago Press.

Strand, P. (1980). Photography. (B. Newhall, Ed.). *Photography, essays, and images.* New York: Museum of Modern Art. 389–397.

Sulcas, R. (Jan. 24, 2011a). The dancer's line and the artist's line intersect in the sand. *The New York Times*, Arts. C5.

———. (Mar. 31, 2011b). Poetry of stillness, in a moment stretched to infinity. *The New York Times*, Arts. C1; C4.

Sutherland, R. (Dec. 6, 2010). Artist to incorporate public in exhibit. *State Press, Arts & Entertainment.* Retrieved May 23, 2011, from *State Press* website: http://www.statepress.com/2010/12/06/artist-to-incorporate-public-in-exhibit/.

Tarrow, S. (Jun. 1996). Making social science work across space and time: A critical reflection on Robert Putnam's Making Democracy Work. *American Political Science Review*, *90* (2), 389–397.

———. (1998). *Power in movement: Social movements and contentious politics.* Cambridge, UK: Cambridge University Press.

Taylor, J. (1989). *Nineteenth-century theories of art.* Berkeley: University of California Press.

Thoreau, H. D., & Witherell, E. H. (2001). *Henry David Thoreau: Collected essays and poems.* New York: Library of America.

Tocqueville, A. de. (1955). *The old regime and the French revolution* (S. Gilbert, Trans.). New York: Anchor Books, Doubleday. (Originally published 1856).

———. (2002). *Democracy in America* (H. C. Mansfield & D. Winthrop, Eds. and Trans.). Chicago, IL: The University of Chicago Press. (Originally published 1835).

Todd, O. (2000). *Albert Camus: A life.* New York: Carroll and Graf.

Tolstoy, L. (1896/1899 Maude English translation). "What is art?" (excerpts). Retrieved from:http://www.csulb.edu/~jvancamp/361r14.html.

Trebay, G. (Apr. 24, 2011). A risk taker's debut. *The New York Times*, Sunday Styles. ST1; ST10.

Tucker, R. C. (Ed.) (1978). *Marx-Engels reader.* New York: W.W. Norton & Company, Inc.

Vacano, D. von. (2007). *The art of power: Machiavelli, Nietzsche, and the making of aesthetic political theory.* Lanham, MD: Lexington Books.

Vajda, M. (1999). Is moral philosophy possible at all? *Thesis Eleven*, *59* (1), 73–85. Retrieved April 1, 2010, from the Sage journals online website: http://the.sagepub.com/cgi/content/abstract/59/1/73.

VH1 Rock Docs: The Drug Years. (2006). "Feed your head (1967–71)".

Waldberg, P. (1997). *Surrealism*. New York: Thames and Hudson. (Originally published 1965).

Warren, M. E. (2001). *Democracy and association*. Princeton, NJ: Princeton University Press.

Weber, M. (2002). *The Protestant ethic and the spirit of capitalism: And other writings*. (P. Baehr, Ed.; G. C. Wells, Trans.). New York: Penguin Classics.

Weibel, P. (2005). Art and democracy: People making art making people. (B. Latour & P. Weibel, Eds.). *Making things public: Atmosphere of democracy*. Cambridge, MA: MIT Press.

White, E. (2008). *Rimbaud: The double life of a rebel*. London, UK: Atlas Press.

Winckelmann, Johann Joachim, & Lodge, Giles Henry. (2010). *The history of ancient art, Vol. 1*. Charleston, SC: Nabu Press, Bibliobazaar.

Willett, J. (Ed. & Trans.) (1964). *Brecht on theatre: The development of an aesthetic*. New York: Hill & Wang.

Witt, M. A. F. (Ed.) (2007). *Nietzsche and the rebirth of the tragic*. Fairleigh Dickinson University Press.

Wolin, S. (2003). *Tocqueville between two worlds: The making of a political and theoretical life*. Princeton, NJ: Princeton University Press.

———. (2004). *Politics and vision: Continuity and innovation in western political thought*. Princeton, NJ: Princeton University Press.

Wood, G. (Feb. 27, 2011). Massive attack. *The New York Times Magazine*, 24–31.

Young, James. (1996). *Reconsidering American liberalism: The troubled odyssey of the liberal idea*. Boulder, CO: Westview Press.

Young, Julian. (1992). *Nietzsche's philosophy of art*. Cambridge, UK: Cambridge University Press.

INDEX